ART ON SKIN

TATTOOS, STYLE, AND THE HUMAN CANVAS

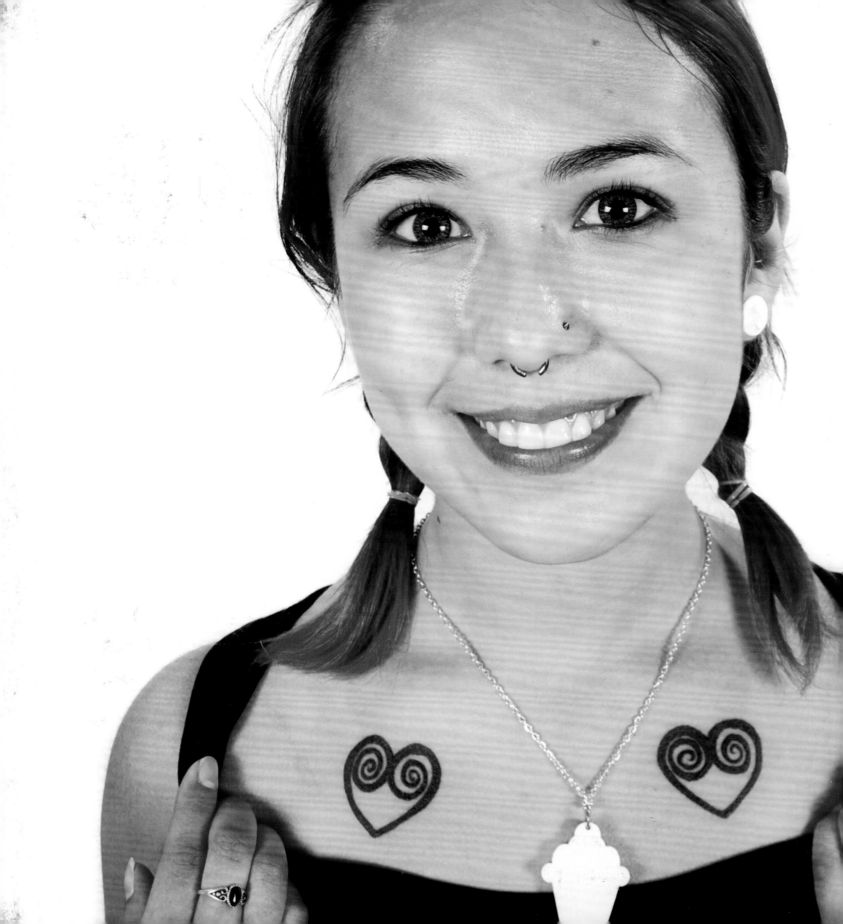

ART ON SKIN

TATTOOS, STYLE, AND THE HUMAN CANVAS

Marcel Brousseau,
Nancy Hajeski
& Lisa Purcell

with photographs by

Jonathan Conklin

and a Foreword by

Troy Timpel

SKYHORSE
PUBLISHING

Skyhorse Publishing books may be
purchased in bulk at special discounts
for sales promotion, corporate gifts,
fund-raising, or educational purposes.
Special editions can also be created to
specifications. For details, contact the Special
Sales Department, Skyhorse Publishing, 307
West 36th Street, 11th Floor, New York, NY 10018 or
info@skyhorsepublishing.com.

Skyhorse® and Skyhorse Publishing® are registered
trademarks of Skyhorse Publishing, Inc.®, a Delaware
corporation.

Visit our website at www.skyhorsepublishing.com.

10 9 8 7 6 5 4 3 2 1

Library of Congress Cataloging-in-Publication Data is available on file.

Cover design by Brian Peterson
Cover photo by Brian Peterson

ISBN: 978-1-62914-209-8
EISBN: 978-1-62914-294-4

Printed in China

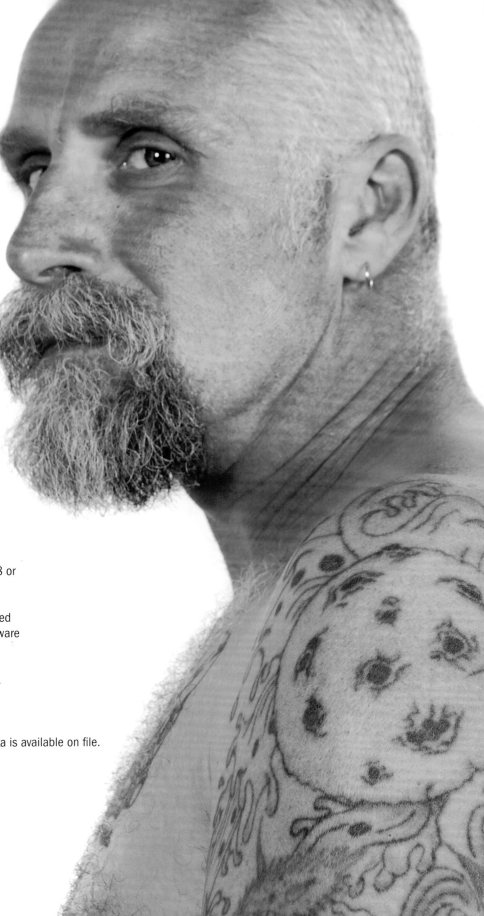

CONTENTS

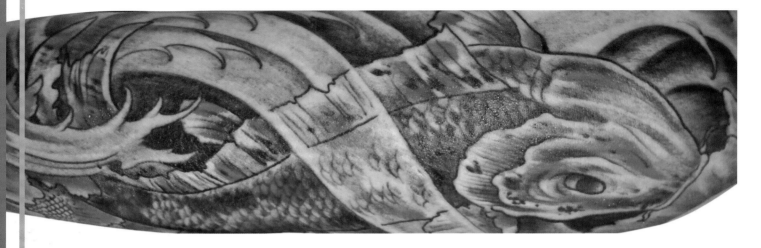

▲ After a bike wreck and three months in a coma, the subject chose a tattoo signifying the brush with death and the fight back to consciousness.
Subject: Morgan Deegan / Artist: Troy Timpe

▲▲ A tattoo rich with meaning. The subject noted that "getting the koi swimming upstream represents a second chance that life has given me."
Subject: Tran / Artist: Troy Timpel

▶ A touching tribute to a lost friend. Tattoo artist Troy Timpel fashioned this intricate pattern for a client who "wanted to mix the paw prints of his recently passed-away boxer dog in this large Japanese floral piece."
Subject: Josh / Artist: Troy Timpel
All photographs this page by Troy Timpel

An intriguing medium with a limitless future, tattooing manages to be an art form as old as time and as modern as today. Tattoos have been found on the oldest preserved human remains, and today they adorn bodies in nearly every culture, all over the world.

From the 1940s through the 1970s, tattooing was largely the territory of military and motorcycle subcultures. The familiar old "sailor" tattoos epitomized military tradition and the stereotyping of our men in service. The 1980s brought a bit more of a progression and broader availability of high-tech tattoo equipment. The 1990s saw the beginning of a tattoo renaissance. The introduction of tattoo magazines, the widening outreach of the Internet, and an increase in the number of tattoo conventions got the public's attention and brought this subculture into an ever-widening arena.

The new players in this tattoo rebirth were mostly art school educated, and they started to push the boundaries. Japanese-style tattooing and various tribal patterns were soon

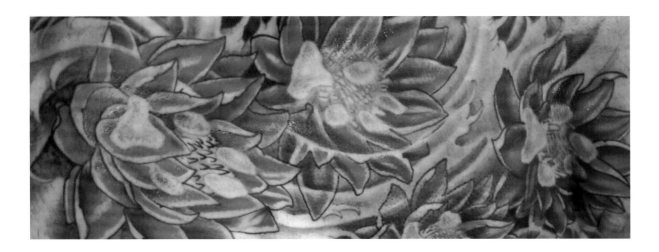

commonplace motifs within the tattoo scene. The new information age awoke interest in both old and new styles of artwork to accommodate the bursting envelope of how to define body art.

Portrait and photorealistic black and gray started to show some of tattooing's true potential. Large-scale tattooing soon became a common sight on an increasing number of individuals. The end of the 1990s saw no stone left unturned. Full bodysuits, mastery of technique, and a flood of equipment developments made tattooing very popular among a huge cross-section of our population.

I started tattooing in 1991, after attending the Milwaukee Institute of Art and Design. I had the pleasure of spending fifteen years (at the time of this book's publication) of tattooing with Philadelphia Eddie. Eddie was a key figure in the development of the tattoo scene from the 1960s to the present. Working with such a legend in the field gave me a true love and understanding of the tatttoo business.

In 1998 I started a tattoo clothing and promotional company called tattooedkingpin. com. We manufacture clothing, accessories, jewelry, and limited edition books. In 2003 we started running the Philadelphia Tattoo Arts Convention. I have since expanded the tattoo convention circuit to include Baltimore, Milwaukee, and Chicago.

The tattoo scene has exploded around me, and it is great to see the worldwide embrace of what was once a small tight-knit subculture. Television documentaries and "reality" shows have given the public an eyeful, providing educational content about this growing art form. I recently had the pleasure of appearing on the History Channel show *The Works*.

This book showcases striking tattoo photos and actual quotes from a broad spectrum of real subjects. I'm happy to be part of this project— it's given me a meaningful glimpse into people's personal feelings about their tattoos.

Troy Timpel

FOREWORD

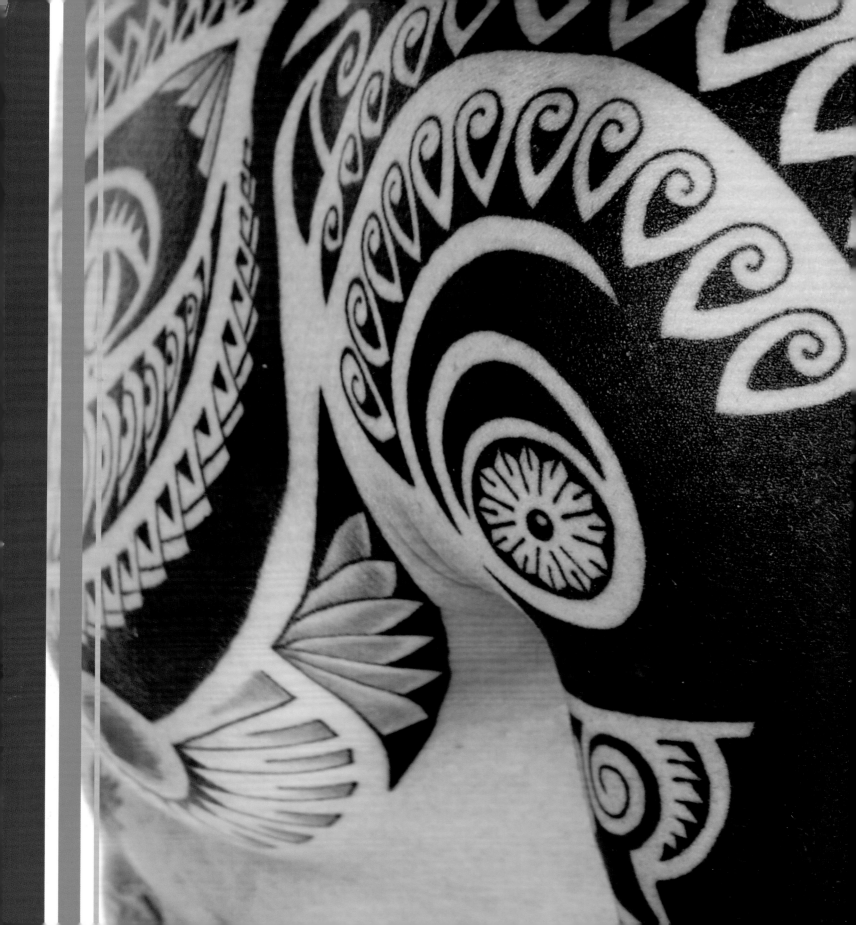

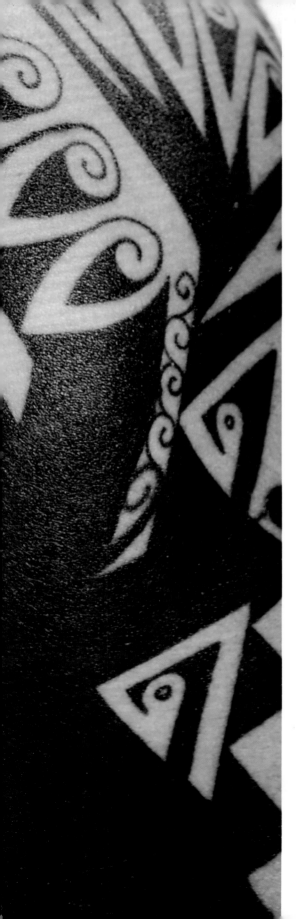

◁ An ancient human art, both stigmatized and celebrated throughout history, tattooing is more popular today than at any time in recent memory. This expansive tattoo embodies a new chapter in a long history. Though tribal in nature, like ancient Polynesian tattoos, it was presumably not done for ritual purposes, but instead it satisfies the wearer's vision of himself. It has ancient precedents but a fully modern conception and execution.

Subject: Seven / Artist: Mony

In the autumn of 1691, the mysteriously exotic Prince Giolo of the island of Moangis first displayed his patterned body to the "learned virtuosi" and "persons of high quality" inhabiting smoky, crowded, turn-of-the-century London. A South Sea Islander enslaved in the Philippines and eventually sold to a British merchant sailor, Prince Giolo was trumpeted as the "wonder of the age" for the intricate and colorful tattooing that decorated the entirety of his torso and legs. A promotional broadsheet for the "Painted Prince" speculated upon the "wisdom and ancient learning" embodied by the man's tattoos and claimed that the magical ink rendered his skin impervious to snakebite or poison. Despite his apparent powers, the ornately ornamented prince could not withstand the ravages of smallpox, and he died within months of arriving in London.

AN ANCIENT ART REBORN

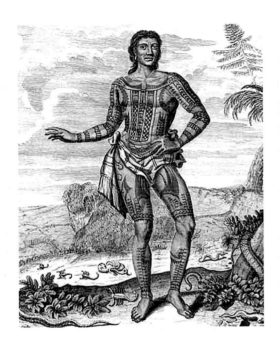

Prince Giolo, as depicted in a fanciful 1692 broadsheet. The "Painted Prince" made only a fleeting appearance in London—disease ended his difficult life shortly after he arrived in the pestilent city.

Engraving by John Savage (1692)

Nearly eighty years later, Joseph Banks, Captain James Cook's naturalist, made the first record of Polynesian tattooing practices during the HMS *Endeavor*'s maiden voyage to the South Pacific. To accompany his scientific observations, Banks, along with other members of Cook's crew, submitted his own skin to the Polynesian tattooists' whims and sailed home forever marked. Upon the vessel's return to Great Britain, the tales and drawings of the tattooed inhabitants of the South Seas captivated British society much as the ill-fated Prince Giolo had eighty years earlier, and body art became a small-scale fad among both well-heeled Britons and, of course, sailors.

Early Eurasian Tattoos

What eighteenth-century Britons didn't realize was that tattooing was not a novel practice on the British Isles: a millennium earlier, their Celtic and, later, their Anglo-Saxon ancestors had customarily decorated their bodies with ceremonial and familial tattoos. Tattooing had once been common across Europe and Asia among the diverse tribal cultures that populated the vast landmass. The 1991 discovery of Ötzi the Iceman in an Alpine glacier on the Austrian-Italian border gave clear evidence that Neolithic Eurasians had marked their bodies—Ötzi's yellowed skin, preserved in ice for more than five

> **"The universality of tattooing is a curious subject for speculation."**
>
> —Captain James Cook, 1775

thousand years, bore multiple small tattoos. Numerous lines were hatched on his lower back. On the inside of his left knee, he wore a small tattooed cross; his ankles were also decorated with clusters of parallel lines. In total, the Iceman wore some fifty-seven tattoos. Their purpose remains conjecture—although some anthropologists link them to social ritual, others believe that some sort of ancient acupuncture, intended to relieve Ötzi's aching joints, left the marks. Whatever the purpose of his tattoos, Ötzi is not alone among the ancients—both his ancestors and his descendents practiced tattooing. Archaeologists have excavated archaic bone needles and clay ink reservoirs at Paleolithic dig sites in Europe.

Eurasian tattooing became far more sophisticated during the millennia after Ötzi perished in the Alps. Tombs discovered in the steppes of southwestern Siberia in the mid- and late-twentieth century revealed remains of the Pazyryk people, who, besides excelling as skilled horsemen and fierce warriors, practiced

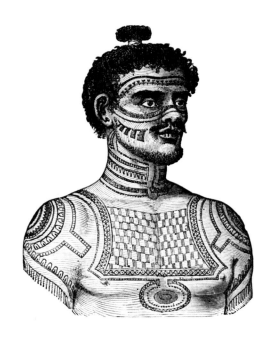

intricate, figurative tattooing. One mummy, a sturdy male believed to be a chief, wore a menagerie of animals on his body, all distinctively rendered. His right arm hosted two mighty deer, a donkey, a ram, and a fictitious carnivorous monster. On his chest, two griffins stood in winged splendor, while on his right shin, a fish

> ## "Not one great country can be named, from the polar regions in the north to New Zealand in the south, in which the aborigines do not tattoo themselves."
>
> —Charles Darwin, *The Descent of Man, 1871*

spanned from his ankle to his knee. Despite these and other elaborate designs, the Pazyryk chief also bore a row of circles along his spine, which, not unlike Ötzi's tattoos, were probably intended as a form of physical therapy.

Universal Ink

History reveals tattooing to be a universal human practice. Not only did the Polynesians and ancient Eurasian tribes decorate themselves with abstract designs and elaborate totems, but also the ancient Egyptians, the Inca, numerous American Indian tribes, and ancient Chinese all practiced tattooing. The famous intricacy and lushness of contemporary Japanese tattooing is a result of the culture's long heritage of body art. When European empires began colonizing the South Seas and the New World during the Age of Exploration (from the early fifteenth century to the early seventeenth century), the inked bodies of Polynesians and American Indians should not have seemed as exotic as they did to the colonizers—Europeans might have looked that way too, had they not, centuries earlier, chosen to abandon tattooing as a social norm. What Europeans saw—proudly tattooed bodies—was a mirror of their own distant heritage before it was swayed, like everything else, by the mores of Greek, Roman, Jewish, and Christian culture.

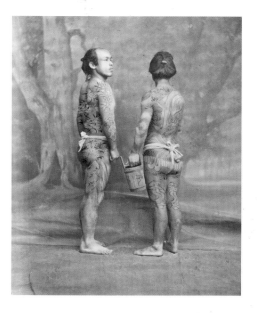

▲ Full-body tattoos on men are a long-standing tradition in Japan. The tattooist commonly uses the entire back as a canvas for intricate, lush depictions of the natural world.
Photograph by Felice Beato, c. 1870

◀ Tattooing in the South Pacific consisted of an array of patterning suited to both the contours of the body and, most surprisingly to European colonizers, the face. Drawings of tattooed islanders amazed European audiences.
Engraving © Jupiter Images

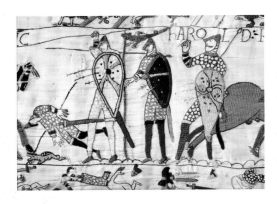

The Battle of Hastings in 1066 saw the Normans conquer the tribal Anglo-Saxons. The Normans brought their Latinate culture north to the British Isles, changing the language and mores of the region. Among the cultural shifts was a cessation in tattooing, which the Normans associated with undesirables.

Fragment of Bayeux Tapestry / Wikimedia

The Greeks were familiar with tattooing, having learned the technique from the Persians, but they were neither enthusiastic nor artistic practitioners. For the cosmopolitan Greeks, a tattooed body was the look of the barbarian tribes that massed across northern Europe. The Greeks thus used tattoos to indicate "barbarians" in their own culture: both slaves and criminals were forcibly tattooed.

The Romans subsequently adopted the Greek stance on tattoos—they tattooed slaves, criminals, and mercenary soldiers. Tattooing was considered anathema in Rome, so much so that its Latin word—*stigma*—is permanently infected with a sense of shame. It is said that the malicious Emperor Caligula would arbitrarily demand that members of his court be tattooed, thus scarring them for life in Roman society.

As Christianity permeated the Roman Empire, tattooing became even more forbidden. Christian culture had adopted the Jewish rule on tattooing as outlined in the Book of Leviticus: "You shall not make any cuttings in your flesh on account of the dead or tattoo any marks upon you." Tattooing, associated as it was with totems and pagan polytheism, had no place in Jewish religion. Likewise, in Christian Europe, tattooing came to be seen as ungodly. Emperor Constantine, who converted the Roman Empire to Christianity in the year 325, even restricted the tattooing of undesirables: slaves and criminals could still be tattooed on the body, but never again could their faces be stigmatized, since they had been "formed in the image of the divine beauty."

Taboo Tattoos

As Christianity swept through Europe, clearing away tribal spirituality, tattooing disappeared. In 787 Pope Hadrian I officially outlawed tattooing, setting a precedent that would last for centuries. In the British Isles tattooing finally seemed to have gasped its last when the Anglo-Saxon King Harold died on the field at Hastings in 1066, his lifeless, tattooed body representing the expiration of an entire culture. Yet tattooing did survive the Middle Ages and the restrictions of Catholicism; indeed, in the service of God, a small tattoo was permissible, such as the tiny crosses that Crusaders inked on their arms before going into battle.

It wasn't the Age of Exploration's rediscovery of tribal tattooing that

> ## "[It was] a narrative of his master's harshness."
>
> —Greek philosopher
> **Bion of Borysthenes**
> (circa 300 B.C.), describing the brutally tattooed face of his father, a former slave

> **"My body is a journal in a way. It's like what sailors used to do, where every tattoo meant something, a specific time in your life when you make a mark on yourself, whether you do it yourself with a knife or with a professional tattoo artist."**
>
> **—Johnny Depp**

pushed body art back toward the mainstream in Western culture after centuries as a stigma. It was scientific innovation—in particular, the electric tattoo needle. As mentioned earlier, after tattooing had reentered the Western consciousness, it became popular among both the aristocracy—who would have their bodies discreetly tattooed in the name of exotica—and seafarers, who would commemorate their voyages. But tattooing by hand, as it had been done for all of human history, was a slow, painful process, and strange as it may seem, a luxury in a modernizing society, due to the time, care, and money

involved. In 1891, Samuel O'Reilly, a British immigrant living in New York, patented a tattoo machine based on an electric pen that had been devised fifteen years earlier by none other than Thomas Edison. O'Reilly's machine revolutionized tattooing—now fast and affordable, tattooing attracted curious individuals from the lower classes, which alienated the rich, who began to shun body art.

During the first half of the twentieth century, the purpose of tattooing shifted. Sailors and soldiers were still regular patrons, requesting insignias indicating their patriotism, inky reminders of loved ones, or scantily clad beauties to gaze upon during lonely nights far away. More markedly, though, modern, electric tattooing developed its own subculture of well-decorated artists and patrons, men—and women—who saw unadorned bodies as blank canvases

The electric tattoo needle transformed body art in the West from a wealthy lark to an everyman art. Today tattoo technology is both enabling and benefiting from the popularity of body art. More tattoos mean more money for innovation. Despite all the gadgets, some adhere to an older way, particularly in Japan, where traditional tattooists decorate great swaths of skin with just needles, inks, and no electricity.

Photograph by David Brimm / Shutterstock

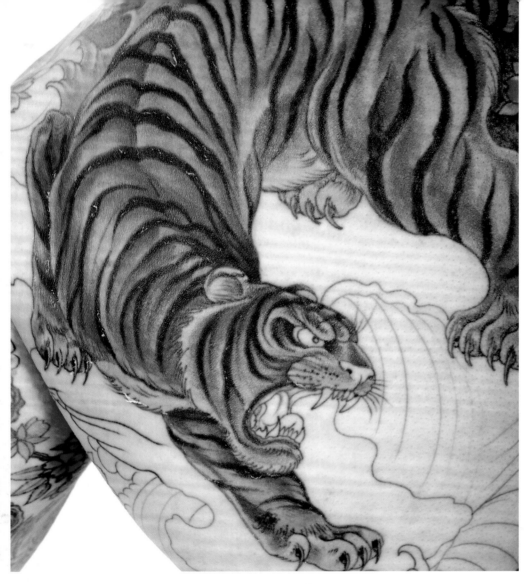

▲ Modern tattooing shows a synthesis of disparate cultural styles. Here a tiger is inked in the sinuous Japanese manner.
Subject: Tommy Shaun / Artist: Greg James, Sunset Strip Tattoo

▮▶ This person opted for a medieval-style crest, reminiscent of old European shields.
Subject: Johnny Directions

▮▶▮▶ This tattooist has created a unique image with a sensibility all its own.
Subject: Josh / Artist: Chop Chop Shop Tattoos

waiting to be colored with the tattooist's whims. The electric needle also led to the reemergence of tattooing as an art form, particularly in the United States, where in keeping with the nation's heterogeneous character, multiple tattoo cultures began to hybridize into wide-ranging styles. Crests and crosses of European heritage merged with tribal abstractions, Polynesian patterns, and the undulating animal forms of China and Japan. Fused by the fine-art ambitions of a handful of prominent twentieth-century tattooists, these disparate strands emerge today on people's bodies as elaborate, tattooed manifestos, ornate indications of heritage, or simply flashes of beauty and whimsy enlivening the skin.

Outcast or Mainstream?

Today tattooing is more popular in Western culture than it has been for perhaps a millennium. Participation and acceptance of tattooing has spread across class and gender boundaries. Once considered the domain of certain subcultures—sailors and soldiers with anchors and "Mother" scrawled across their arms, criminals etched with crude jailhouse tattoos, or carnival "freaks" decorated head to toe with impenetrable designs—tattoos decorate a substantial portion of society today. Some call it a resurgence of tribal culture; others call

"For someone who likes tattoos, the most precious thing is bare skin."

—Cher

it a fad. Some see the popularization of tattooing as a cooption of working-class habits by the middle class; others see it as a surging new arena for fine art. Some see it as indicative of the undimmed human desire for exotica amid a bleak existence; others see it as a gesture of commitment and self-expression. Of course, some still feel it is purely the domain of misfits. Yet, regardless of theories, the reasons and inspirations for tattoos are deeply personal: everyone has a unique reason for tattooing his or her body. No longer the requirement of a ritual culture or the stigma of a parochial society, tattooing is more than ever before a choice, though not one to be taken lightly. When the needle pierces the skin, the whims of an artist and his or her subject become permanently embedded in the body. This book explores the nature of that experience through the photographs and recollections of myriad decorated individuals who continue to propagate one of the oldest and most controversial modes of human artistic expression.

Women are greatly responsible for the current resurgence of tattooing. They are decorating their bodies more today than at any time in recent history. The rise of tattooed women has coincided with a rise in female tattoo artists.

Photograph by Dima Kalinin / Shutterstock

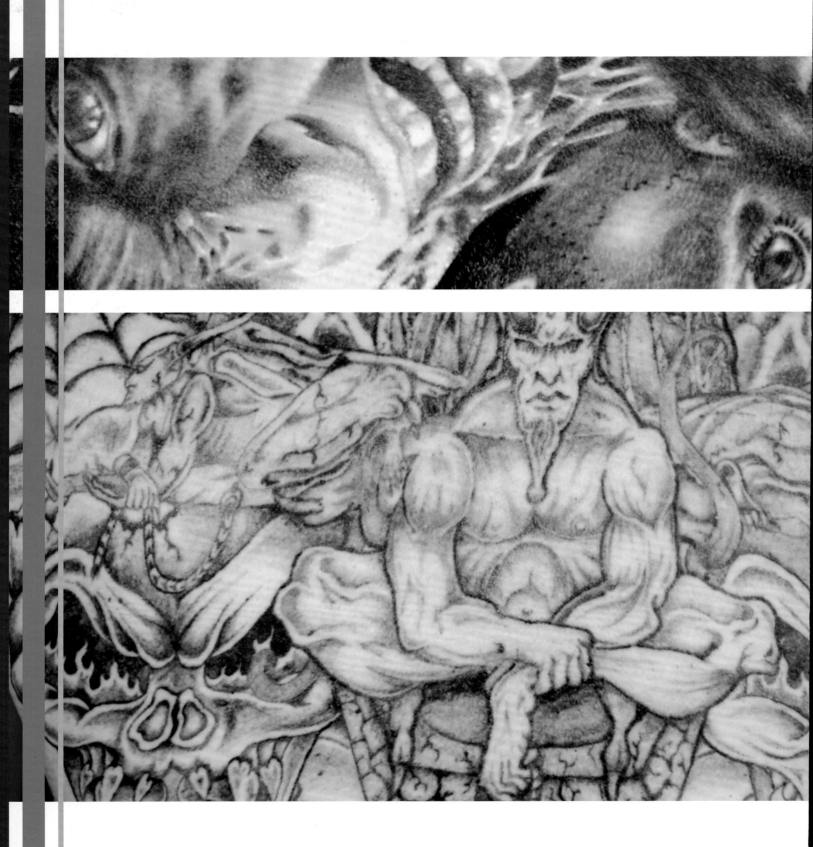

◁ The bearer of this sinister tableau gave his tattooist free rein to create a horrifying image.
Subject: Steve Bregenzer / Artist: Brian Donovan, Mercury Tattoo

▽ There's a method to this madness—this full-back tattoo recounts its wearer's life story.
Subject: Jason Bergmann / Artist: Jonathan Linton

Tattoos have always been emblems of fantasy. Centuries ago the tattooist and the tattooed were fantastic individuals dwelling in an exotic world at the far edge of the oceans. Today the tattooist is an entrepreneur and an artist who works with his or her clients to conceive bizarre worlds and give them life under shallow skin. Some people request malevolent totems to convey their comfort with the underside of life—skulls, ghouls, dragons, avenging angels. Others submit their skin to the sinister imagination of the tattooist; on the planes of their body entire worlds of macabre frenzy emerge, as grim and intricate as Bosch or Brueghel landscapes. Tattooing is a painful process; these tattoos give form to that pain. The bodies here are canvases haunted with shadows and monsters. Born from the brains of the artist and the client, dark fantasies come alive on the skin.

DARK FANTASIES

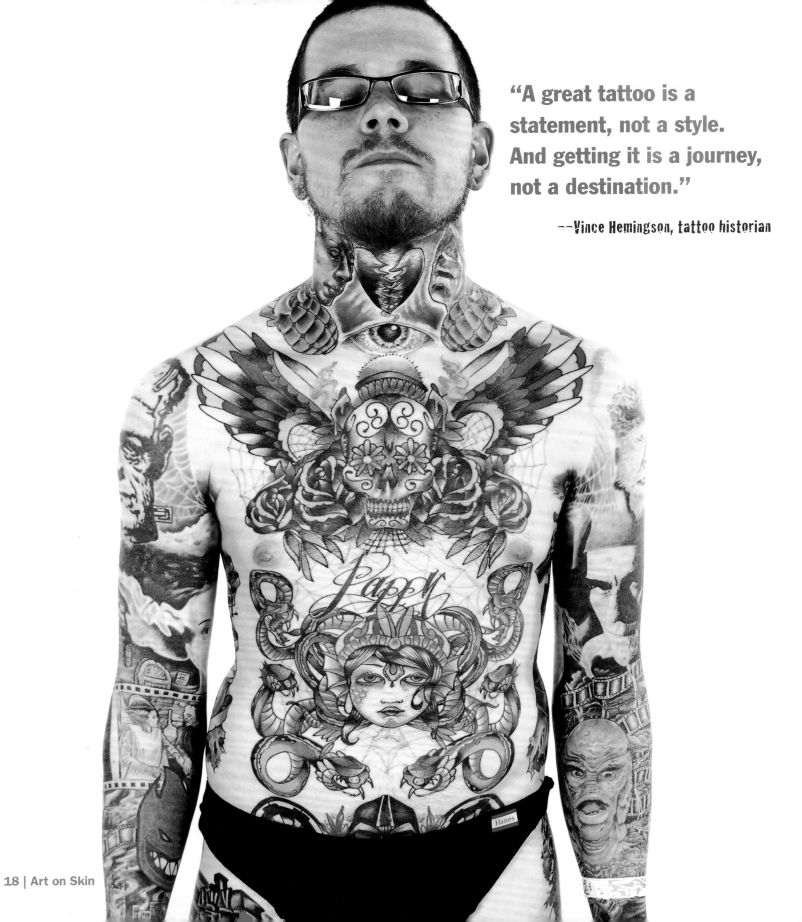

"A great tattoo is a statement, not a style. And getting it is a journey, not a destination."

--Vince Hemingson, tattoo historian

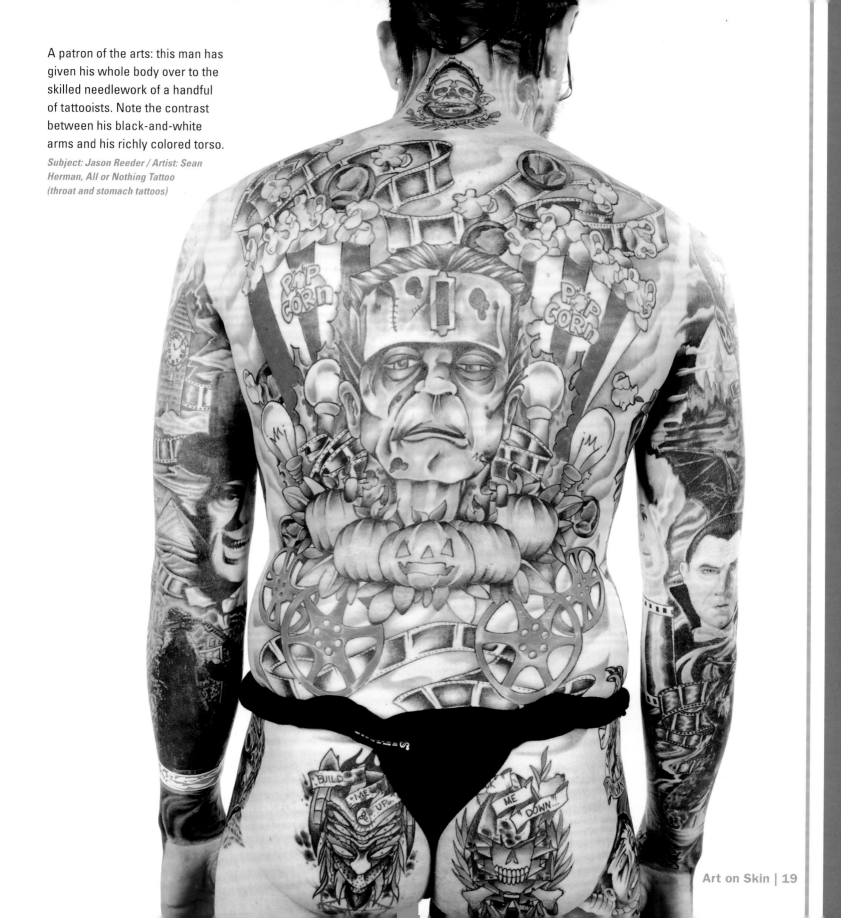

A patron of the arts: this man has given his whole body over to the skilled needlework of a handful of tattooists. Note the contrast between his black-and-white arms and his richly colored torso.

Subject: Jason Reeder / Artist: Sean Herman, All or Nothing Tattoo (throat and stomach tattoos)

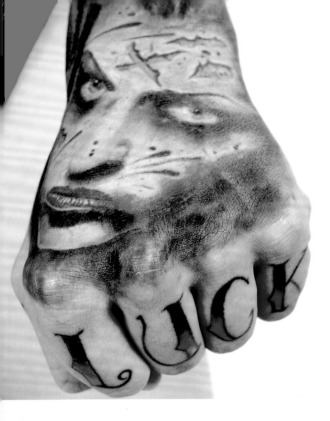

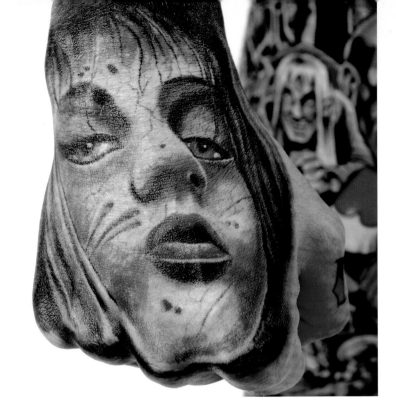

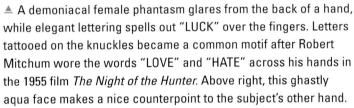

▲ A demoniacal female phantasm glares from the back of a hand, while elegant lettering spells out "LUCK" over the fingers. Letters tattooed on the knuckles became a common motif after Robert Mitchum wore the words "LOVE" and "HATE" across his hands in the 1955 film *The Night of the Hunter*. Above right, this ghastly aqua face makes a nice counterpoint to the subject's other hand.

Subject: Jason Reeder

▮▶ Among this man's myriad tattoos, some may be inspired by the artists' whims, while others may carry a personal meaning. Each image harmonizes with not only the curves of this man's body but also with the borders of each adjacent image.

Subject: Jason Reeder

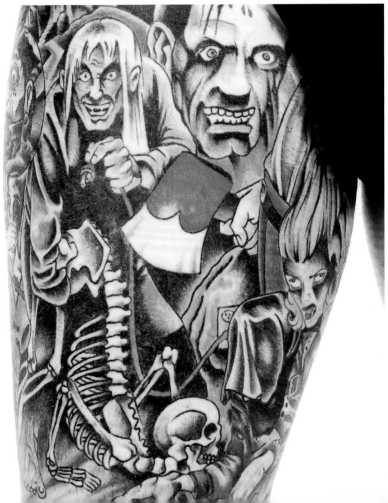

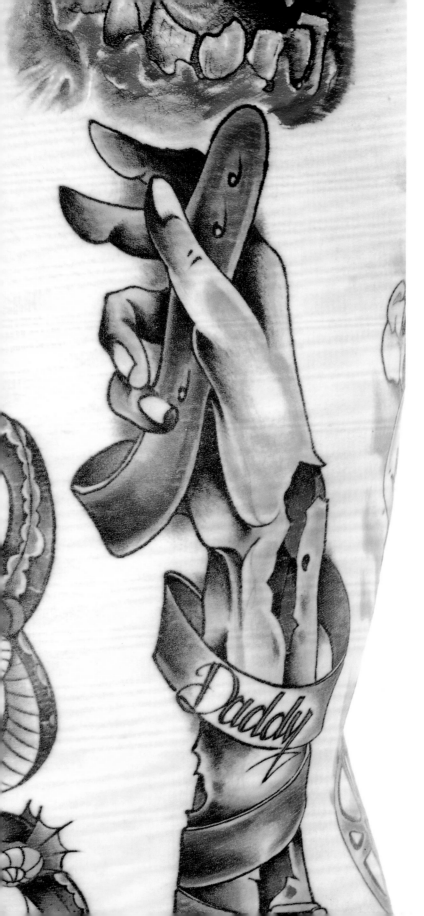

◄ A ghastly green severed arm wrapped in a belt slides upward on the rib cage, dangerously close to a tooth-filled maw.
Subject: Jason Reeder / Artist: Thomas Kenney, Classic Electric Tattoo

▽ A red-eyed demon stares out from underneath the subject's arm.
Subject: Jason Reeder / Artist: Thomas Kenney, Classic Electric Tattoo

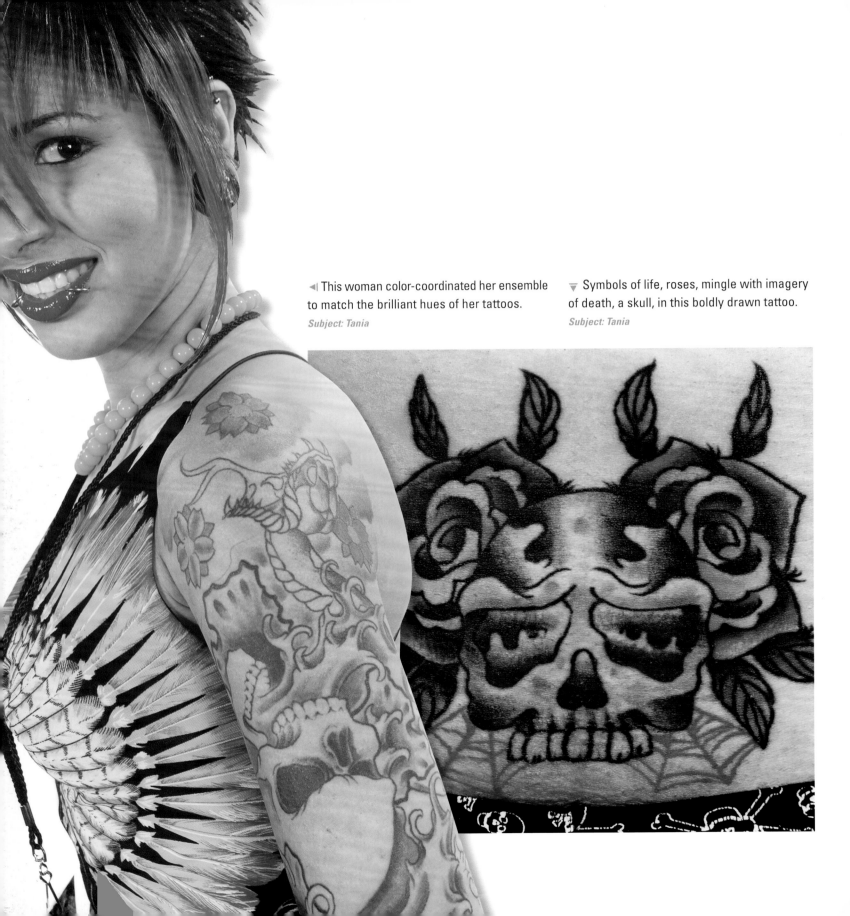

◄ This woman color-coordinated her ensemble to match the brilliant hues of her tattoos.
Subject: Tania

▽ Symbols of life, roses, mingle with imagery of death, a skull, in this boldly drawn tattoo.
Subject: Tania

▶ Not your ordinary Kabuki face—this one, dripping with blood, has met a gory fate.
Subject: Tania

▼ Beauty and the beast combined in one grim visage. It is a ghoulish turn on Picasso's trick of combining a profile and a whole face.
Subject: Tania

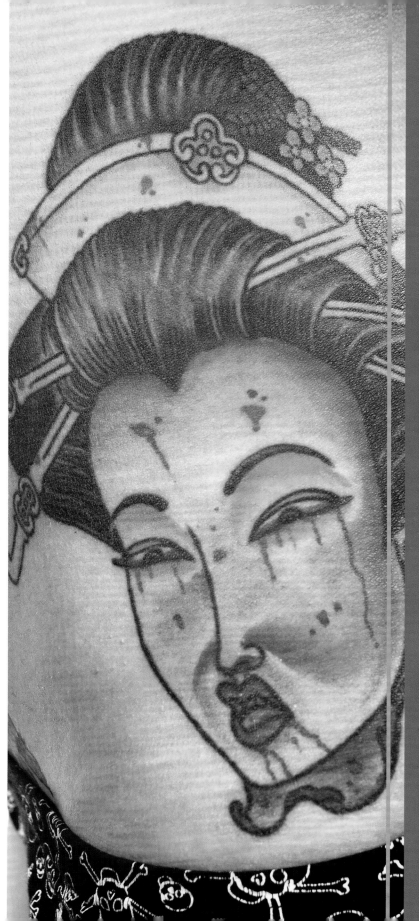

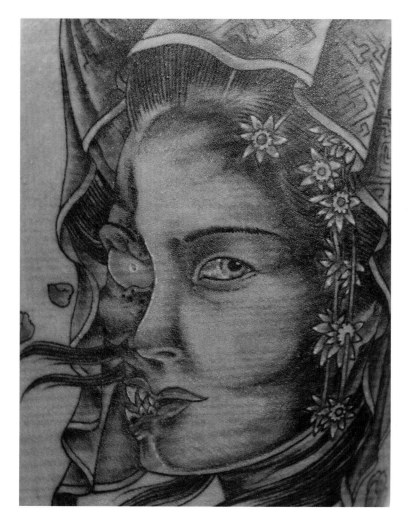

Whether leering, snarling, or pointing tongues, demon faces are meant to elicit fear, but they also give tattoo artists opportunities to create images of ominous beauty. Demons have been a popular subject of artists for centuries. In the Middle Ages they were used in the allegorical paintings of Hieronymus Bosch and Pieter Brueghel the Younger and even adorned churches in the form of hideous gargoyles. In modern times demons populate horror films and dark-themed comic books. Demon faces will likely remain a staple of tattoo culture, a blend of grinning evil and amazing ink.

▶ The skin of this sinister face has been flayed down to the muscle—note the intricately drawn sinews.

Subject: Tommy Visconto / Brian Donovan, Mercury Tattoo

▶▶ A ghoulishly green demon skull. The skull is a universal symbol for death.

Subject: Casper / Artist: Adam Bruce

▶▶▶ Opposite page left, a red face, flaming hair, piercing stare, little beard—Satan, in the flesh! Center, in myth, long noses and pointed chins often carry sinister connotations—as does, of course, a mouthful of sharp teeth.

Subject: Stephen Lyte

▶▶▶▶ A bestial, feral, yet almost human creature illustrates the subject's sense of "the evil inside of me."

Subject: Alid Marquez / Artist: Alex Alien, Aztec Roots Tattoo

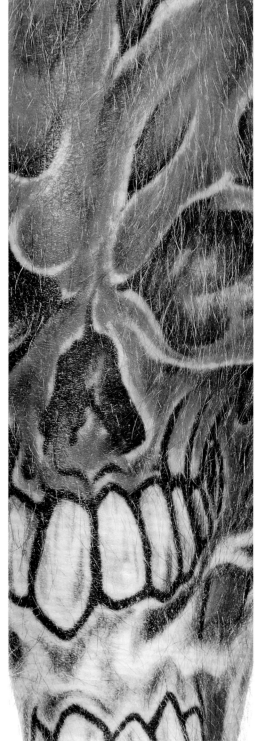

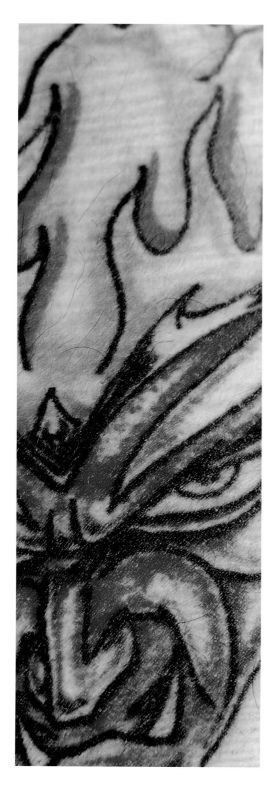

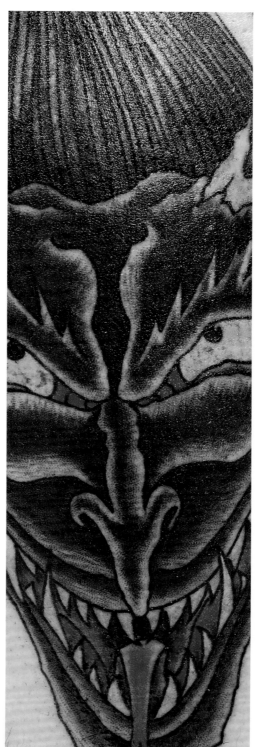

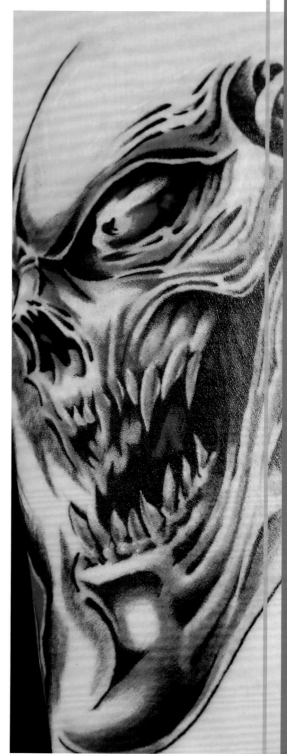

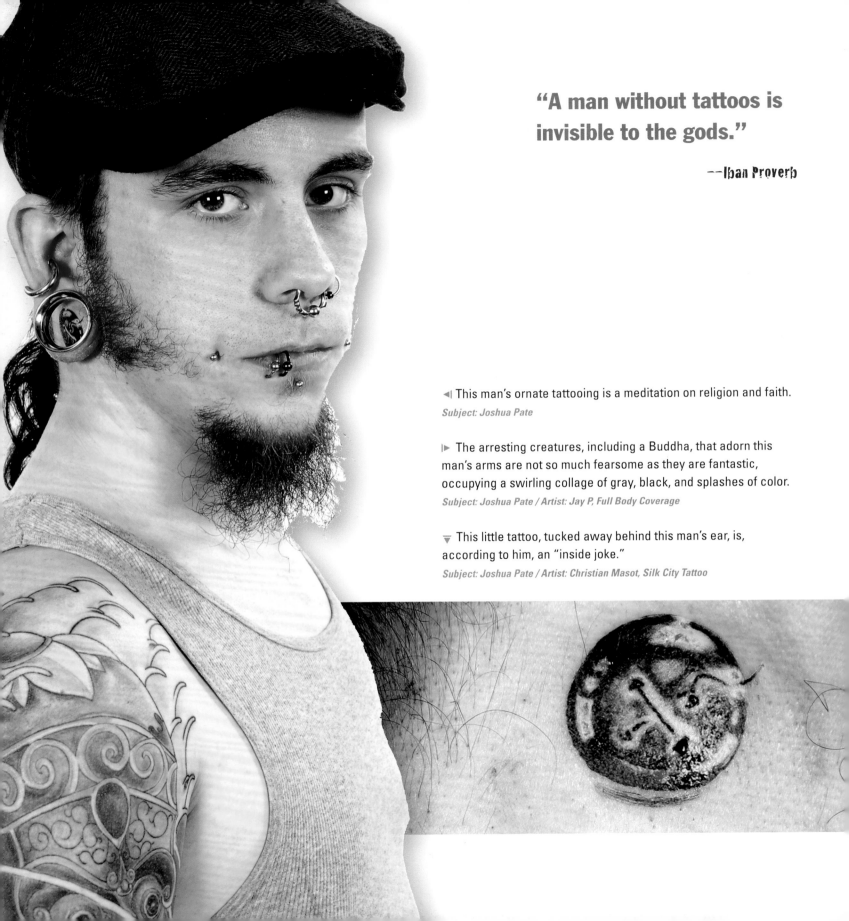

"A man without tattoos is invisible to the gods."

--Iban Proverb

◄ This man's ornate tattooing is a meditation on religion and faith.
Subject: Joshua Pate

►▶ The arresting creatures, including a Buddha, that adorn this man's arms are not so much fearsome as they are fantastic, occupying a swirling collage of gray, black, and splashes of color.
Subject: Joshua Pate / Artist: Jay P, Full Body Coverage

▼ This little tattoo, tucked away behind this man's ear, is, according to him, an "inside joke."
Subject: Joshua Pate / Artist: Christian Masot, Silk City Tattoo

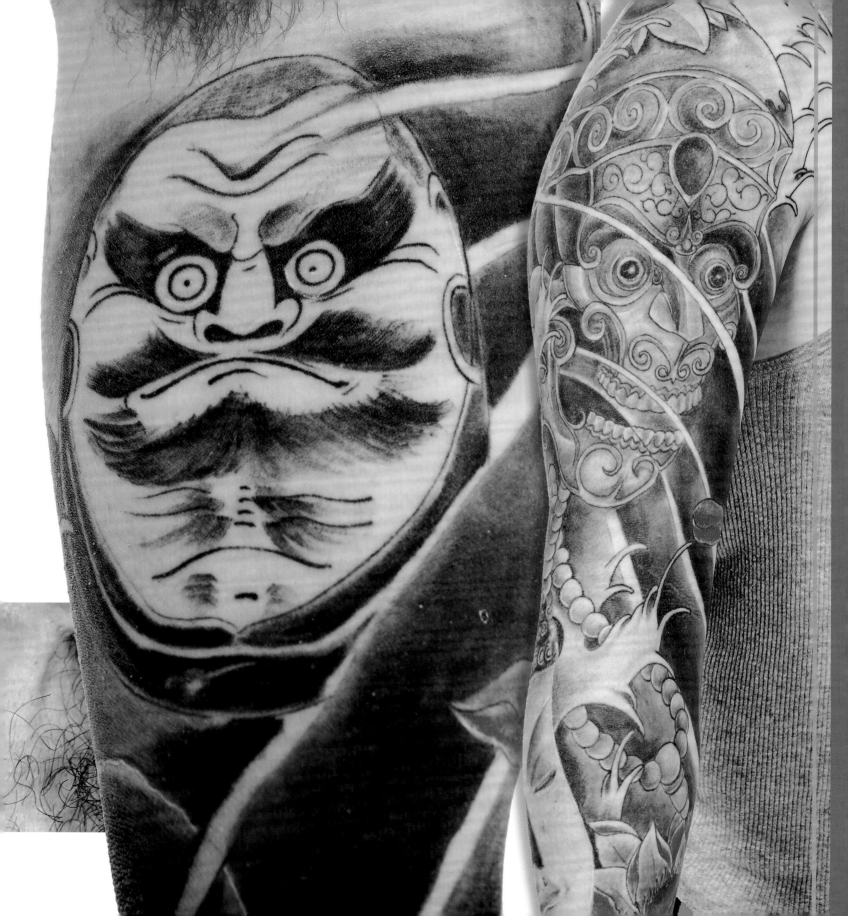

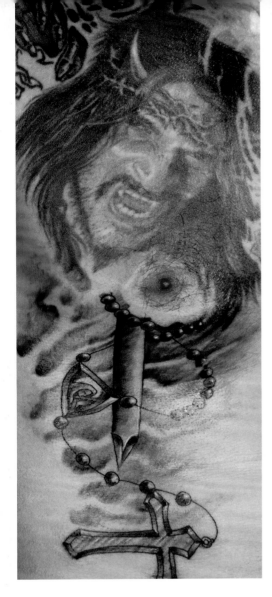

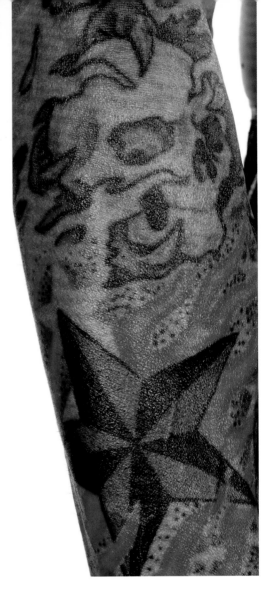

▲ A tortured Jesus is captured in all of his agony on this man's upper chest.

Subject: Noel Roman Velez

▲ Rosary beads amid tendrils of flame pattern this man's chest.

Subject: Noel Roman Velez

▲ Abstract shapes contrast colorfully with a sharply rendered five-pointed star.

Subject: Noel Roman Velez

▮▶ An array of styles—cartoonish, surreal, realistic, abstract—decorate this man's skin, but the overall mood is macabre.

Subject: Noel Roman Velez

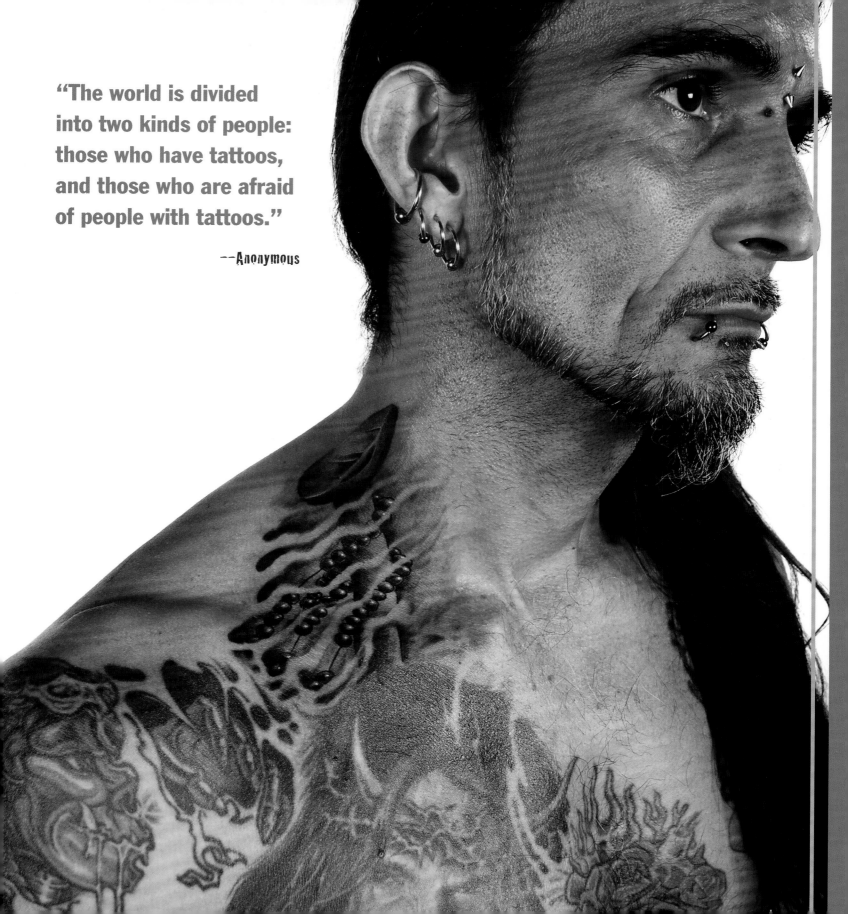

"The world is divided
into two kinds of people:
those who have tattoos,
and those who are afraid
of people with tattoos."

--Anonymous

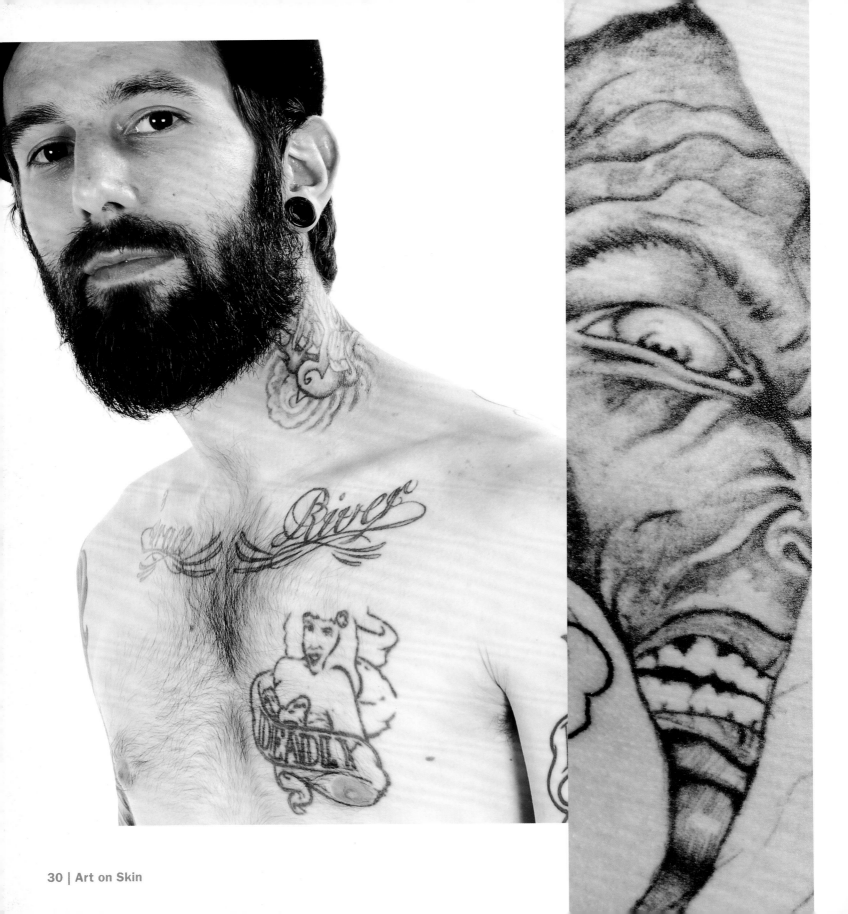

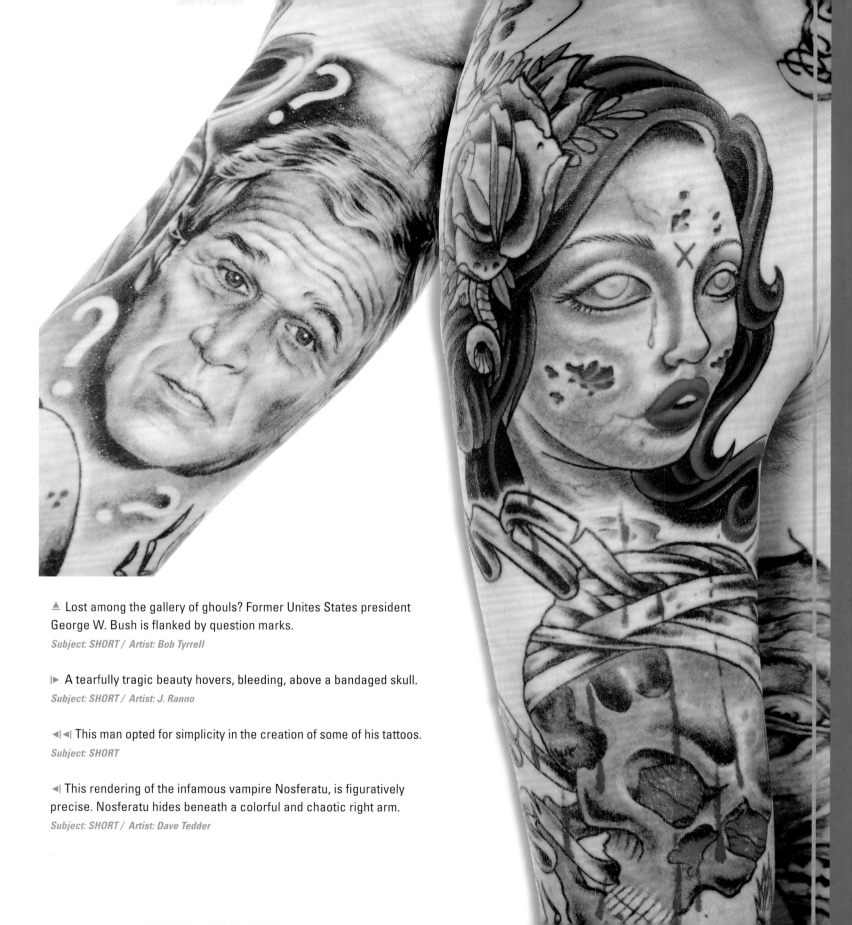

▲ Lost among the gallery of ghouls? Former Unites States president George W. Bush is flanked by question marks.
Subject: SHORT / Artist: Bob Tyrrell

▶ A tearfully tragic beauty hovers, bleeding, above a bandaged skull.
Subject: SHORT / Artist: J. Ranno

◀◀ This man opted for simplicity in the creation of some of his tattoos.
Subject: SHORT

◀ This rendering of the infamous vampire Nosferatu, is figuratively precise. Nosferatu hides beneath a colorful and chaotic right arm.
Subject: SHORT / Artist: Dave Tedder

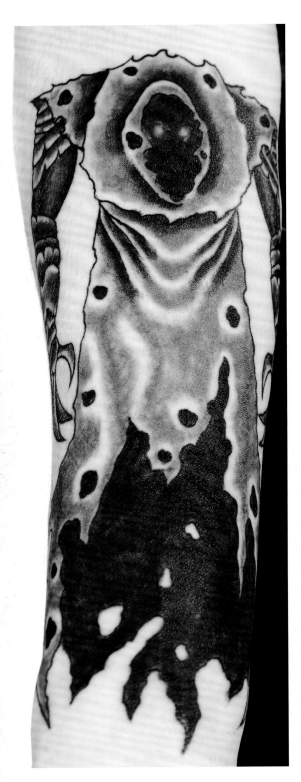

◀ Purple, black, and a little bit of green were all the colors needed to make this ghoulish specter, which hovers, tattered, over the subject's forearm. This hulking, faceless apparition appears riddled with bullet holes. Those undead guys just refuse to die!

Subject: Derek Vile / Artist: Ozzie Perez

▶ The Rocket from the Crypt . . . fresh from underground, this combo Bride of Frankenstein / sexy mummy glows with electric energy and seems ready to leap from her skull-adorned coffin.

Subject: Tim Fisher / Artist: Smitty

▼ A richly colored and rendered golden tiger pays homage to Japanese tattooing. It rises menacingly from searing waves of crimson and violet.

Subject: Cal / Artist: Brian Donovan, Mercury Tattoo

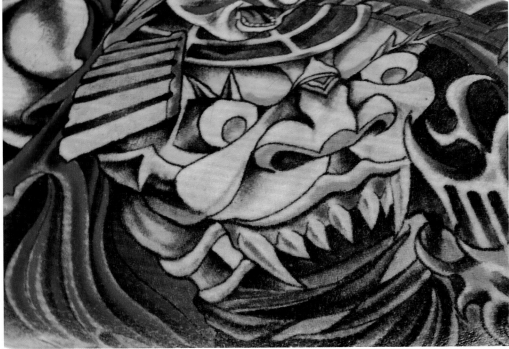

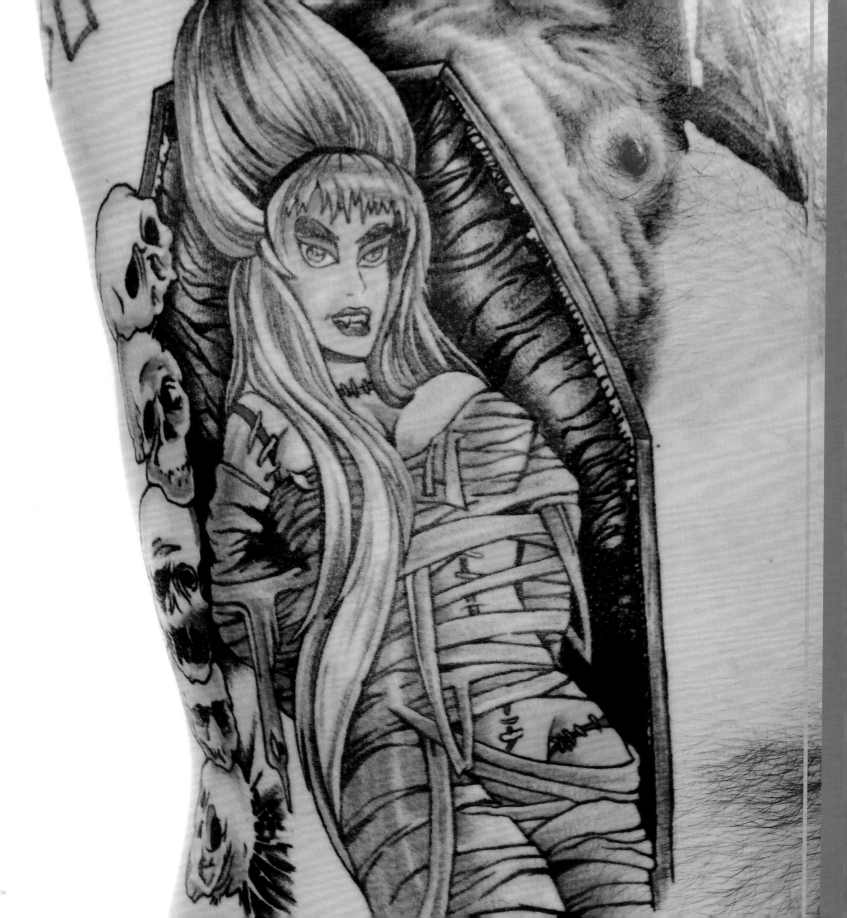

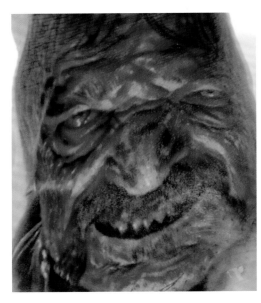

◀ The fearsome "Lord of the Dead" finds himself inked on the subject's right foot.
Subject: Jim / Artist: Paul Acker

▶ "The horror! The horror!" This man's body is a gallery of gore, some of it inspired by the movies, some of it totally original.
Subject: Jim

▼ Mixed messages: evil Darth Vader from *Star Wars* looks over at a banner-entwined heart that reads "Hopeless Romantic."
Subject: Jim / Artist: Paul Acker

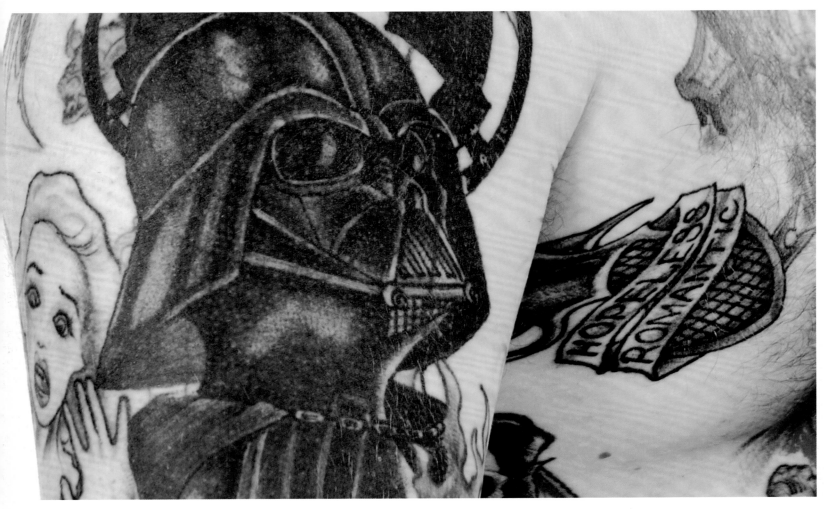

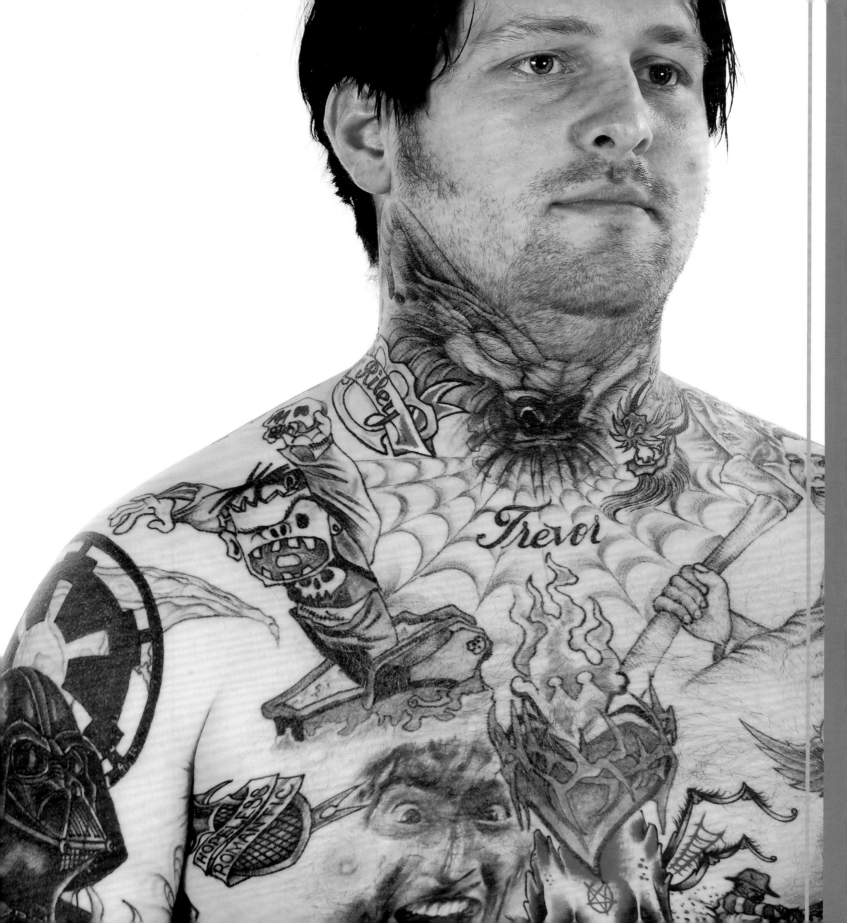

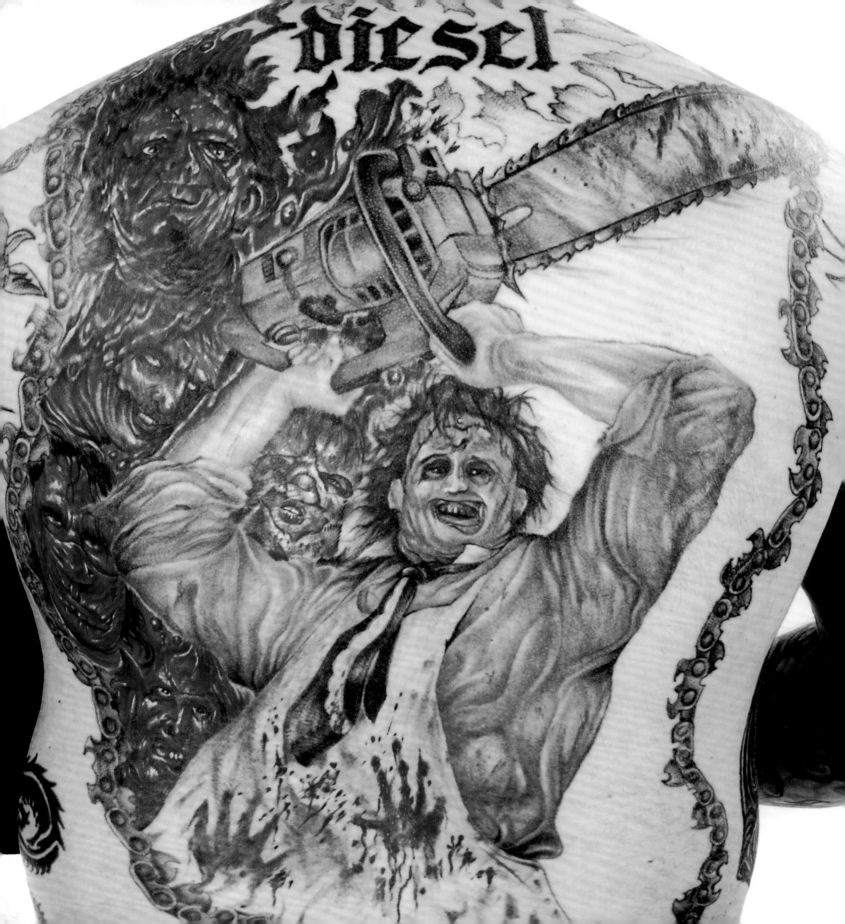

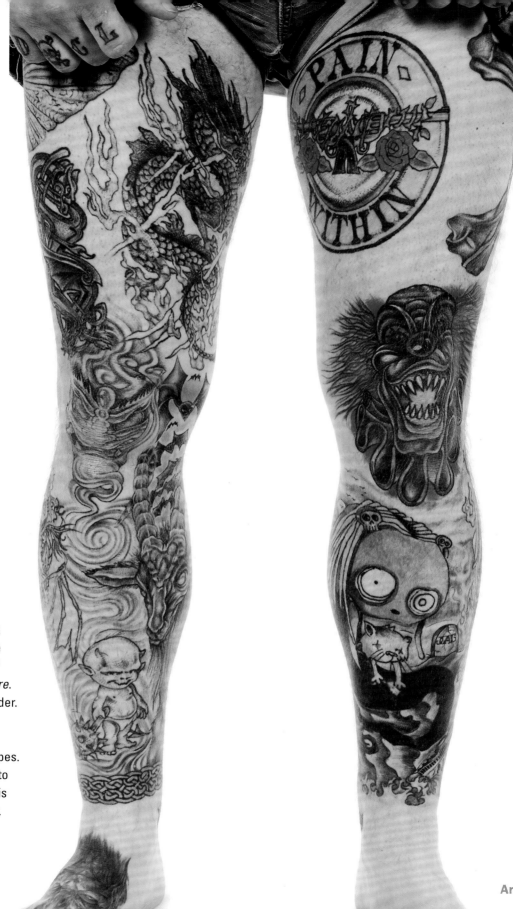

◀ Much of the subject's back is devoted to Leatherface, the chainsaw-wielding maniac of *The Texas Chainsaw Massacre*. Note the chainsaw-chain border.

Subject: Jim / Artist: Paul Acker

▶ Nightmares and dreamscapes. From a diabolical clown face to a demon baby, the detail of this man's tattoos is extraordinary.

Subject: Jim

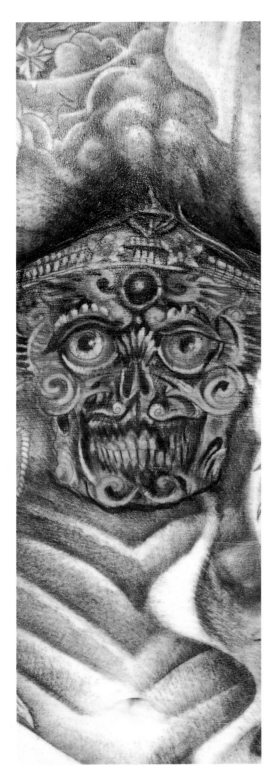

"You may lose your most valuable property through misfortune in various ways. You may lose your house, your wife and other treasures. But of your *moko*, you cannot be deprived except by death. It will be your ornament and companion until your last day."

-- Netana Whakaari of Waimana tattoo

This man sports a veritable shirt of tattoos, each one blending into the text to form an intricate, colorful mosaic of fantastically sinister body art. At left, a golden, grinning skull occupies the center of the man's well-decorated torso.

Subject: Vincent Gallo / Artist: Mike LeBoffe, Baker Street Tattoo

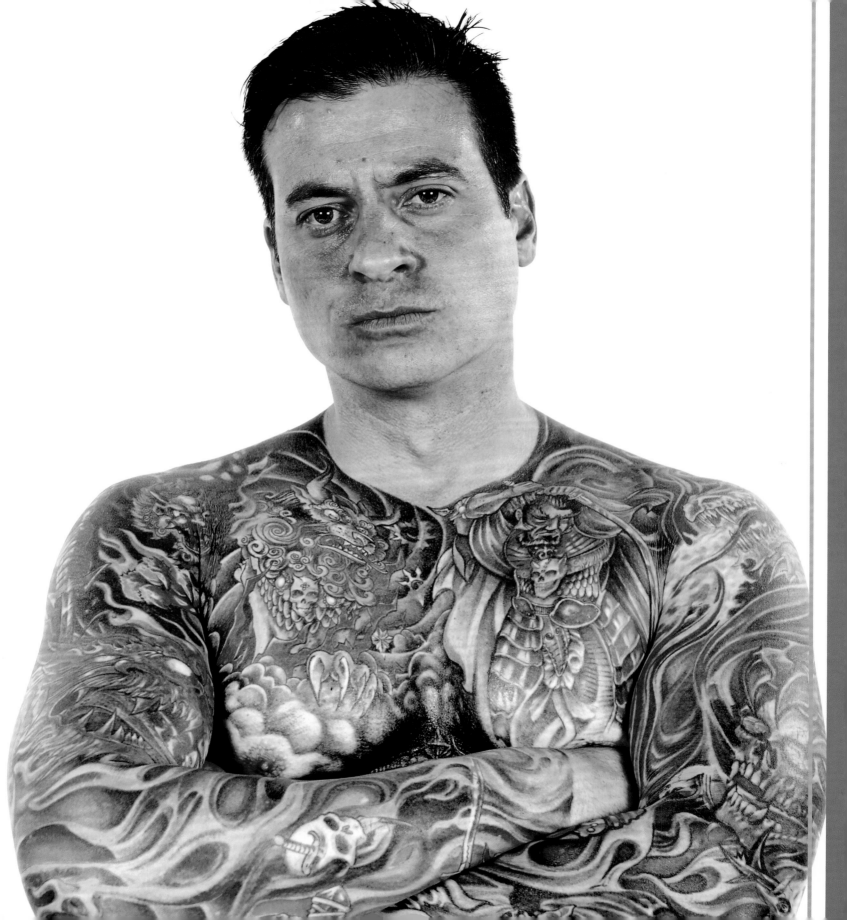

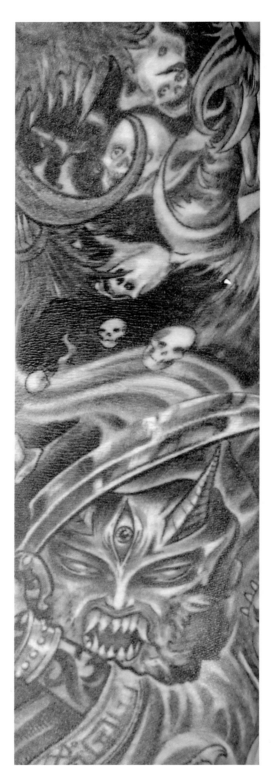

Scenes of mayhem and mortality swirl across this man's skin. Both his left and right arms bear colorful designs of chaotic skulls, while at the far right, his entire back tells an exotic story of destruction in rich black and white. Perhaps, in time, it too will be colored in.

Subject: Vincent Gallo / Artist: Mike LeBoffe, Baker Street Tattoo

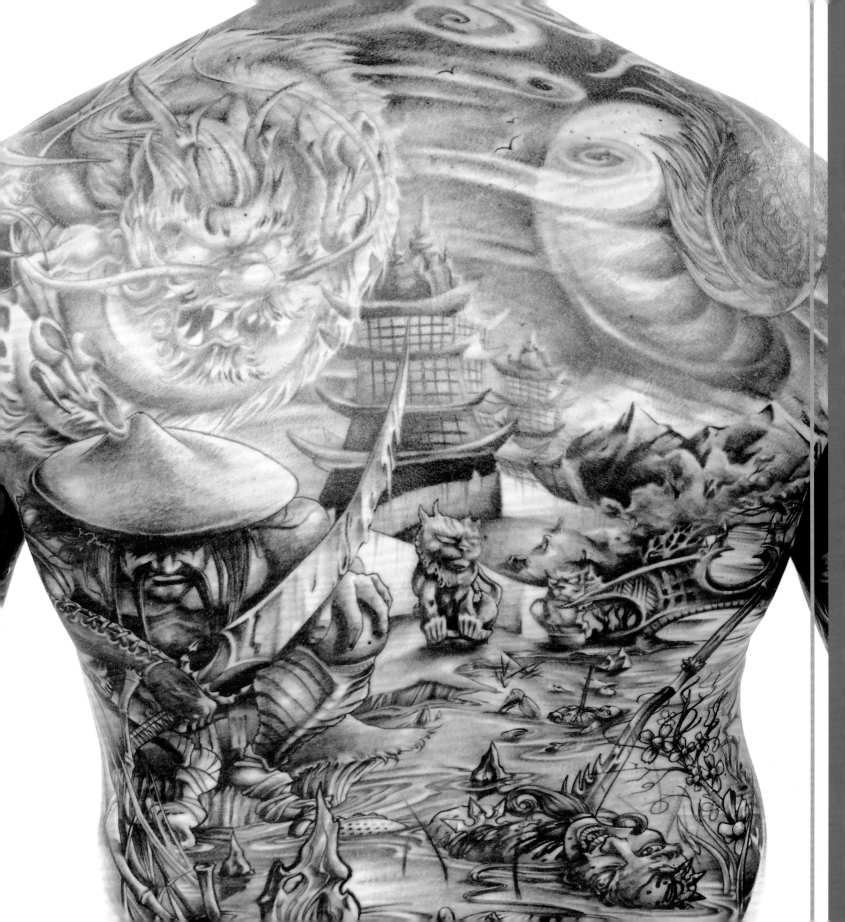

◀ A classic skull image with a yellow-eyed rat atop was lifted from the subject's own drawings.
Subject: Josh N. Brader / Artist: Juan (Spare)

▶ Another vintage tattoo motif—skulls and roses—takes on a new dimension. Is that the skull's eyes or something a bit more amorous?
Subject: Angela Bibey / Artist: Ink Bitch

▶▶ A checkerboard sleeve ends in a grim skull visage.
Subject: Chuck

▼ Fierce in its framing, this militant skull glares out menacingly from a shield-like background.
Subject: Stephen Lyte

"I'm a tattoo artist myself, and these tattoos on my body were my personal drawings. My art inspires me, and now it's on my body forever."

—Josh N. Brader

"There's more to the skull
than meets the eye."

—Angela Bibey

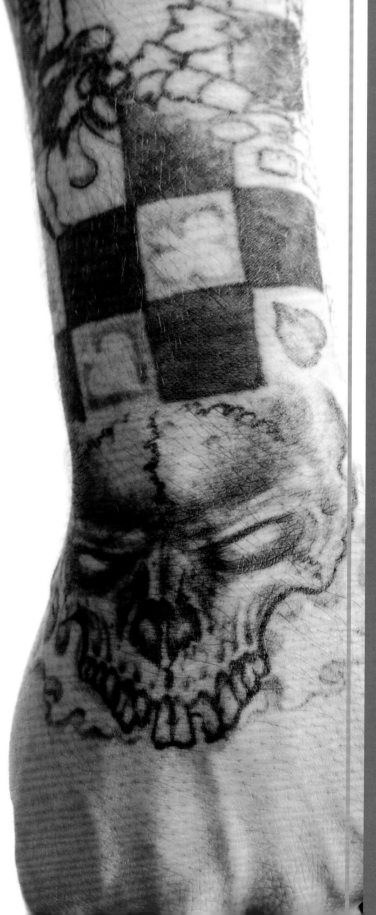

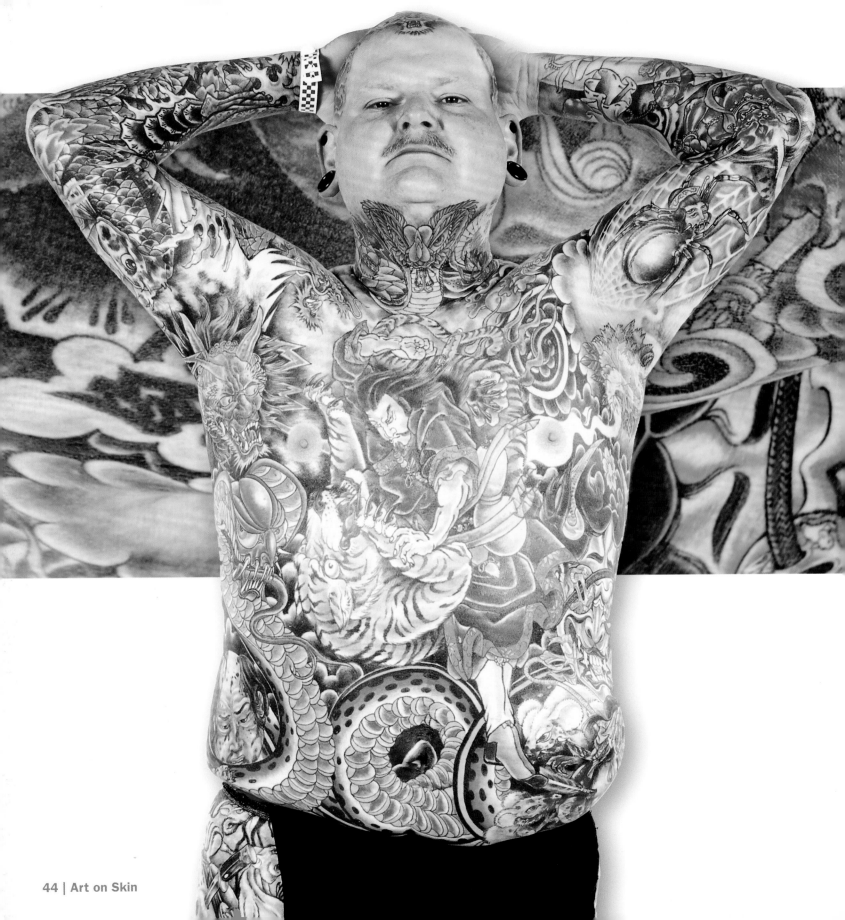

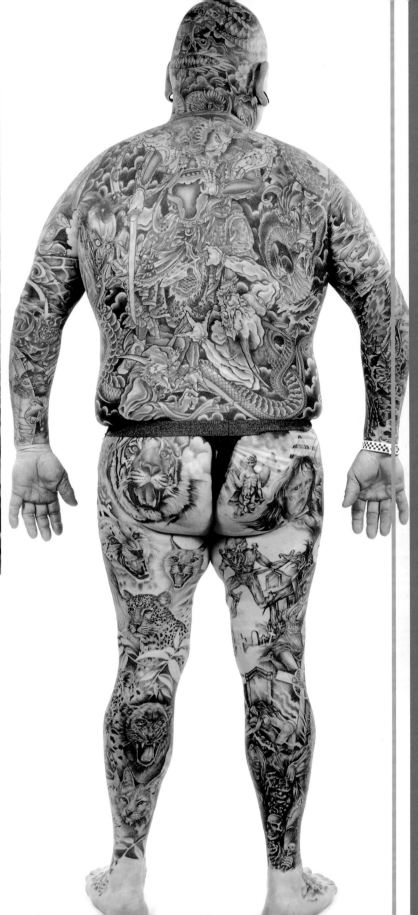

Here is a great body of work, all of it done by one artist. A
fantastical array of creatures, from tigers and leopards to serpents
and spiders weave from head to toe. A samurai vanquishing a
tiger forms the centerpiece of this man's full-body coverage. Often,
tattooists form long-standing relationships with their customers,
adding a new piece to the living canvas year after year.

Subject: Catman / Artist: James Vond, Straight A Tattoo

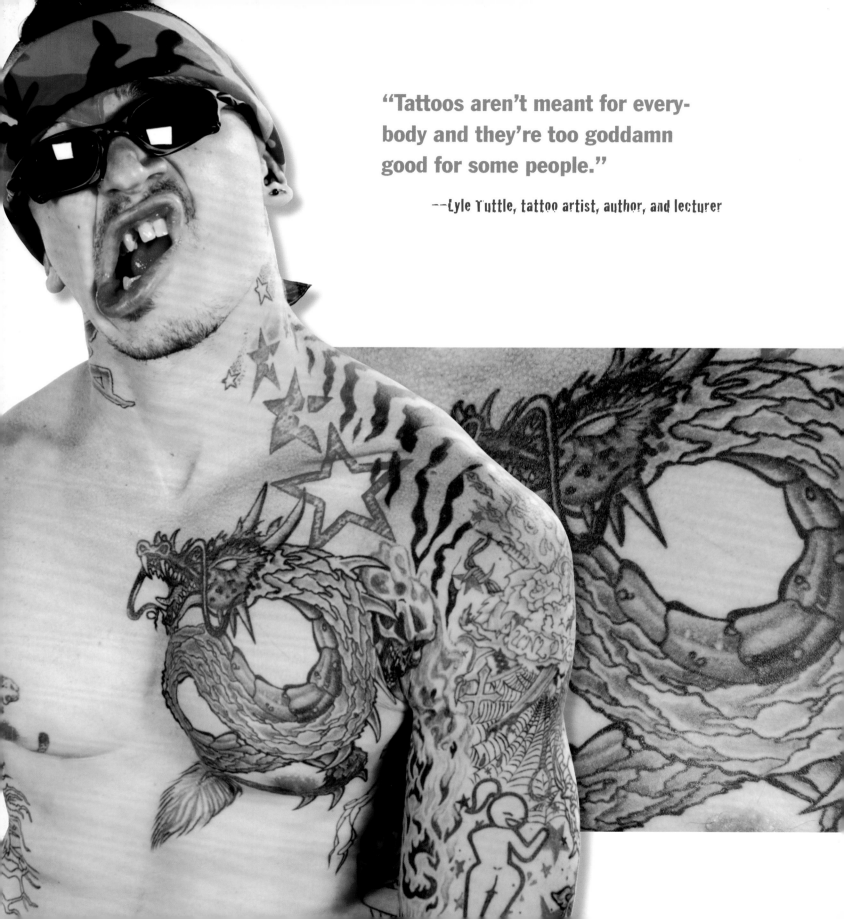

"Tattoos aren't meant for every-body and they're too goddamn good for some people."

--Lyle Tuttle, tattoo artist, author, and lecturer

A stark palette of red and black explodes into intricate scenery on this man's arms and torso. Woven into the dense pattern are radiating cobwebs, a swirling dragon, and cascading stars.

Subject: Chuck / Artist: Whatever Tattoo

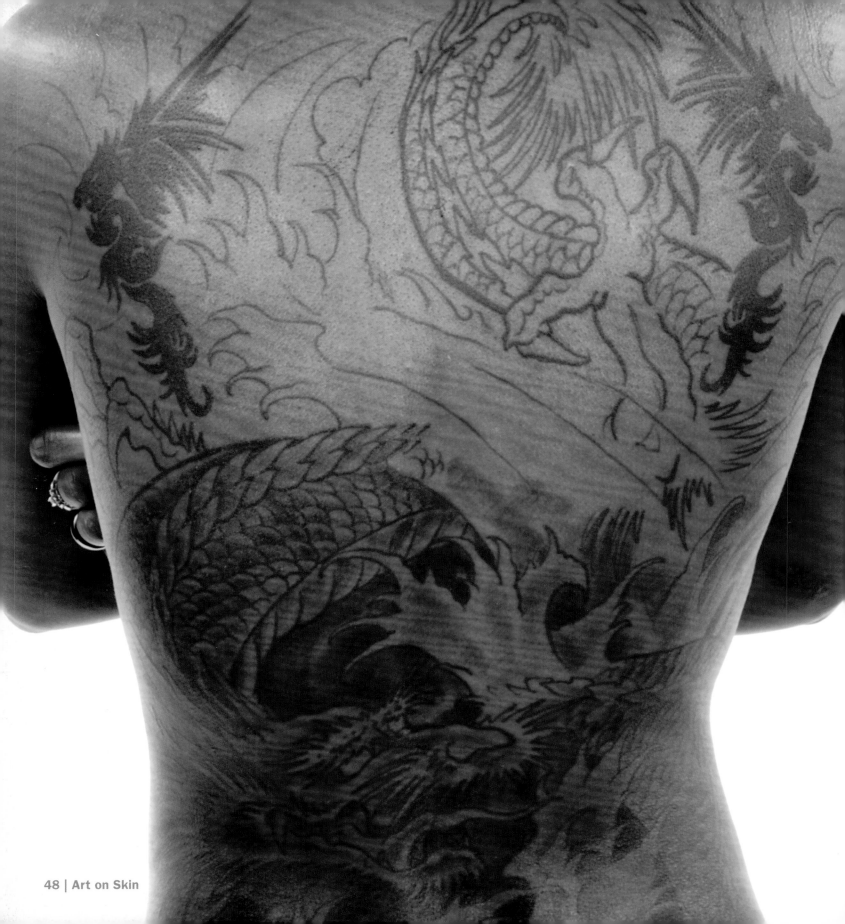

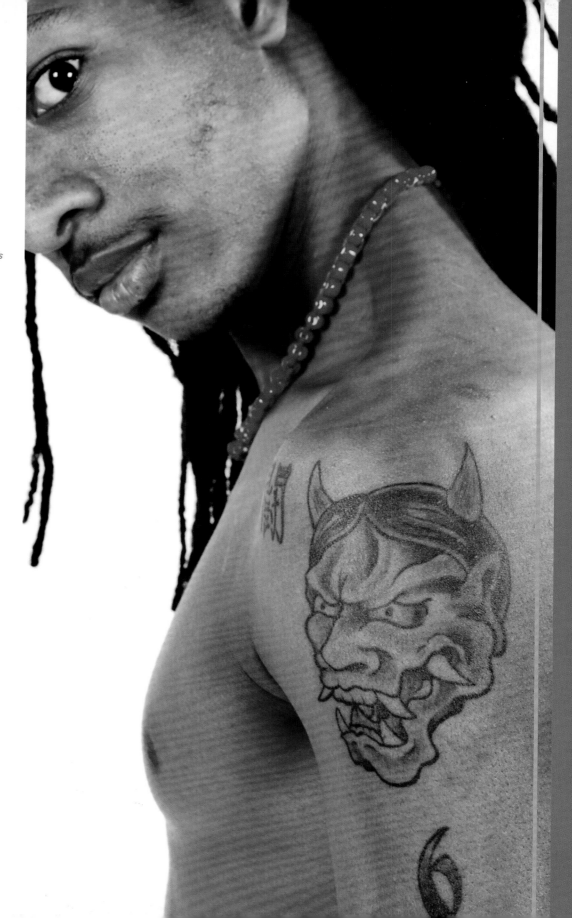

◀ The back makes a large, flat, unbroken canvas, well suited to ambitious tattoos.

Subject: Jen

▶ "Life's struggle and the appearance of evil" inspired this hanya mask tattoo. Kabuki theater uses hanya masks to represent a woman so consumed with jealousy that she transforms into a hideous demon.

Subject: Chris / Artist: Troy Timpel, Philadelphia Eddie's

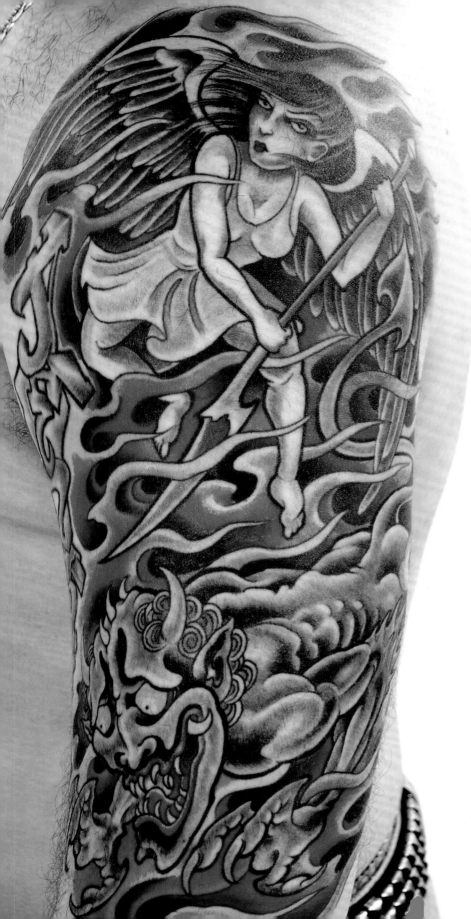

◀ Colors give a tattoo depth and set its mood. At left, reds and yellows alternate with gray and a sudden splash of cornflower blue.
Subject: Lenny Breaks / Artist: Kevin LeBlanc, White Lotus Tattoo

▷ At right, the ghoul's sienna eyes illuminate this stormy pattern of murky grays and black.
Subject: Lisa Zelenak / Artist: Khaoz

▷▷ At far right, this dragon is highlighted by well-handled washes of fluorescence.
Subject: Anthony Colonnello

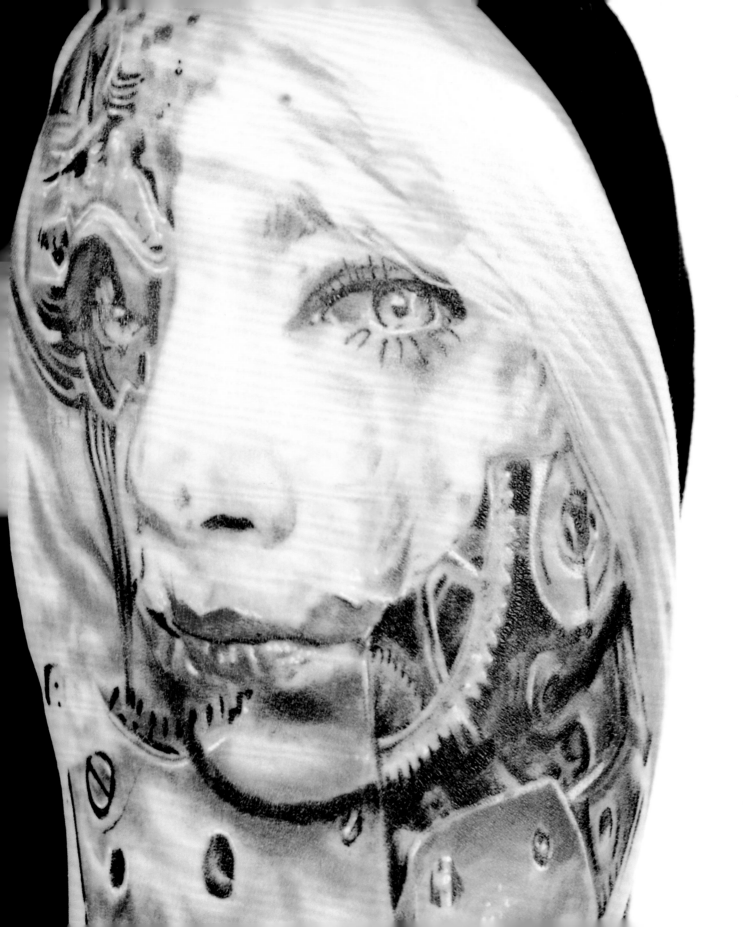

▲ Visions of the scary and the surreal: the steel encased, riveted torso in this dramatic tattoo is cut away to reveal an organic heart.
Subject: Stephanie Campbell / Artist: Joe John's

◄ On this subject's left arm, an android's pretty face is cut open; lifelike skin no longer covers the internal matrix of guts and gears.
Subject: Robbo / Artist: Steve Monie, Pinz & Needlez

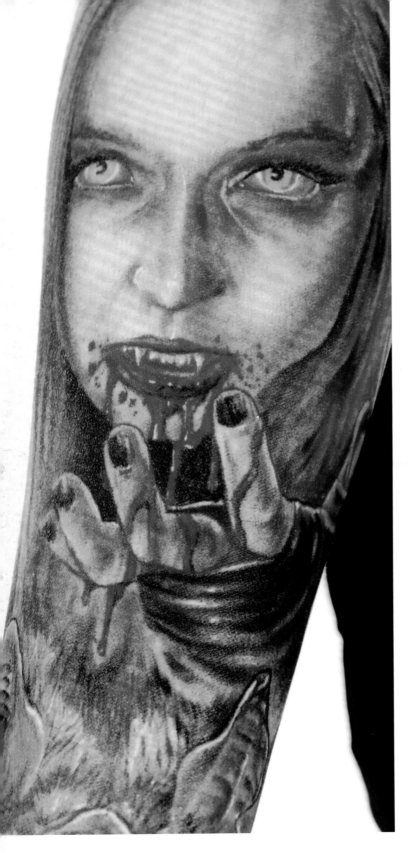

"I love horror. I love my dog."

--Kristin Maszkiewicz

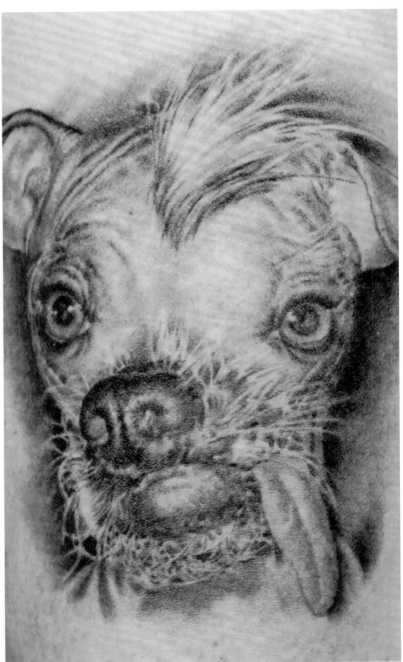

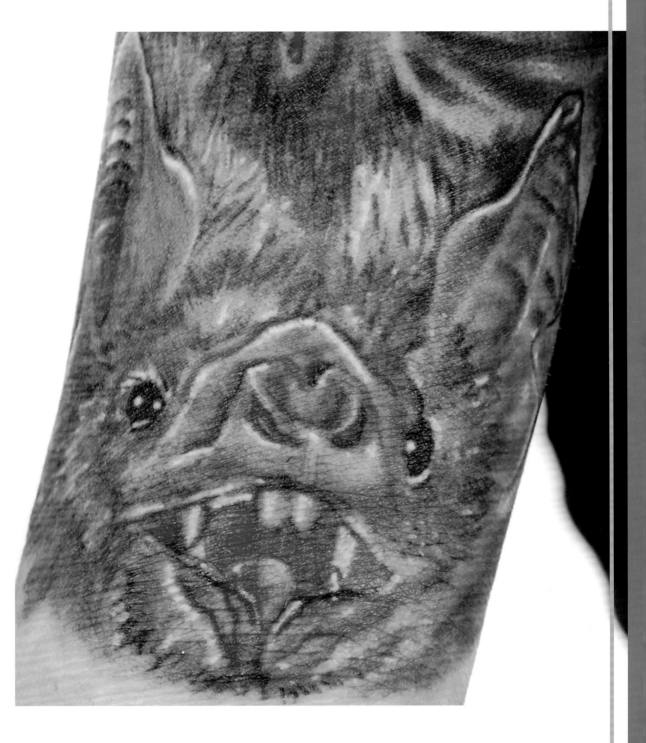

◀◀ A blue-eyed, bloodthirsty female vampire looms above a tattoo of a source of the legend, the vampire bat.

Subject: Kristin Maszkiewicz / Artist: Paul Acker

◀ A skillful rendering of the subject's dog, Pee Wee Martini, a Chinese crested, shows the lolling tongue typical of the breed. Chinese cresteds often win "ugliest dog" contests, but their owners find them charming.

Subject: Kristin Maszkiewicz / Artist: Shane O'Neill

▶ A close-up of a vampire bat, showing the razor-sharp teeth. Although fierce looking, these flying mammals feed mainly on dozing cattle, not human prey.

Subject: Kristin Maszkiewicz / Artist: Paul Acker

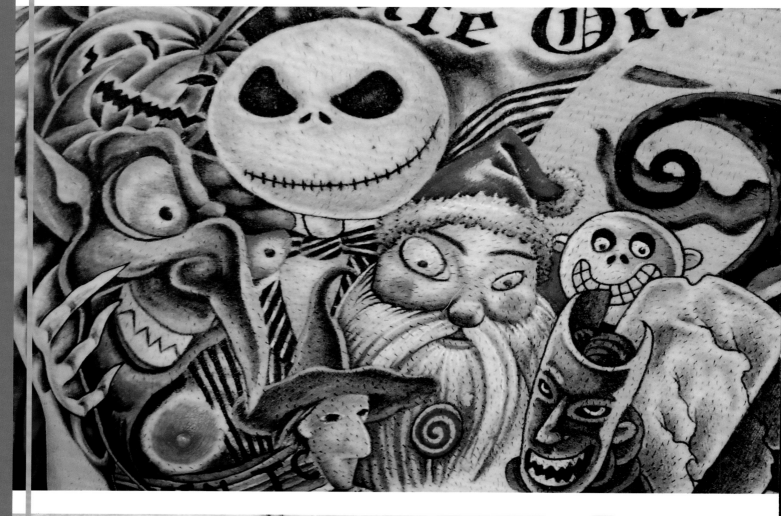

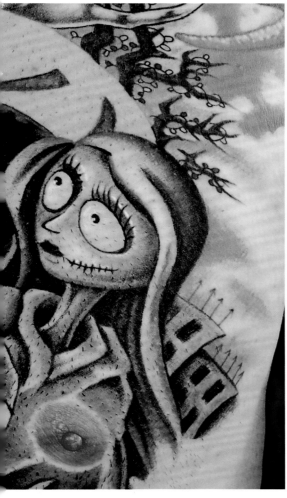

◄ This man's love for the movie *The Nightmare Before Christmas* compelled him to permanently decorate his skin with the film's distinctive characters.
Subject: Matt Mauro / Cort Bengtson, Corts Royal Ink

▼ This woman inked a gentle, light-hearted reminder to herself and others to try to relax a little amid the "hardships of life."
Subject: Big Johnson / Artist: Meghan Patrick

Today a tattoo is no longer a ritual mark. It is a form of self-expression, and when it comes to expressing themselves, some people just want to have fun. For a nominal fee you can walk into the tattoo parlor, endure an hour or so of creative needlework, and emerge wearing the characters from your favorite movie, rock gods or real gods, pithy quotes or words of wisdom. These bodies are collages of diverse enthusiasms; these tattoos map people's passions in washes of color and delicate hatching and affix their mottoes permanently, never to be forgotten. Tattoos are commitments—these tattoos show people's faith in their inspirations and reveal them as conduits of creativity—the art that moved them is reproduced on their skin so that it may move others to think, or even to laugh.

LIGHTER LOOKS

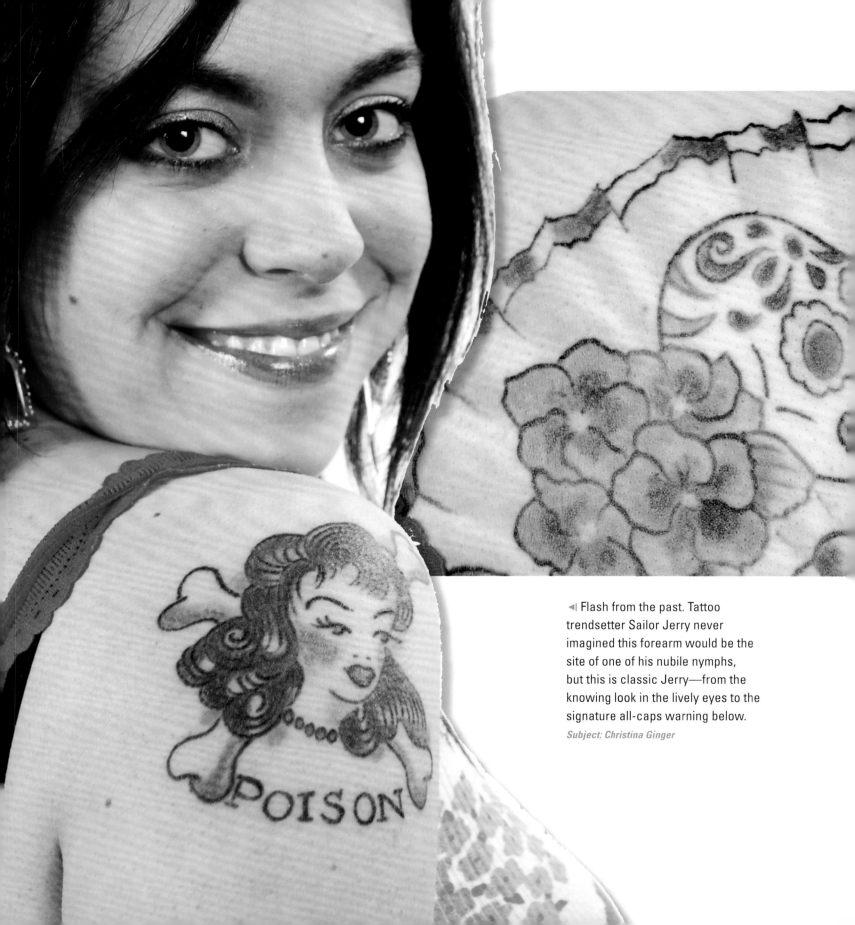

◀ Flash from the past. Tattoo trendsetter Sailor Jerry never imagined this forearm would be the site of one of his nubile nymphs, but this is classic Jerry—from the knowing look in the lively eyes to the signature all-caps warning below.

Subject: Christina Ginger

POISON

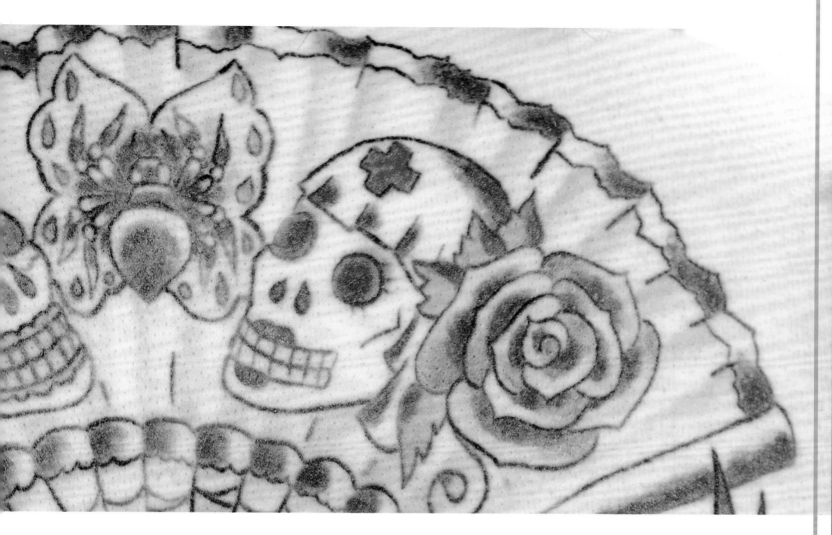

▲ Another vintage look, this time with a macabre twist. A delicate fan forms the backdrop for a floral frame of violets and a rose that surround a pair of skulls. The skulls' gazes draw the eye to the tarantula in the center.

Subject: Christina Ginger / Artist: Sara Purr

"I got 'Life Is Beautiful' written across my chest as my first tattoo when I was eighteen—it was kind of like motivation for me after I got out of the hospital. I deal with depression and drug issues in my life, and it just helps to remind me that there is beauty in this world worth living to see."

--Shannaan

▲ This life-affirming message has motivated its wearer to deal with the difficulties of her life, and to see past them to the underlying beauty in this world.

Subject: Shannaan / Ian Greenings, Artistic Integrity

▶ A glorious mess. This woman wears the cluttered paraphernalia of modern life.

Subject: Jessica Dibala / Adam Pietras

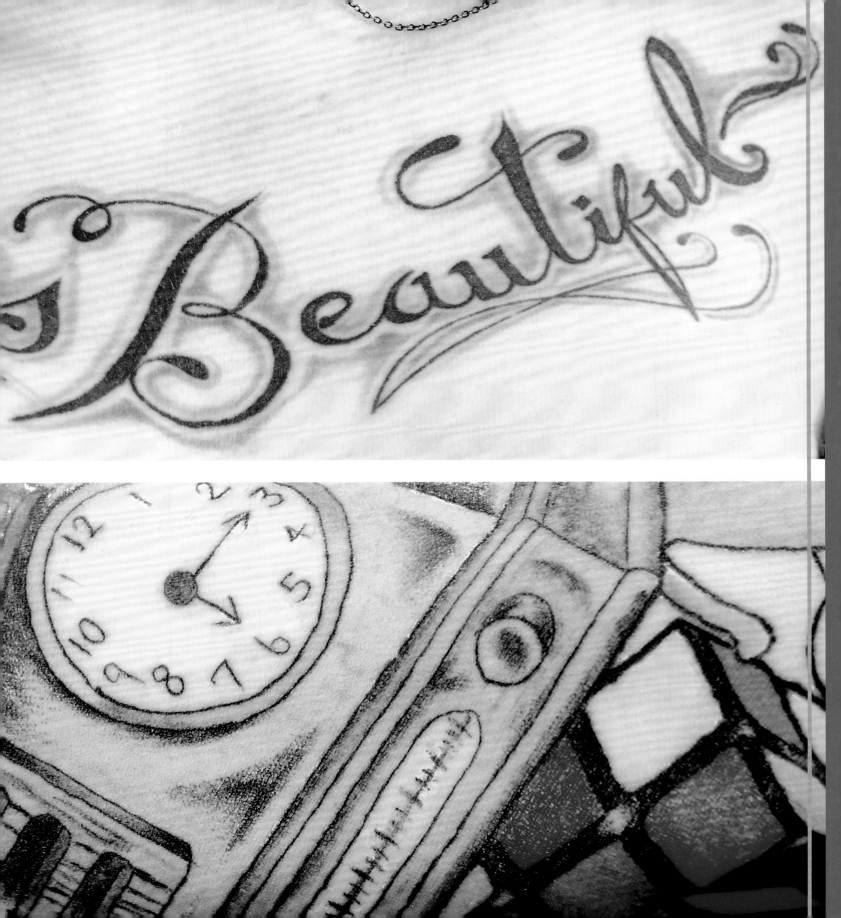

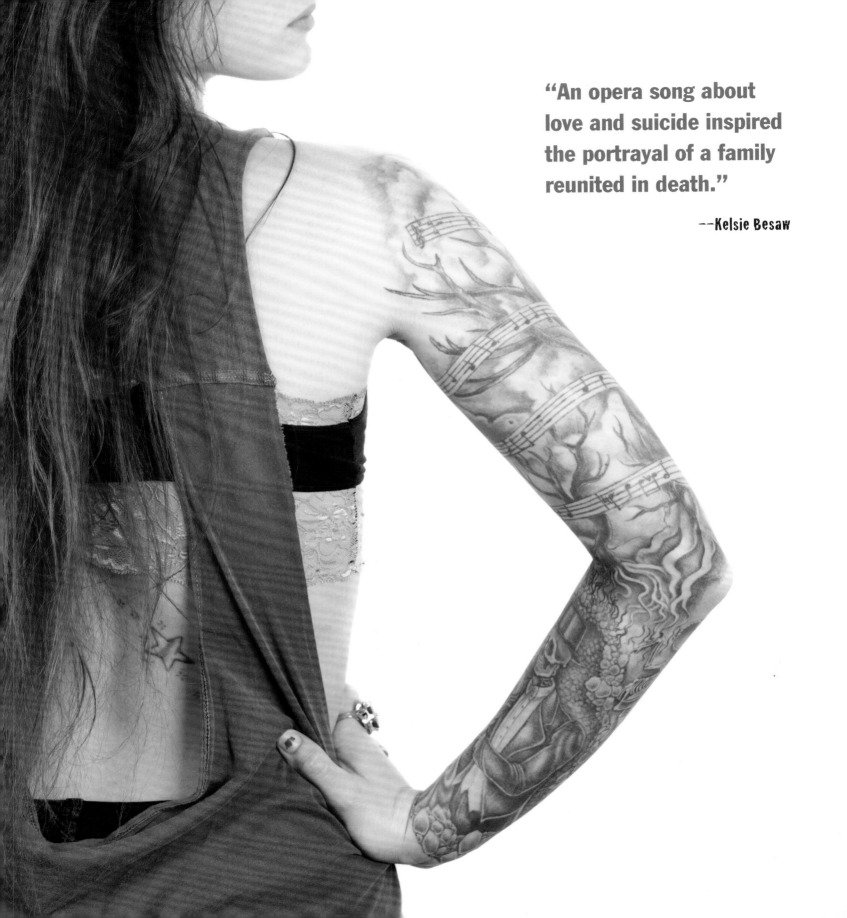

"An opera song about love and suicide inspired the portrayal of a family reunited in death."

--Kelsie Besaw

▲ A bride, groom, and their child are portrayed as skeletons buried underground in this forearm piece, inspired by an opera song called "The Black Swan."

Subject: Kelsie Besaw / Artist: Jessica Mascitti, East Side Ink

◄ A love for Harry Potter inspired this cartoonish rendition of the owl Hedwig.

Subjects: Kelsie Besaw / Artist: Nate Elwell, Skinny Buddha Tattoo

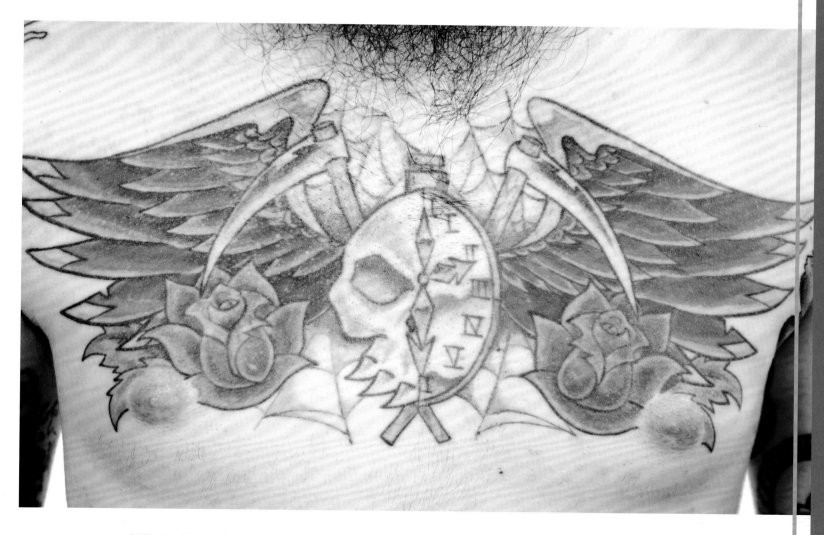

"A tattoo is a true poetic creation, and is always more than meets the eye. As a tattoo is grounded on living skin, so its essence emotes a poignancy unique to the mortal human condition."

—V. Vale and Andrea Juno, *Modern Primitives*

This man's chest is alive with classic tattoo symbolism. Scythes frame a skull clock that sits amid cobweb-backed wings and roses.
Subject: Raymond Baranowski

Although the art of tattoo is most often associated, and rightly so, with intricate and beautifully rendered images, words are increasingly moving to center stage—or center skin. It's certainly not new to include words and lettering in tattoo designs; for example, subjects have long chosen to pay homage to mothers, lovers, military units, and hometowns by naming them by name. These days, though, the words themselves are often the entire tattoo, written clearly for all the world to see. Simple affirmations such as "Just Go For It" or "Life Is Beautiful" and proud proclamations such as "Drug-free" draped across chests or snaking around waists and legs, show that ink truly forms the message.

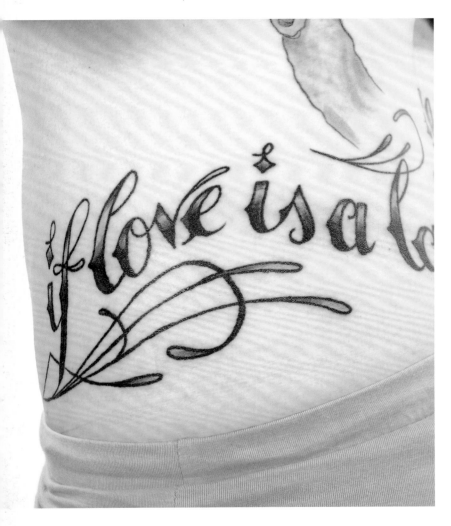 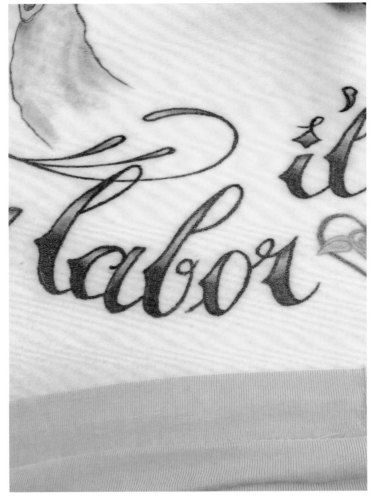

This woman doesn't limit her manifesto—a belief that love is worth the work—to one part of her body. The words "If love is a labor, I'll slave till the end" circle her hips like a belt.

Subject: Lacey Villareal / Artist: Chris Lowe, Naked Art Tattoos

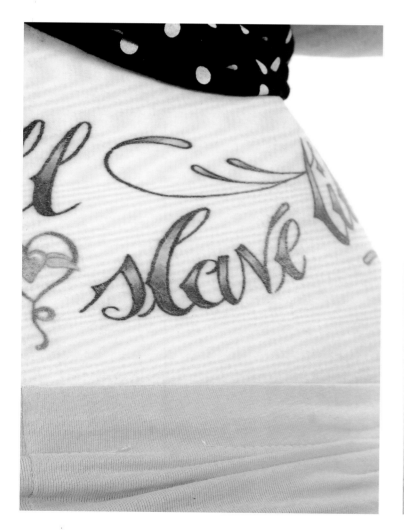

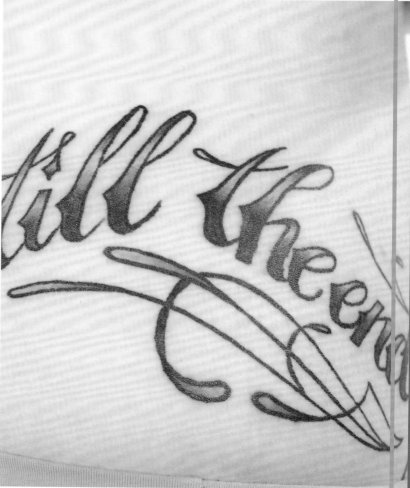

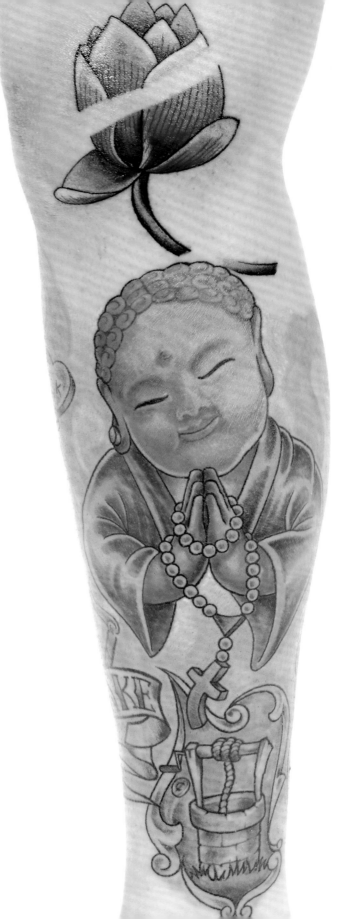

◄ Colorful, cartoonish, and well-rendered imagery decorates much of this woman's body. A self-affirming ode to the band Hole decorate one leg, far left. And echoing the rich palette of the opposite leg, a beatific Buddha smiles serenely while clasping Roman Catholic rosary beads.

Subject: Lacey Villareal / Artist: Chris Lowe, Naked Art Tattoos

▮► An homage to spring: graceful butterflies and delicate cherry blossoms.

Subject: Lacey Villareal / Artist: Orlando, Creative Visions

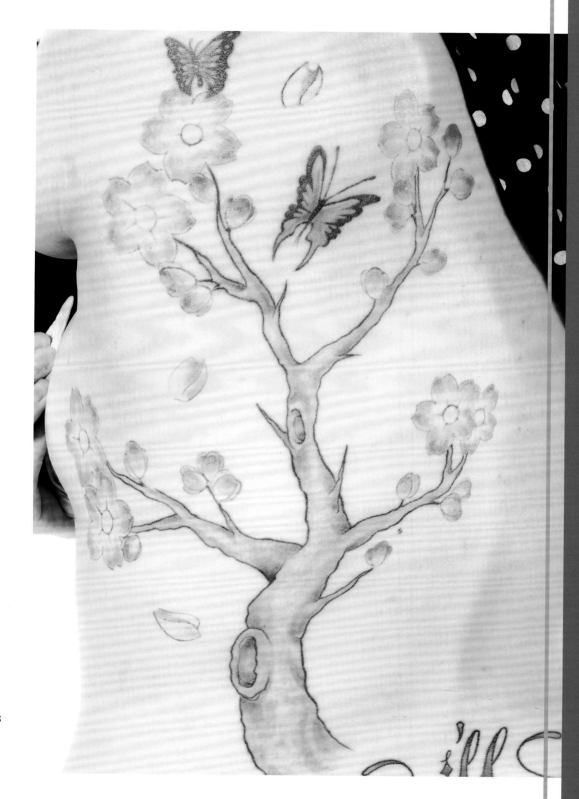

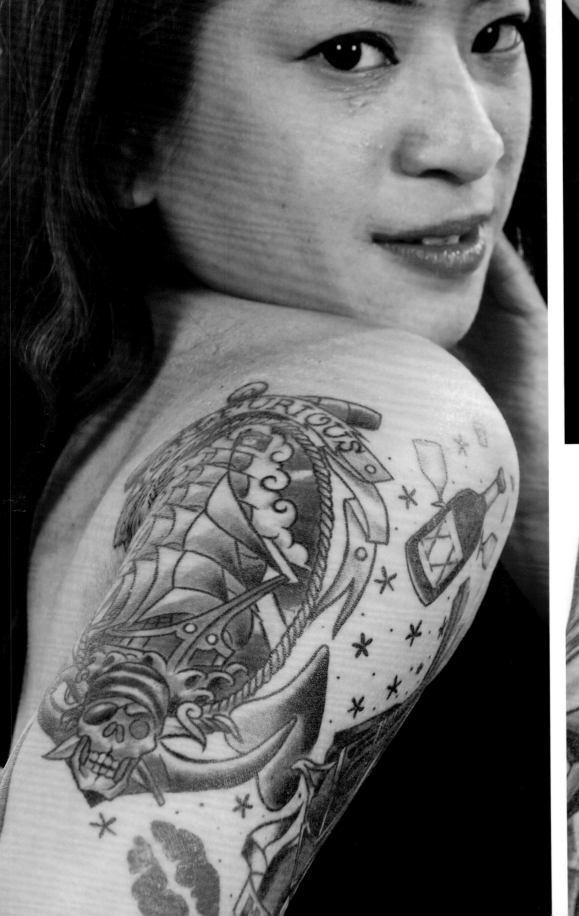

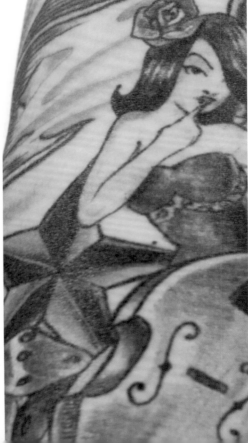

Though modern tattoos run the gamut from fun to funky to downright fierce, for centuries these old standbys topped the charts—hearts, often featuring the name of a loved one; nautical tattoos, including anchors, mermaids, and sailing ships; and flowers, especially red roses, which symbolize true love. More recently there were the ever-popular "souvenir" tattoos—hula dancers from Hawaii, tumbling dice from Vegas, and palm trees and exotic birds from the tropics. Cheesecake tattoos, such as pin-up girls and saucy nudes, were also a key part of the ink tradition. Not surprisingly, many of these vintage tattoos have been making a comeback. Sometimes you just can't beat a classic.

This woman and her tattooist have collaborated a number of times to create a pastiche of colorful scenery, ranging from a new take on the trusty old anchor motif to wildlife imagery to a pretty jazz musician amid skulls and stars.

Subject: Linh Le

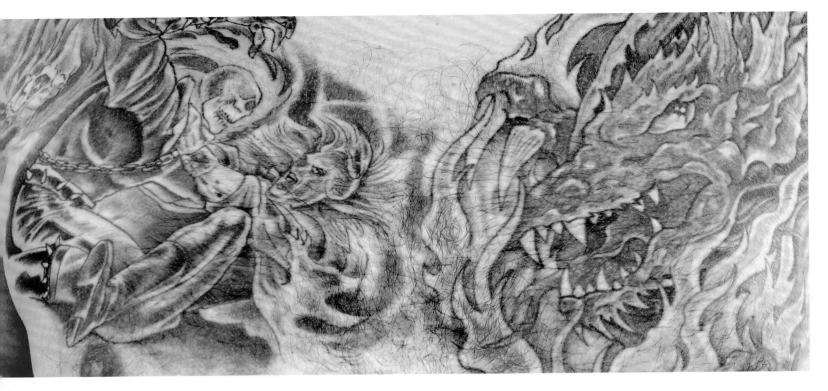

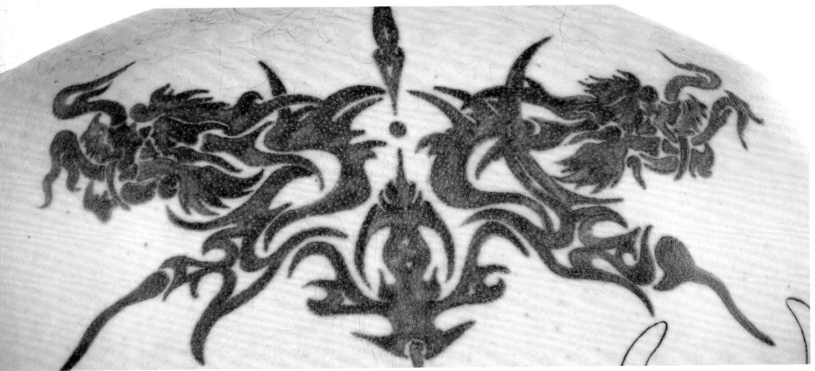

▲ This couple shows two different approaches to tattooing—he decorates himself with sprawling dense-coverage scenes, while she favors isolated images, such as a finely drafted chrysanthemum.
Subjects: Rebecca Kolodziejczak and Nick Less

◀ This man wears dragons on both his chest and his back, but the styles diverge—one is in lush color and the other in stark black.
Subject: Nick Less / Artist: Troy Timpel

"Everybody gets the tattoo they deserve."

--David Duchovny, actor

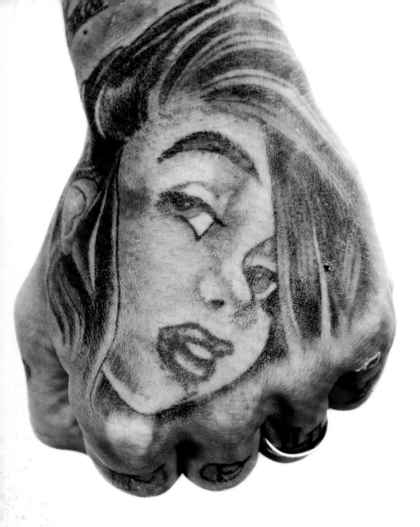

"Who doesn't love
chicks that scrap?"

--Short

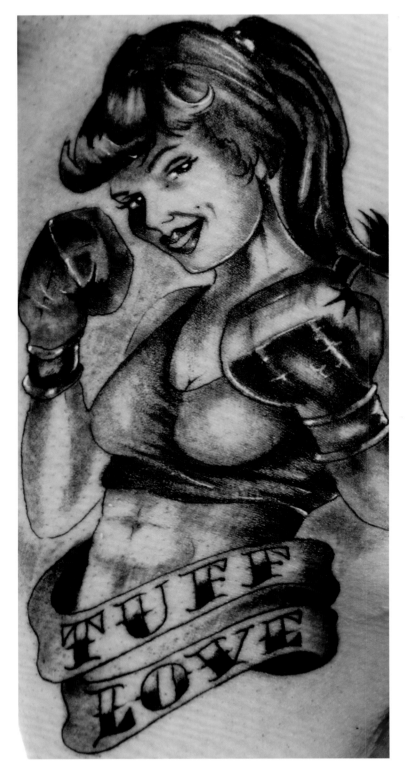

▲ Pure cheesecake flash with a 1940s feel features a card-dealing cutie baring her best from a lucky horseshoe.

Subject: Amanda Doran / Artist: Jim Weiss, Slinging' Ink

◀ Miss "Tuff Love" looks like she's ready to take on all the bad boys—and keep smilin' while she kicks some butt.

Nicholas S. Grandinetti "Short" / Artist: Christian Masot, Silk City Tattoos

◀◀ This sexy portrait tattoo of a pouty brunette beauty makes full use of the subject's hand and wrist.

Subject: Aaron Michalovski / Artist: Mike Comp

▷ In typical pin-up girl fashion, this curvy graduate flashes her ample assets and stoops to conquer.

Subject: Pearl Donovan / Artist: Capt. Gordon Staub

This woman commemorates her favorite pop culture figures, including cartoon stars Ren and Stimpy, at top left; fashion doll Barbie, top right; and the characters from the film *Beetlejuice*, at bottom.

Subject: Debbie Monie / Artist: Steve Monie

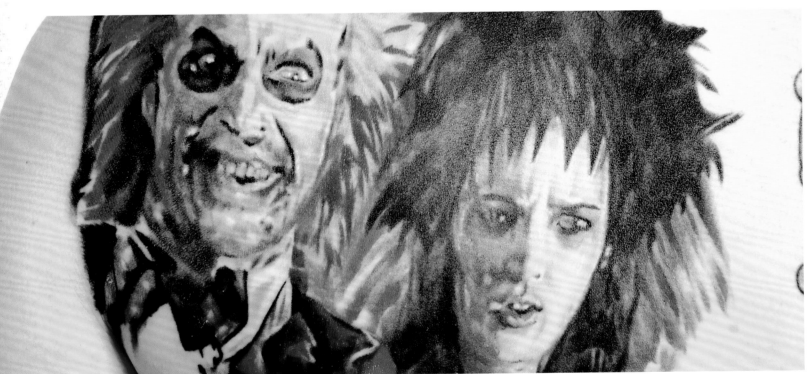

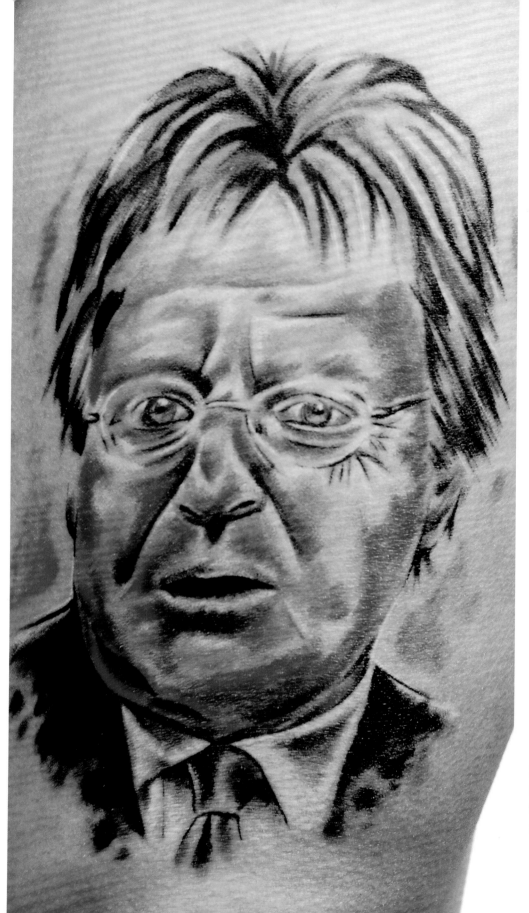

Note the rich coloring—several hues, ranging from ink black to cotton candy pink, combine to form an arresting portrait of Jerry Springer.

Subject: Debbie Monie / Artist: Aaron

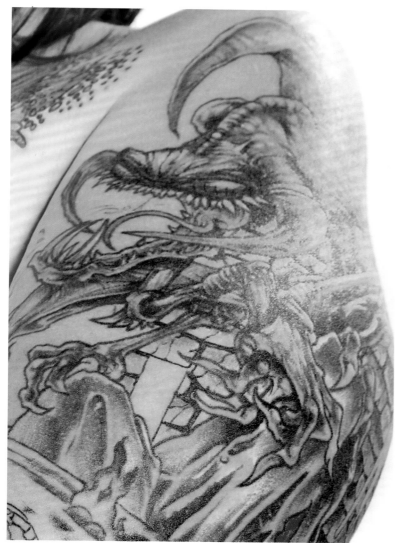

▲ The pretty but surreal occupies one side of this woman's body, while the savage and surreal consumes her other half. Her left arm abruptly changes from a soft blue butterfly to a scene of monstrous terror in black and white with highlights of red and yellow.

Subject: Risa / Artist: Trey, Baltimore St. Tattoos

◄|◄| The serene multi-hued bird on her right arm seems to merely smirk in response to the chaos wreaking havoc on the other side.

Subject: Risa / Artist: Mr. Jason, Baltimore St. Tattoos

▶ Miniatures of the macabre and the mischievous adorn this woman's body, including a vignette from the film *The Nightmare Before Christmas.*

Subject: Risa / Artist: Mr. Jason, Baltimore St. Tattoos

▶▶ Opposite, a couple of unique penguins take up residence on her limbs. A fierce crested rockhopper penguin stands framed by a knife and fork, above; while below a seemingly angelic emperor penguin seems to have hit the bottle a bit too hard.

Subject: Risa / Artist: Missi Blue, Baltimore St. Tattoos

▶▶▶ Minimalist effects: a simple woebegone stick figure and an elegant monogram trail down her back, while a grinning jack o' lantern hides behind her ear.

Subject: Risa / Artist: Matted Ink

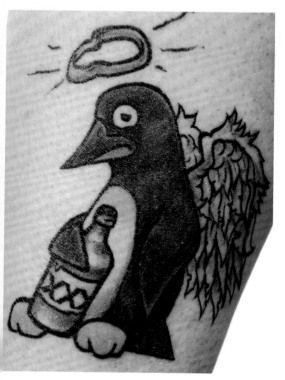

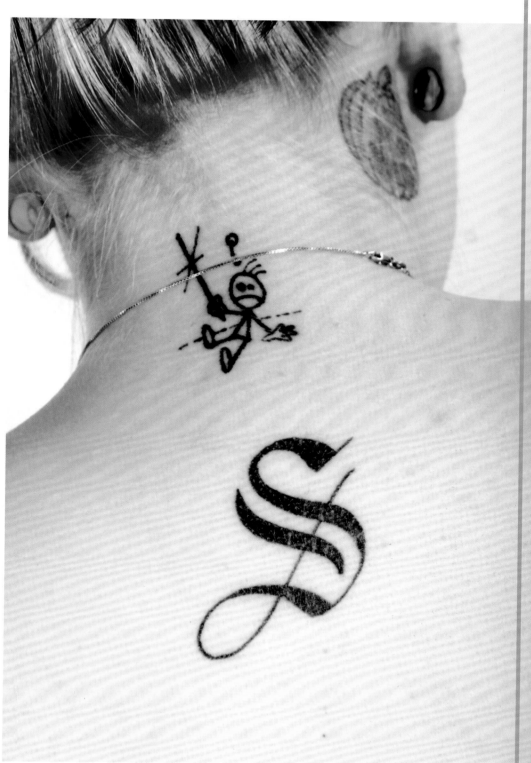

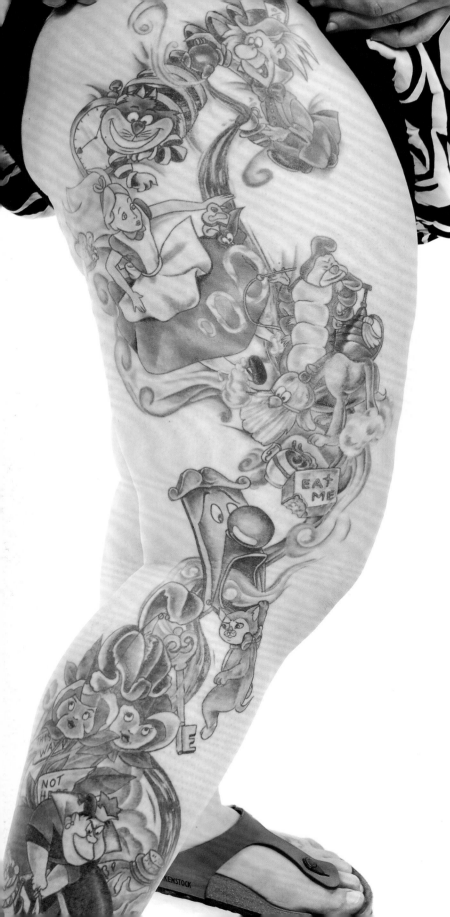

Whether it's Disney, Pixar, Looney Tunes, Hanna-Barbara, or Tim Burton's animation, fanciful cartoon characters have always been popular as tattoos, especially with women and with men who aren't looking for that Goth/biker gang effect. Cartoons allow ink artists to use the brightest of colors and "inject" humor into their tattoos, while allowing the bearer to make a statement that is playful rather than predatory.

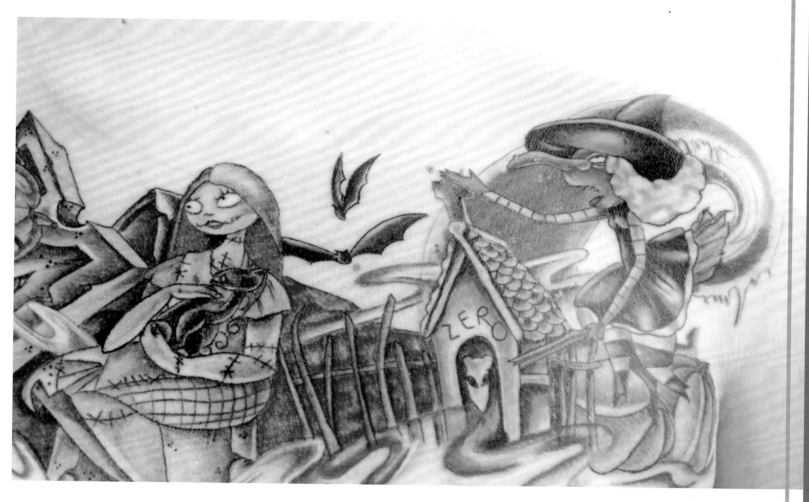

◀ Alice, the Mad Hatter, and the Cheshire Cat tumble down the subject's leg in this paean to the Lewis Carroll classics *Alice in Wonderland* and *Through the Looking Glass* as adapted by the Walt Disney animation studio.

Subject: Candice Martell / Artist: Meghan Patrick

▲ The weirdly wonderful characters of Tim Burton's *The Nightmare Before Christmas* flow across this woman's skin, each rendered with fine detail and rich color. Thankfully, copyright protection hasn't stymied body art.

Subject: Candice Martell / Artist: Meghan Patrick

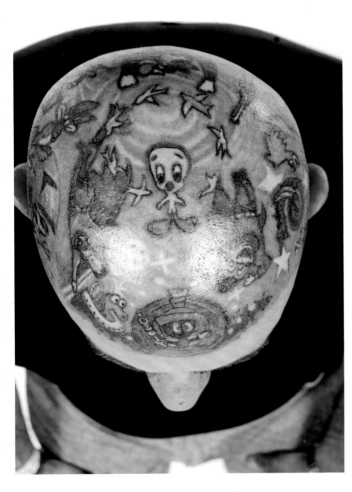

▲ Surrounded by Bugs Bunny, Yosemite Sam, Sylvester, and other cartoon favorites, Tweety Bird takes center stage in one man's full-head homage to Looney Tunes and Merrie Melodies.

Subject: The Boo

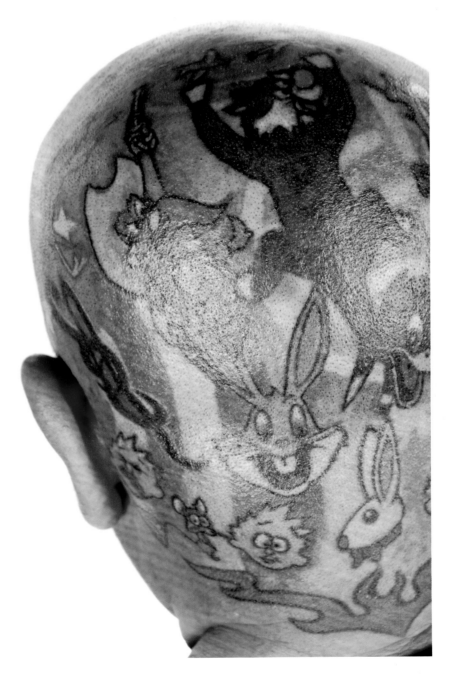

▶ For the truly dedicated, no spot of skin should go undecorated, including the top of the head. This model's dragon tattoo is lush and detailed.

Subject: Catman / Artist: James Vond, Straight A Tattoo

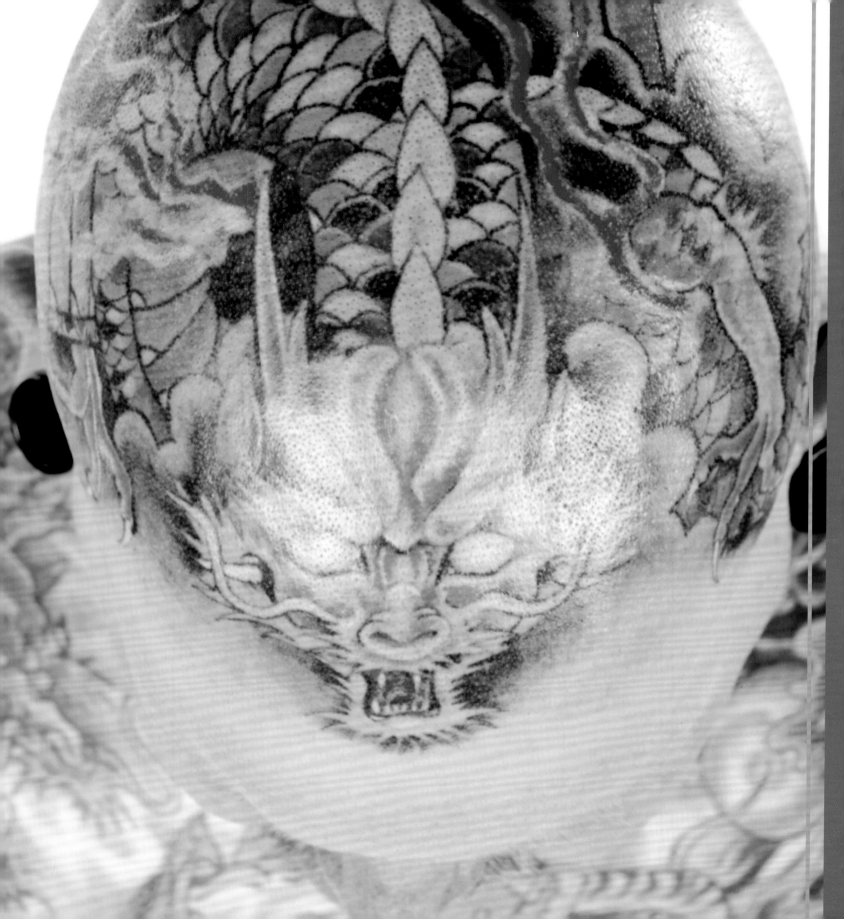

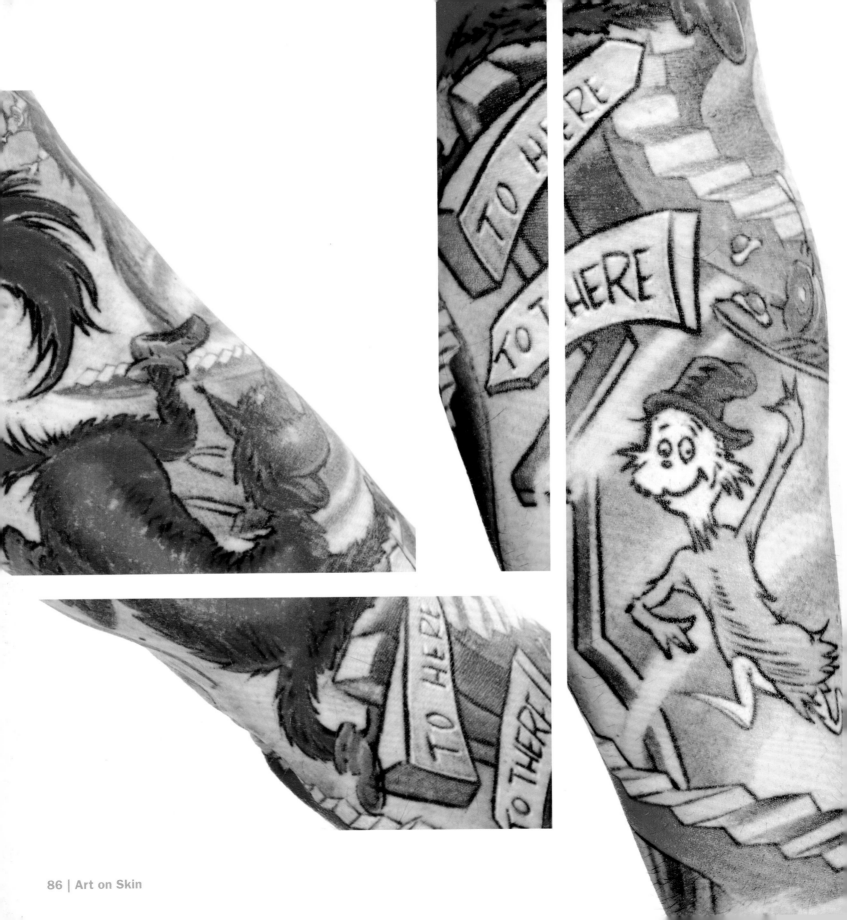

"Be who you are and say what you feel because those who mind don't matter and those who matter don't mind."

--Dr. Seuss

Three of Dr. Suess's most beloved creations parade along the subject's arm: the cherry-red Fox in Socks, a happy Who, and, of course, the Grinch—whose heart was three times too small until he discovered the true meaning of Christmas.

Subject: Brian Doebler / St. Marq, New Breed Tattoo

"**I am not strange, I am just not normal.**"

—**Salvador Dali**

This man pays enthusiastic homage to the master of Surrealism, Salvador Dali, picturing both the artist, opposite page, and his creations, such as a take on the "melting clocks" from his famous 1931 painting *The Persistence of Memory*, above left. Above and right is an ink interpretation of Dali's enigmatic lithograph *Drawers of Memory*.

Subject: Brian Doebler / St. Marq, New Breed Tattoo

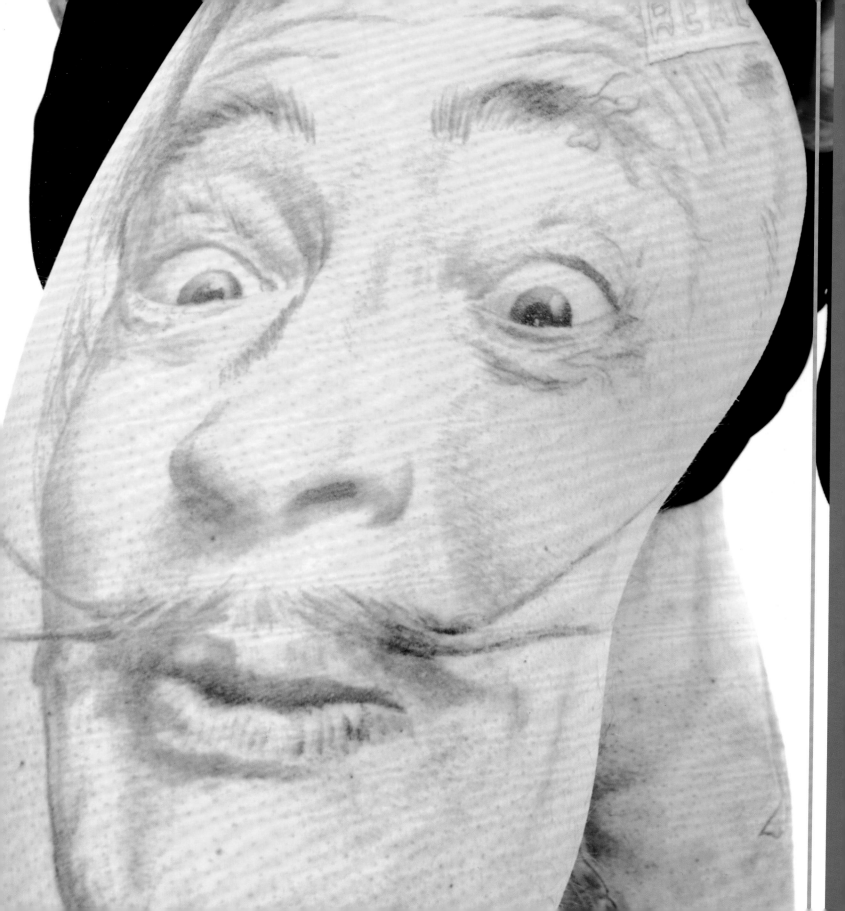

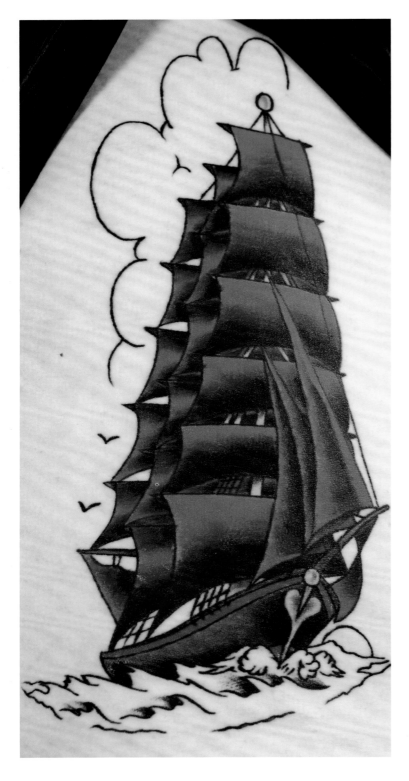

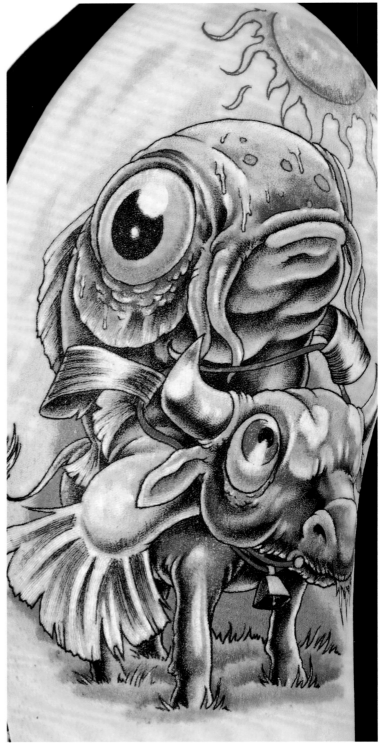

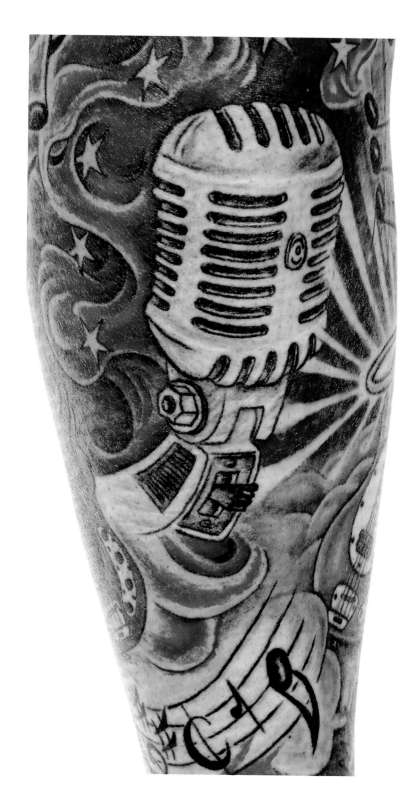

◀ Like an inky explosion of vibrant color, this tattoo homage to pop music—with its oversize microphone, electric guitars, and sheet music—is awash with dazzling, saturated hues.
Subject: Johnny Directions

◀◀ This unique image of an oversized and big-eyed carp taking a ride on an overburdened ox is taken from the tattoo artist's sketchbook. It shows both rich color choices and masterful shading.
Subject: Matthew DesOrmeaux / Artist Jeff Paetzold

◀◀◀ Color . . . astonishing, vivid color . . . is key in all of these lively tattoos. Deep emerald green sails make this square-rigged ship seem to surge upward from the subject's skin.
Subject: Matt Bernard / Artist: Miami, Miami's Tattoos

Aliens are among us! And they're right there on our arms, legs, and torsos. Space creatures became popular tattoo subjects during the 1950s, when science fiction movies were the rage, and have never lost their appeal. Whether it's the gut-busting creature from *Alien*, sweet, google-eyed ET, or Marvin the Martian, these space invaders have won us over. Surrender Earthlings!

▽ ALF, the famous alien life form from TV makes an amusing tattoo. His hairy coat is rendered with a soft pastel effect.

Subject: Alicia "Koala Kid" Collins / Artist: O, Oxygen Tattoos

▽ Another tribute to childhood idols: *Transformer* autobot Bumblebee stalks this subject's skin in a colorful blaze of shaded yellows and black.

Subject: Johnny Directions

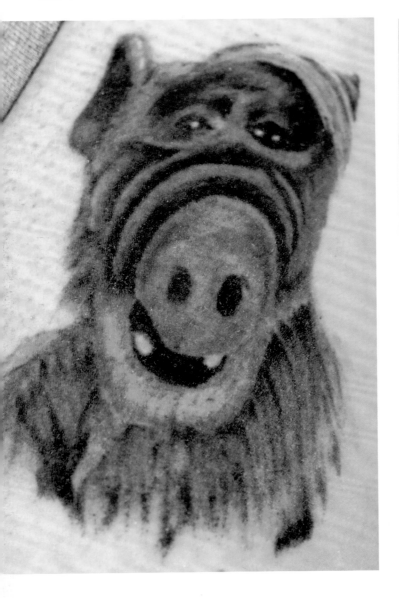

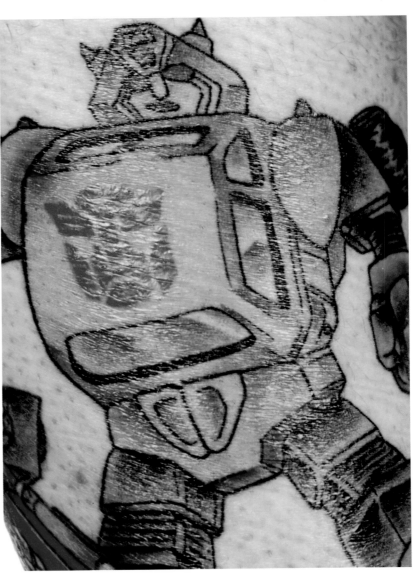

▼ This childlike alien scene features a flying saucer, a panicked human, and several super heroes zooming around in the sky.

Subject: Starr DesOrmeaux

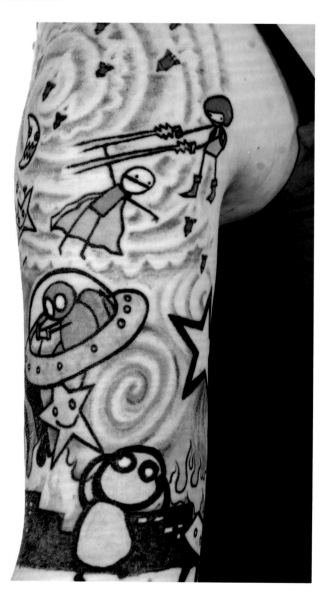

▼ Comical one-eyed spacemen fend off a huge, spewing caterpillar, proving that even aliens need a reliable exterminator.

Subject: Christopher Merker / Artist: Amber, Blue Velvet

▲ An uncomplicated, but vivid, burst offers simple, but effective advice.

Subject: Rebecca Kolodziejczak

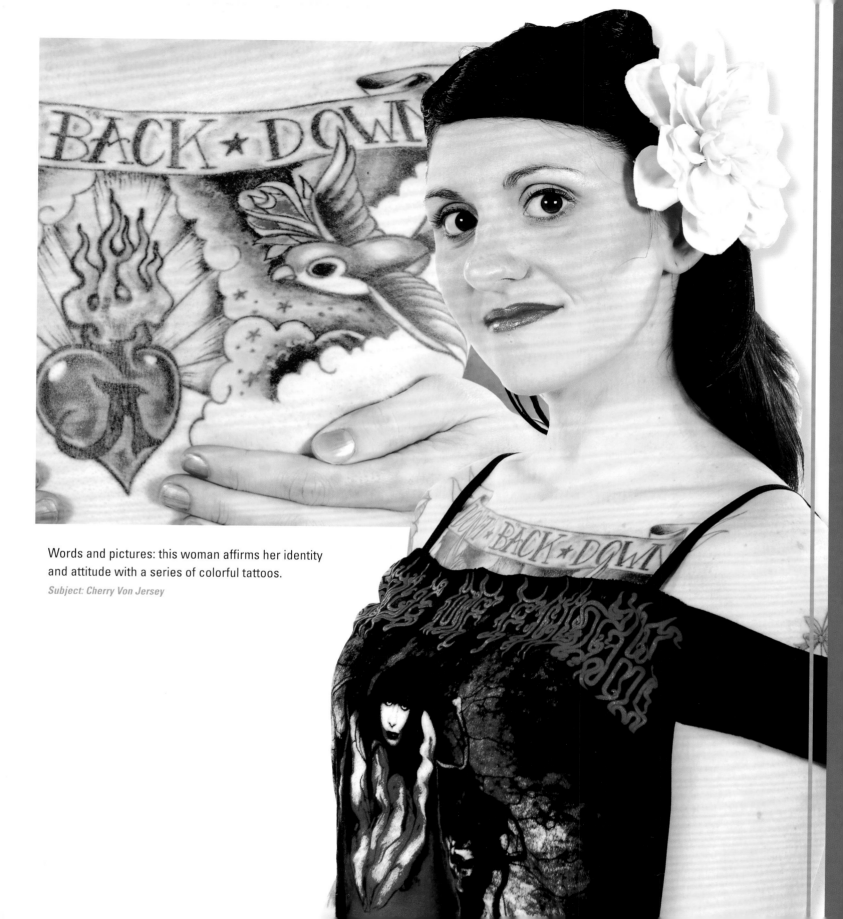

Words and pictures: this woman affirms her identity
and attitude with a series of colorful tattoos.

Subject: Cherry Von Jersey

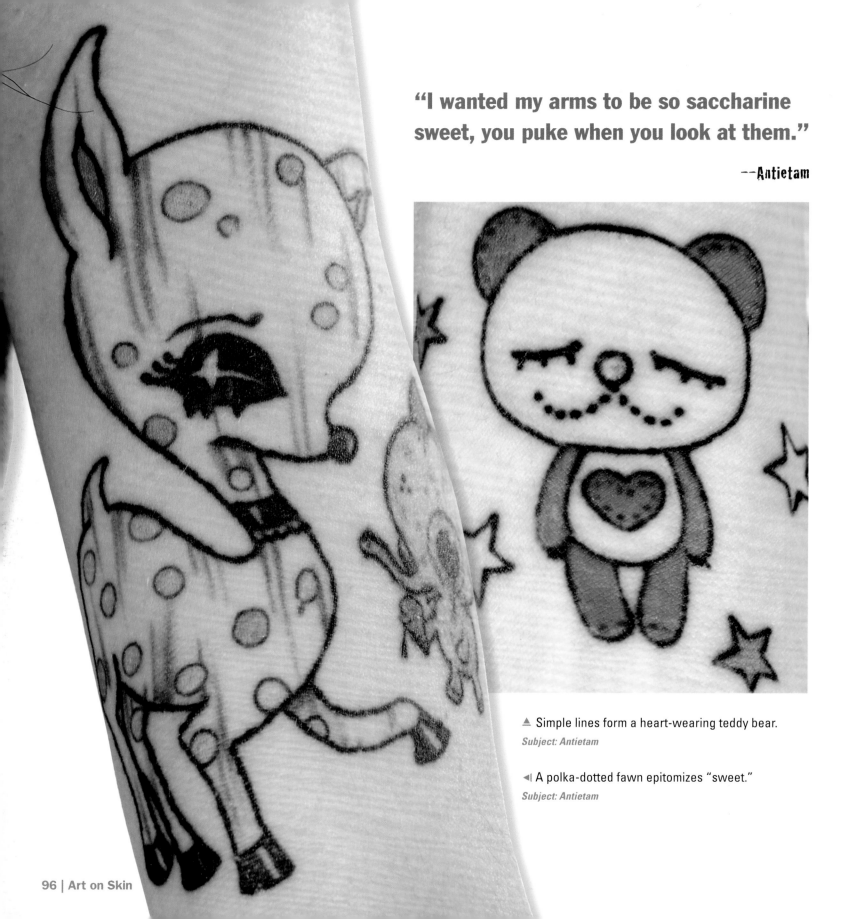

"I wanted my arms to be so saccharine sweet, you puke when you look at them."

--Antietam

▲ Simple lines form a heart-wearing teddy bear.
Subject: Antietam

◀ A polka-dotted fawn epitomizes "sweet."
Subject: Antietam

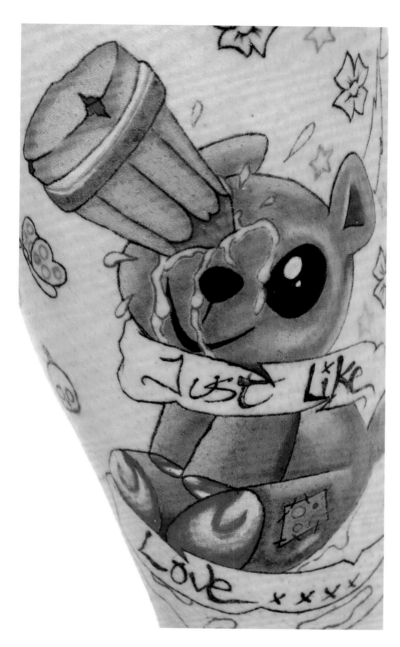

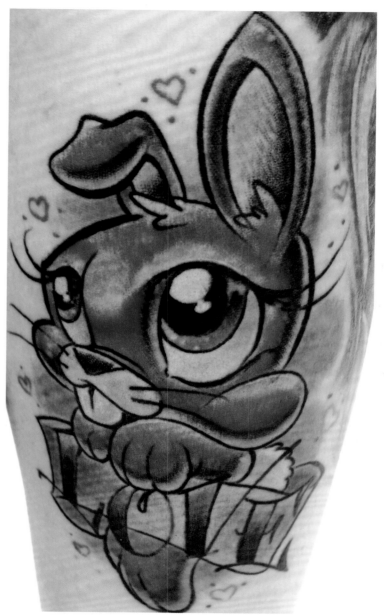

▲ Using color brilliantly, this tattoo remains adorable and perky—even if it does point out that love is like getting a pencil in the eye.

Subject: Jamie Margera / Artist: Bill Bill, Imperial Design Tattoo

▲ Possibly a tribute to the subject, this winsome rabbit is well served by its bold use of scarlet and baby blue.

Subject: Bunny / Artist: Jime Litwalk

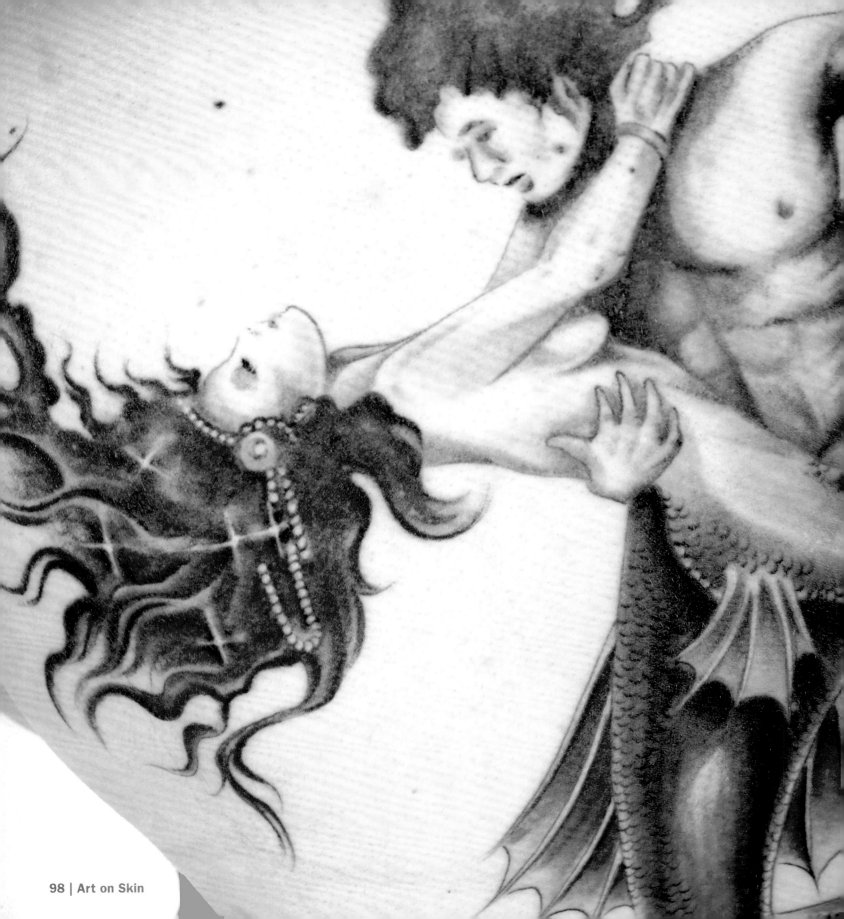

"The love between the mermaid and the merman reminds me of the love and desire my parents always had. It just reminds me that real love exists and does stand the test of time."

—Shannaan

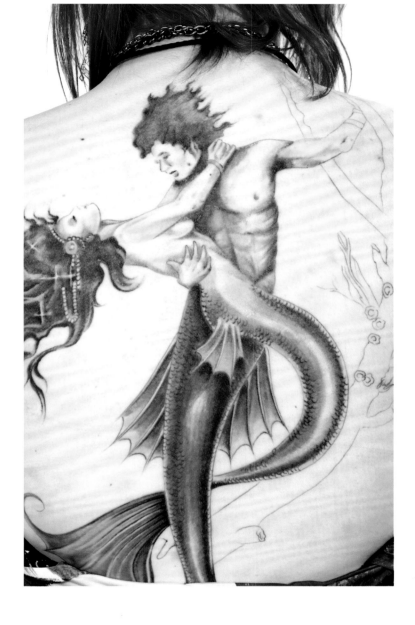

Mermaid tattoos have always been popular motifs with sailors, representing both longing for love after lonely months at sea and the threat of being lured to a watery grave. This tattoo of a mer-couple is an example of a soft-focus treatment that also creates a wonderful spatial quality.

Subject: Shannaan / Artist: Rachel Telles, Side Show Tattoos & Piercings

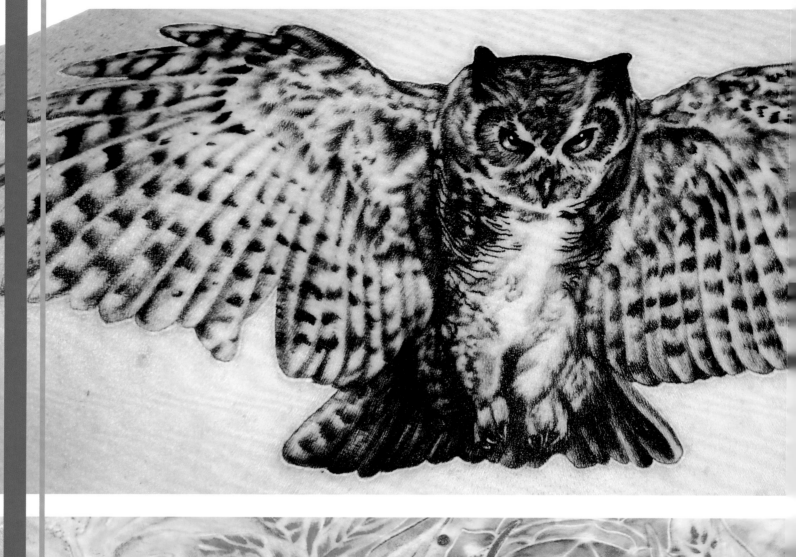

◁ A great horned owl in full stretch decorates the entirety of this man's upper back. The bird's plumage is well depicted in only shades of black and brown.

Subject: Michael Leaver / Artist: Jackie Jennings, Ink Bitch

▽ A fluorescent garden decorates a chest, with numerous flowers realistically rendered.

Subject: Lauren Sears / Artist: Jon Jon, Cutting Edge Arts

Tʰe patterns of nature have seemingly always poured forth from the tattooist's needle. More than a millennium ago the Pazyryk people in what is now Russia regularly decorated themselves with ink animalia, both real and imagined. Today it is not uncommon to see bodies that are galleries of beasts—carnivores and herbivores, fish and fowl. Tigers bare their fangs and stare menacingly through yellow eyes from forearms and thighs; eagles and owls stretch their wings across shoulder blades and scapulae; water flows down the skin in inky rivulets, sheltering frogs in lilied pools. These bodies are worlds unto themselves—sinuous trees hold clouded skies aloft, flowers spread, dragons emerge from the vaunted deep. To be somehow more than human is a dream of some—to wear the patterns and camouflage and color of wild fauna and flora. Here the mysterious designs of nature are harnessed by the tattooist and recreated in ink upon bare skin.

THE WILDLIFE

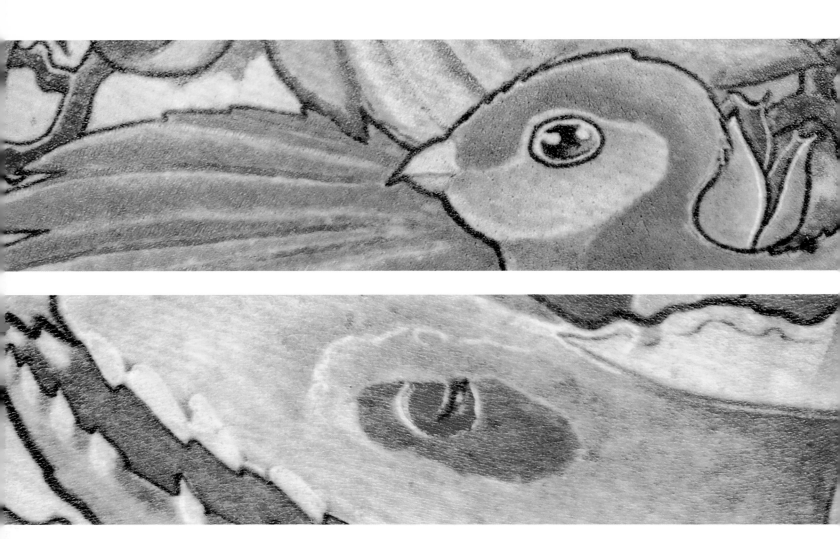

"I like the way getting a tattoo feels.
If I'm depressed, it's nice to get one
and deal with the pain. "

--Megan Fox, actor

For millennia, humans have used tattooing to invoke the qualities of wild animals. Personal struggle inspired this couple to get their tattoos, and they chose animal images that evoke beauty, grace, and strength.

Subjects: Kim Edwards and Todd Glover

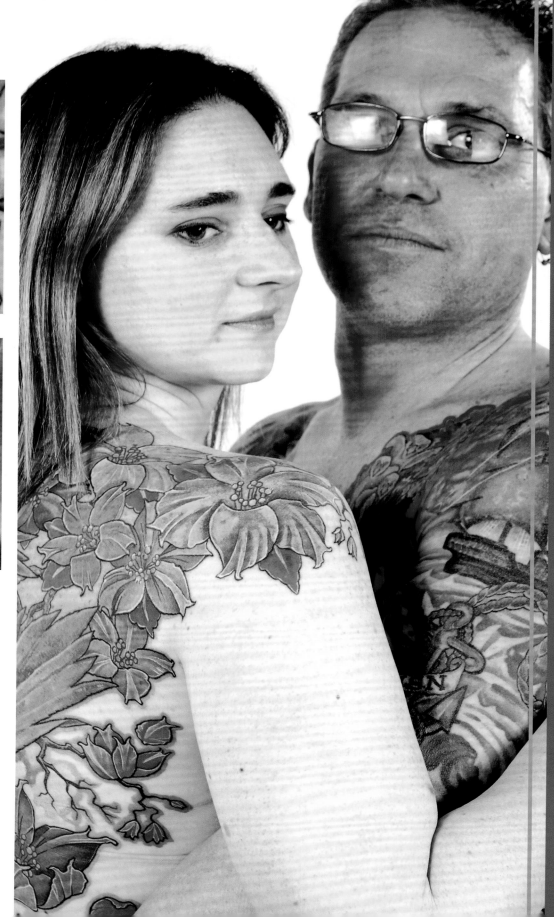

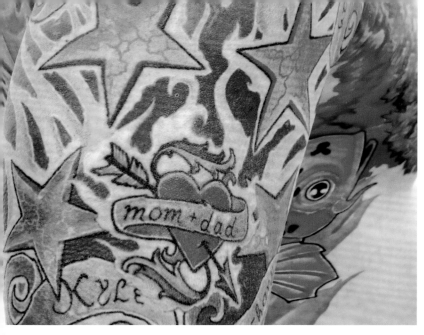

Intense ink coverage is the theme at left , as flying stars and shooting flames appear to have erupted around the older, more humble, heart tattoo commemorating the subject's parents. Below left: The carefully delineated lines of this koi are filled in with burnished golden hues interspersed with jet black and shimmery silver markings, which pop against the cerulean and aqua hues of the water.

Subject: Todd Glover / Artist: Tara Goshow, Phenom-A-Bomb Tattoo

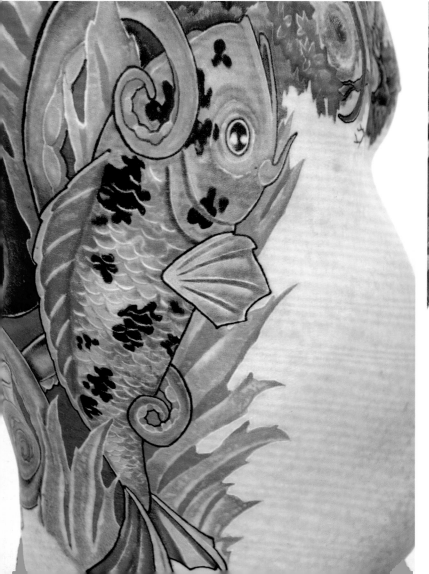

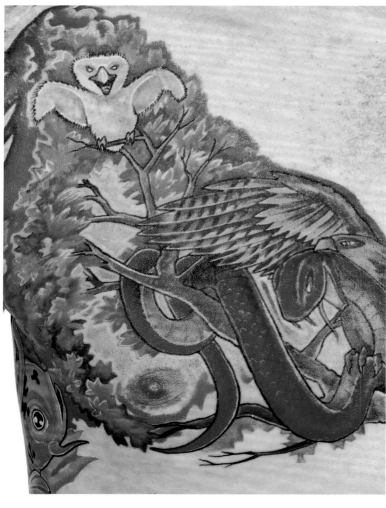

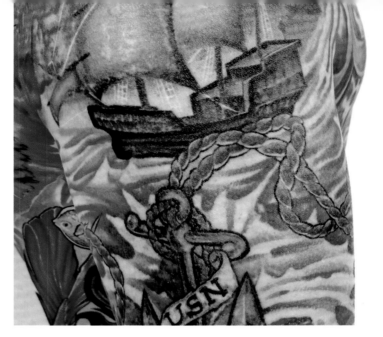

This striking chest panorama, below, features an adult eagle about to feed its young with a writhing snake. The color choices, graphic symmetry, and naturalistic treatment of the animals are all outstanding. At right, nautical motifs appear in adjoining chest and arm tattoos—and include a galleon, the US Navy anchor and line, and a mermaid surrounded by curious sea creatures.

Subject: Todd Glover / Artist: Tara Goshow, Phenom-A-Bomb Tattoo

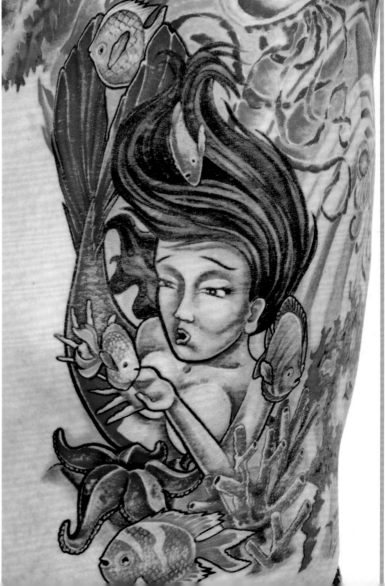

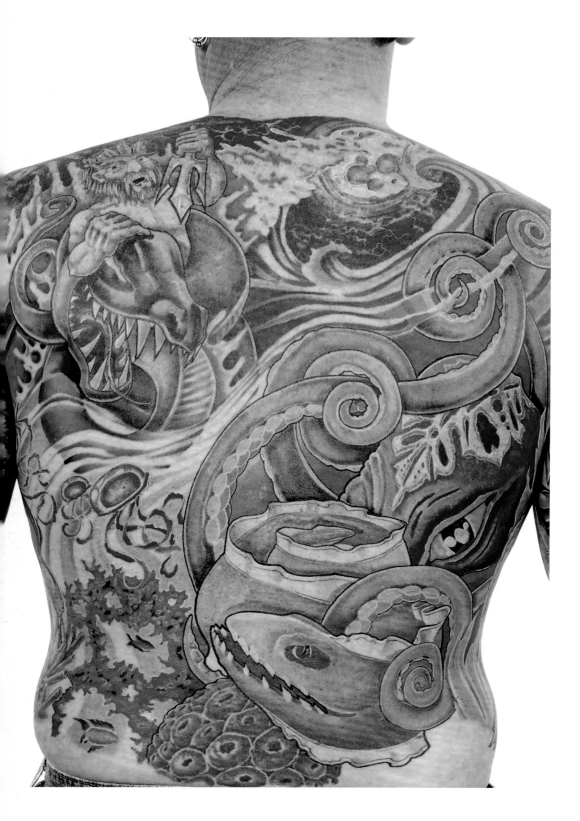

Leviathans abound on this man's back, amid a diverse underwater environment. To wear an animal on your body is to identify with its attributes.

Subject: Todd Glover / Artist: Tara Goshow, Phenom-A-Bomb Tattoo

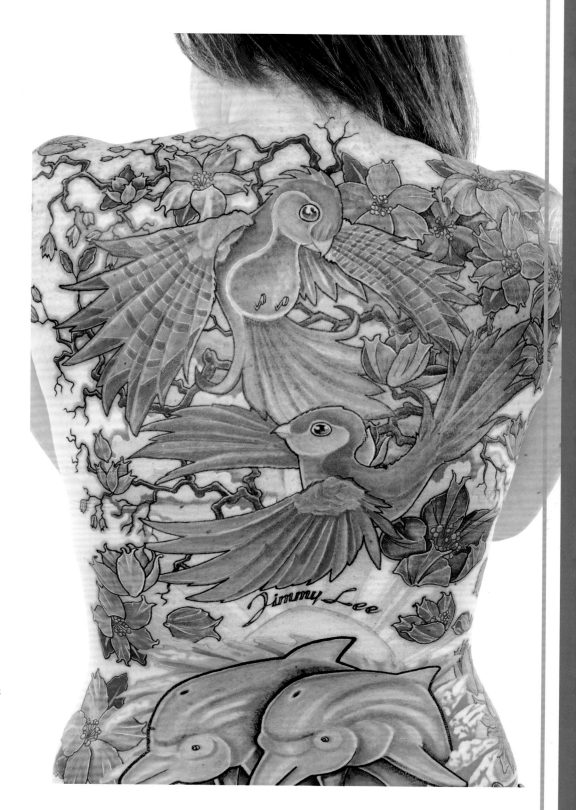

The same artist has richly decorated this woman's back, though she has crafted a more placid scene of brilliant cerulean bluebirds and cavorting dolphins.

Subject: Kim Edwards / Artist: Tara Goshow, Phenom-A-Bomb Tattoo

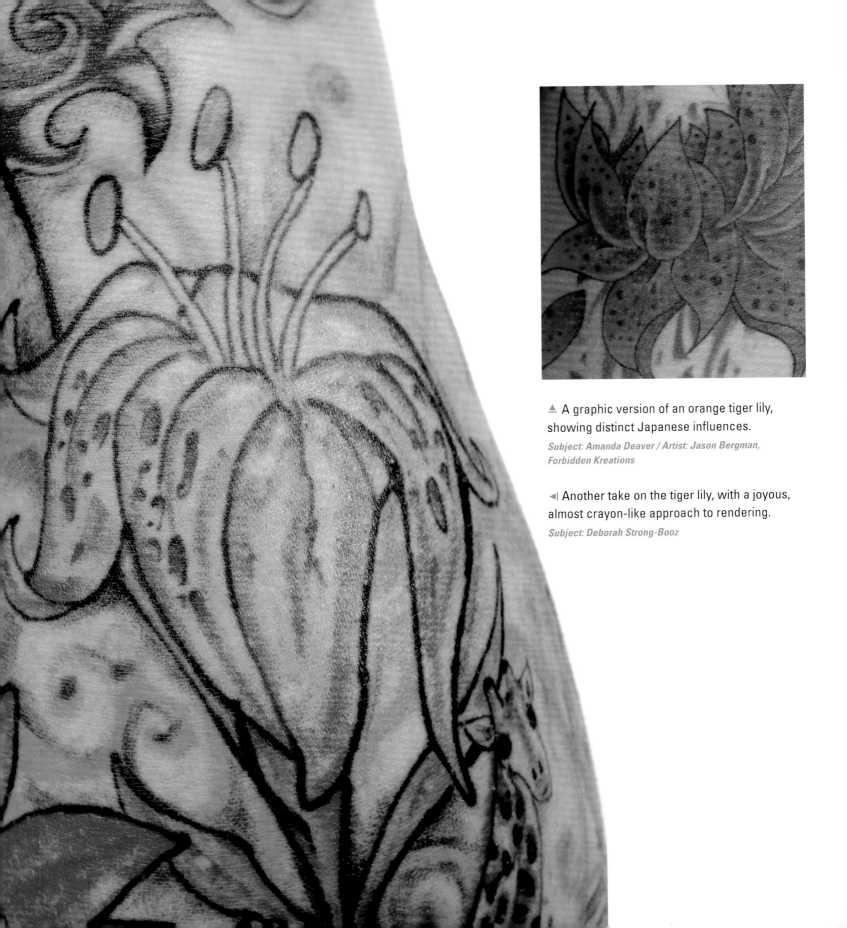

▲ A graphic version of an orange tiger lily, showing distinct Japanese influences.

Subject: Amanda Deaver / Artist: Jason Bergman, Forbidden Kreations

◄ Another take on the tiger lily, with a joyous, almost crayon-like approach to rendering.

Subject: Deborah Strong-Booz

▲ A glowing fire flower in Day-Glo bright colors evokes flames and peacock plumage.

Subject: Rio Rivera / Artist: Jon Jon, Cutting Edge Body Art

▲ Serene Chinese lilies take on a watercolor serenity in verdant greens and blushing pinks.

Subject: Karen Herb / Artist: Christopher Depinto, Shotsie's Tattoo

▮► Masterful control of cool color and subtle shading gives these moody cobalt and azure blue roses an airbrushed lightness.

Subject: Mark Peck / Artist: Eric Willis

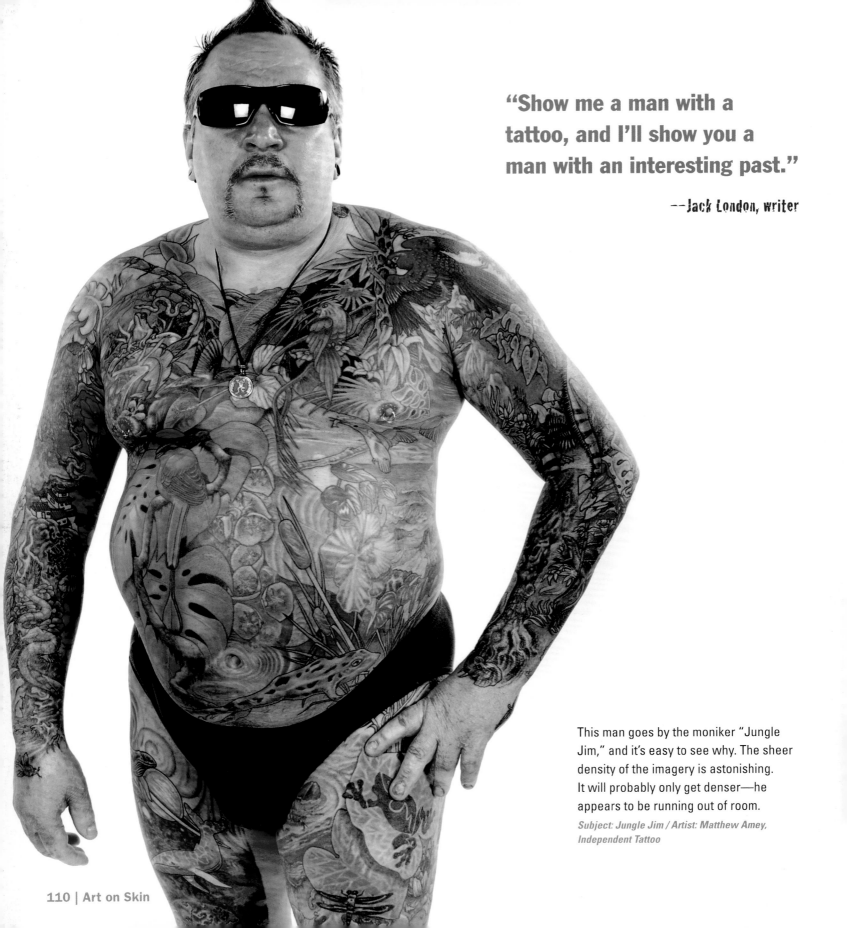

"Show me a man with a tattoo, and I'll show you a man with an interesting past."

--Jack London, writer

This man goes by the moniker "Jungle Jim," and it's easy to see why. The sheer density of the imagery is astonishing. It will probably only get denser—he appears to be running out of room.

Subject: Jungle Jim / Artist: Matthew Amey, Independent Tattoo

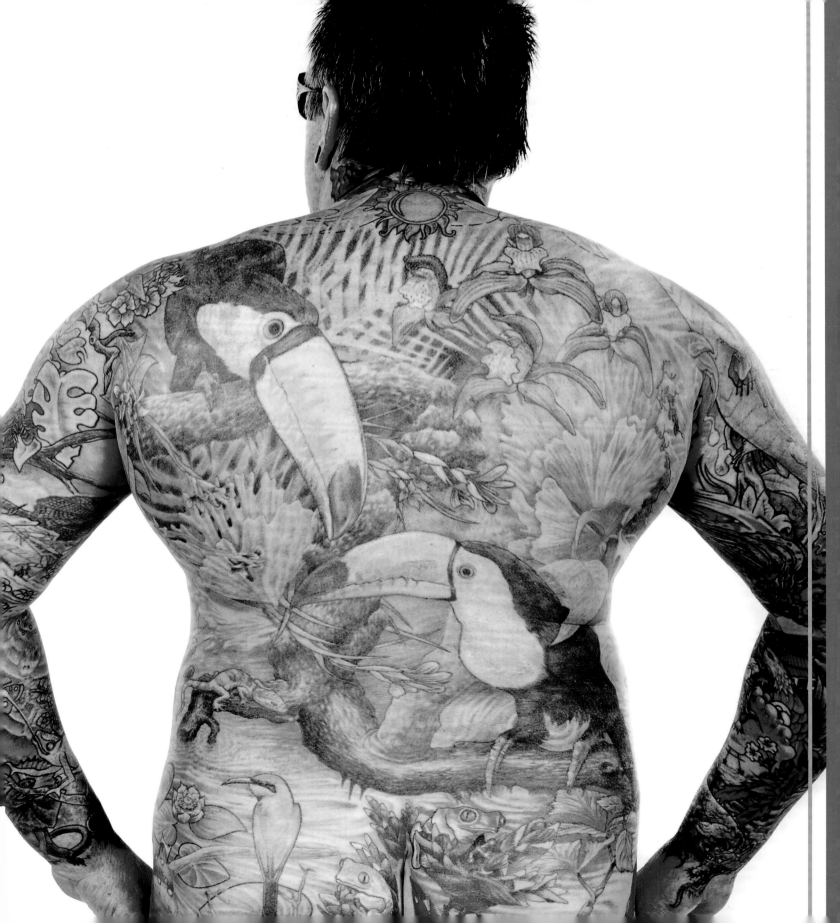

Some more of Jungle Jim's lush tattooing. The expansive world on his skin even includes a well-populated ocean, below, frogs leaping lily pads, right, and a dazzling variety of flora interwoven everywhere.

Subject: Jungle Jim / Artist: Matthew Amey, Independent Tattoo

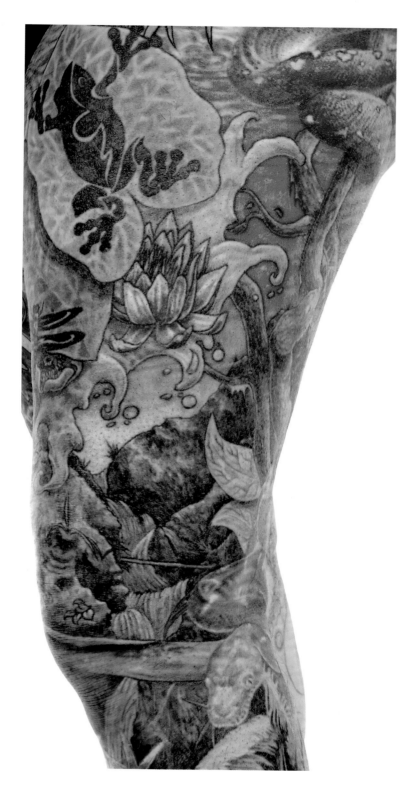

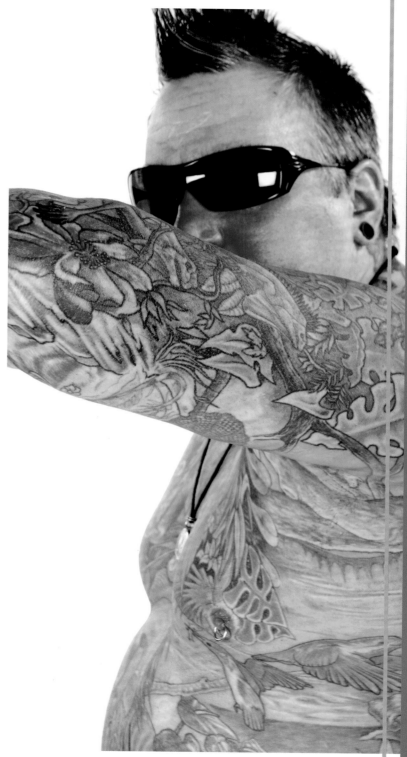

Lions and tigers and parrots, oh my! The handsome, stately, and savage features of a big cat always make for a striking tattoo, whether it's a tiger pictured in repose or a leopard in full snarl. The rich plumage of a parrot also lends itself nicely to body art.

Subject: Curly / Artists: Paul Acker and Mike Hull, Deep Six Laboratory Tattoo Shop

▷ Old-school flash suits this owlish intellectual.
Subject: Hannah G. Lilly / Artist: Rodrigo Melo

▽ Unexpected flashes of heliotrope pink and lazuline blue makes this a bird of distinction.
Subject: Curly / Artists: Paul Acker and Mike Hull,
Deep Six Laboratory Tattoo Shop

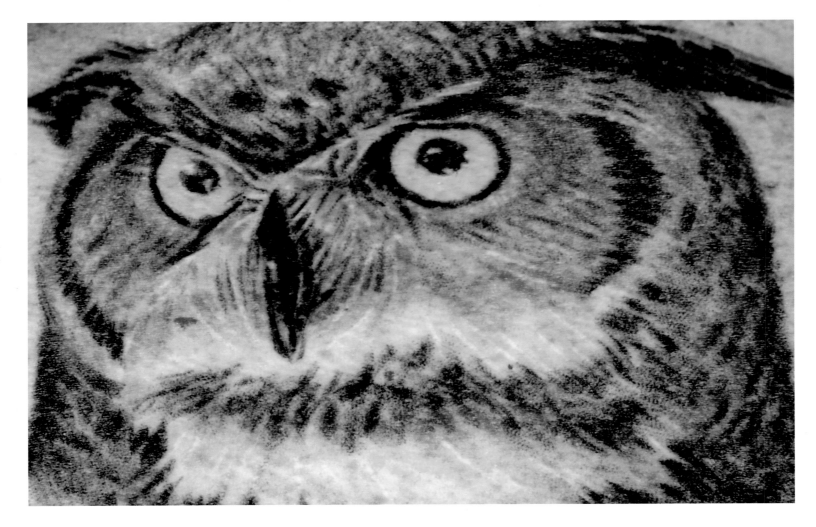

◀ Sky blue and bubblegum pink highlight this charming monocled owl tattoo.

Subject: Jody Warner / Artist: Matt Zimmerman

◀ An Asian-influenced owl in fierce tones of chrome yellow and cherry red on black.

Subject: Joseph Sanbrotti / Artist: Casey

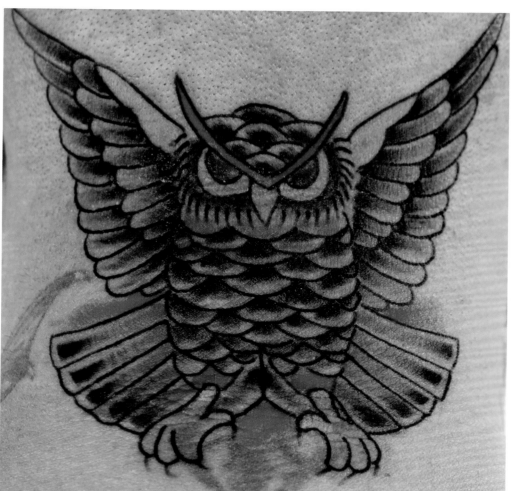

"I love how smart owls are. Rainy days in tattoo shops = owl tattoos."

—Jody Warner

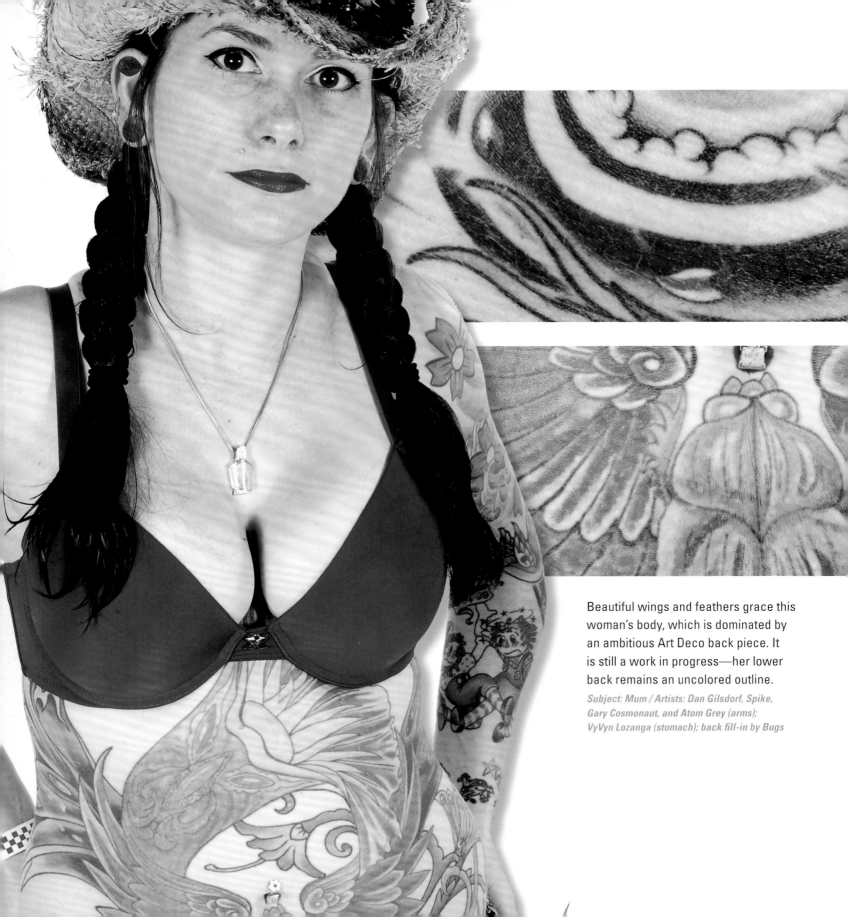

Beautiful wings and feathers grace this woman's body, which is dominated by an ambitious Art Deco back piece. It is still a work in progress—her lower back remains an uncolored outline.

Subject: Mum / Artists: Dan Gilsdorf, Spike, Gary Cosmonaut, and Atom Grey (arms); VyVyn Lozanga (stomach); back fill-in by Bugs

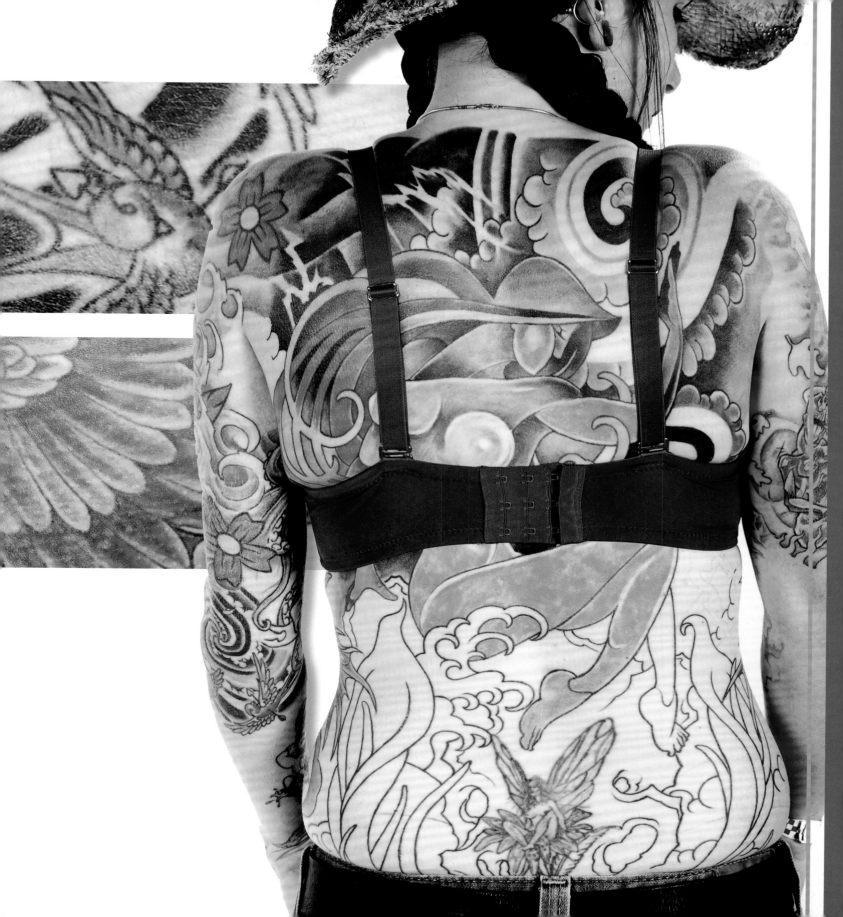

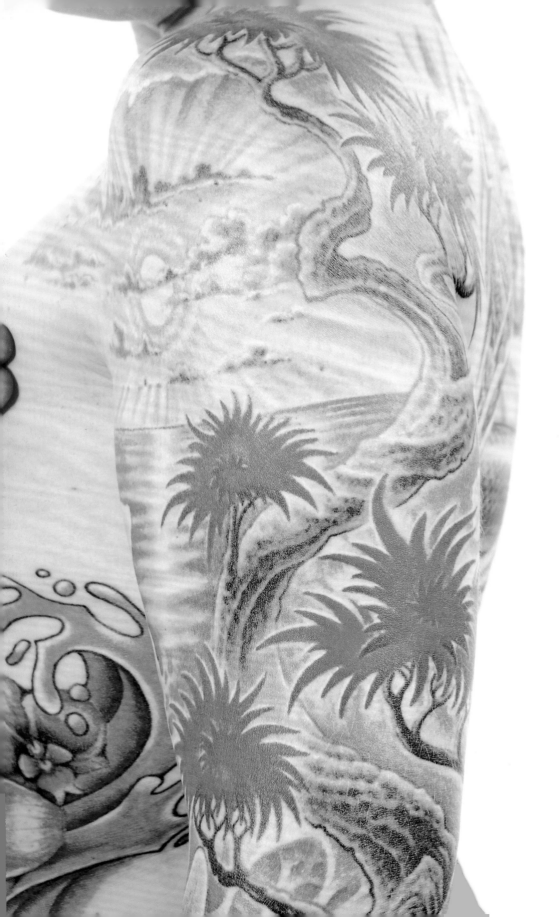

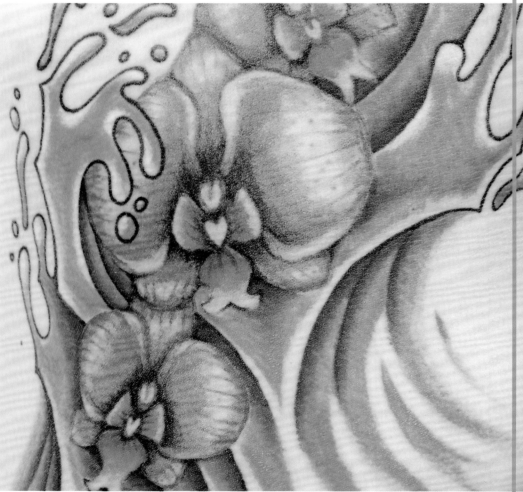

Water, water, everywhere. Just as the ocean can be both calm and turbulent, so can the tattoos that depict it. This subject chose swirling designs of wave-swept orchids and lilies for her body, while sinuous palms frame a purple sunrise over a serene sea.

Subject: Sue Gertner / Artist: Guy Aitchison (arm); Dustin McAndrew, The Ultimate (ribs)

Colorful, boldly rendered scatterings of butterflies, from blue morphos to monarchs decorate this subject's body.

Subject: Angela Bibey / Artist: Ink Bitch

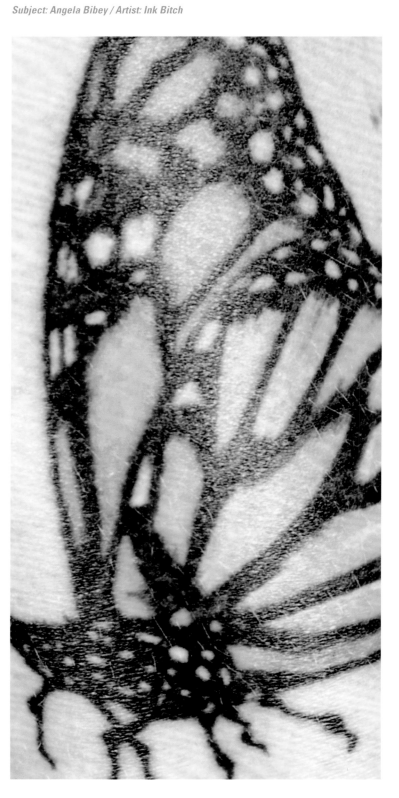

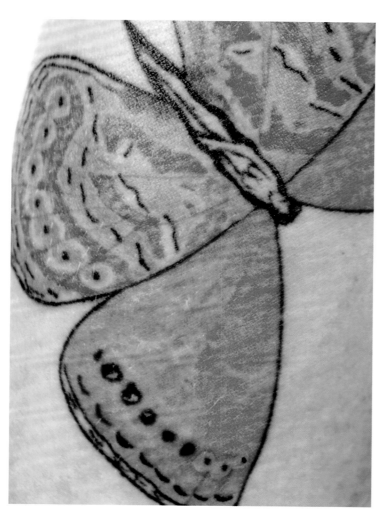

◁ Winsome woman or beautiful butterfly? It takes a careful look to reveal the female form between these orange and turquoise wings.

Subject: Angela Bibey / Artist: Ink Bitch

▽ Butterflies convey beauty and grace amid a rough, ugly world. This is especially exemplified by the elaborate back piece below, in which a butterfly flits freely among a tangled, thorny garden.

Subject: Angela Bibey / Artist: Gil

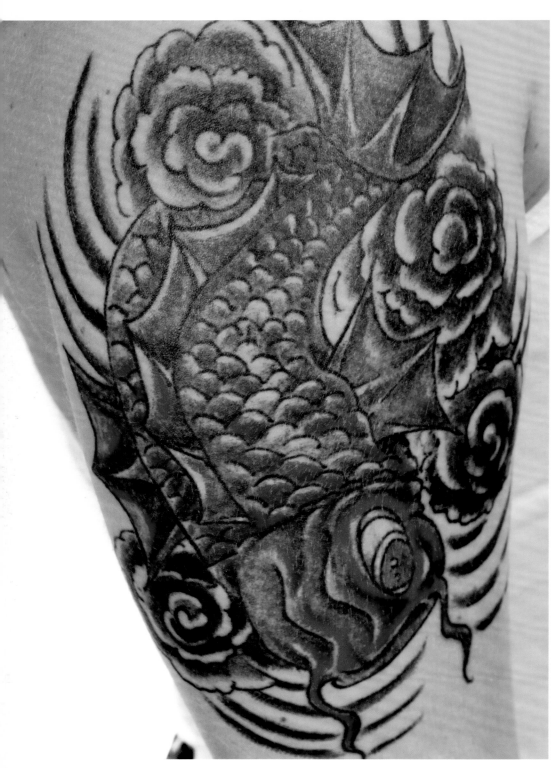

◁ Nature imagery abounds on this woman's body, including fanciful fire engine red fish swimming through inky blossoms.
Subject: Rachel Riley

▽ Scarlet skulls center the blue-tinged orchids that guard the exposed heart across her chest.
Subject: Rachel Riley

▼ The barest hint of pale aqua and breathy tints of smoky amethyst color graphic feathery wings on her shoulder.

Subject: Rachel Riley

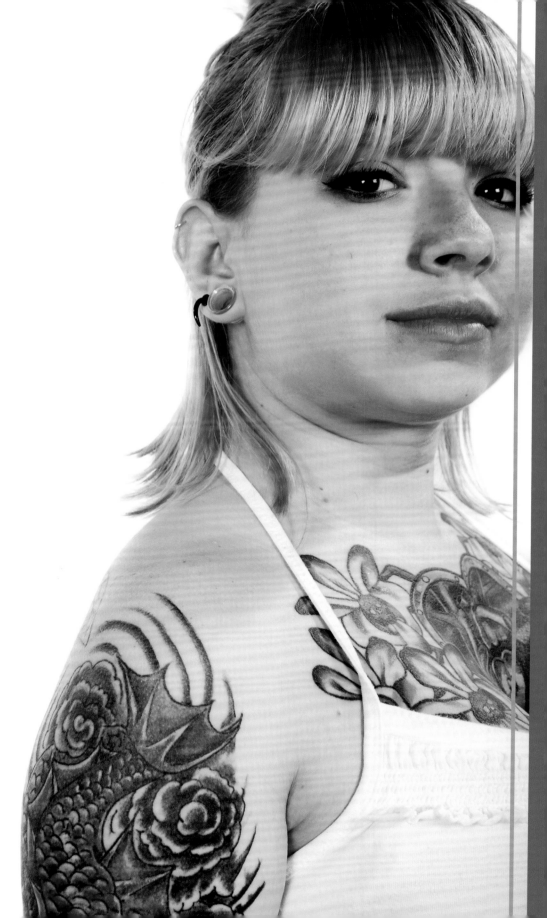

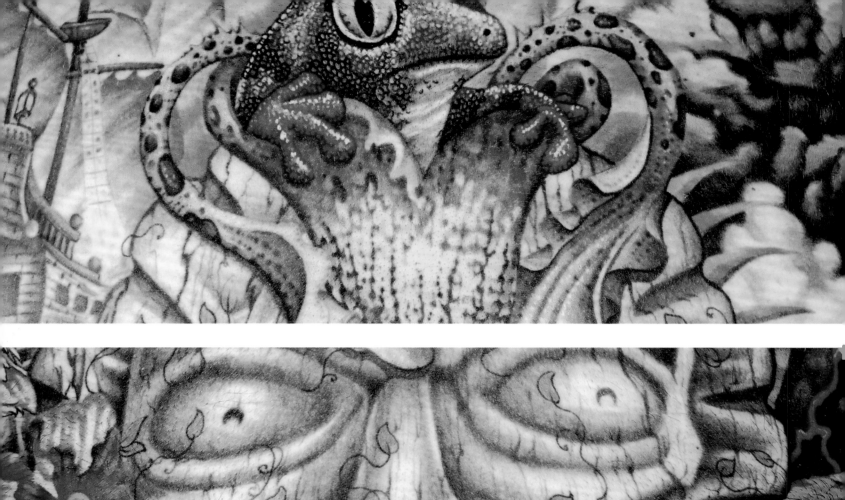

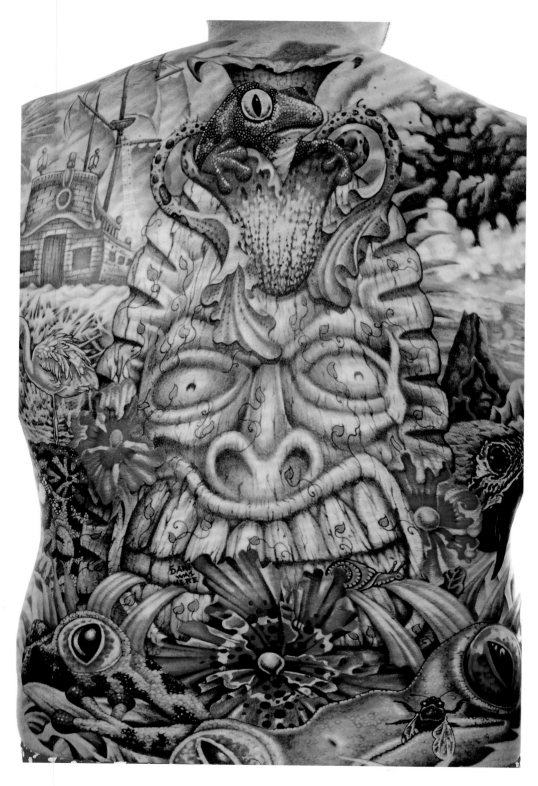

This man states that the "rain forest makes him think of vacation." Examining the imagery on his back is certainly an escape from the mundane.

Subject: Matt Mauro / Artist: Cort Bengtson, Corts Royal Ink

"I saw the duckling at the curiosities exhibit and fell in love."

—Beth Neronski

▼ A quirky but lovable two-headed duckling, finely rendered and shaded in elegant earth tones, is offset with luminous lavenders.

Subject: Beth Neronski / Artist: Kevin Berube, Art for Life

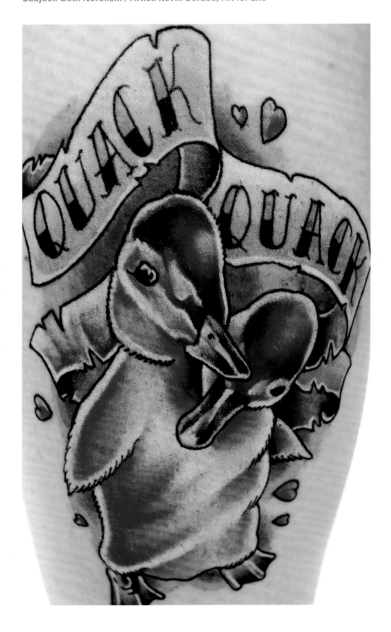

► This mauve-headed bird seems to glow from within, with fine feather gradations of deep carmine red to bright cadmium yellow.

Subject: Vinnie Greer / Artist: Meghan Patrick

▼ Colorful and slightly surreal—a proud rooster, below and left, waves a delicately rendered peacock feather within its already splendid plumage. His comb is edged in nearly neon yellow.

Subject: Rebecca Kolodziejczak

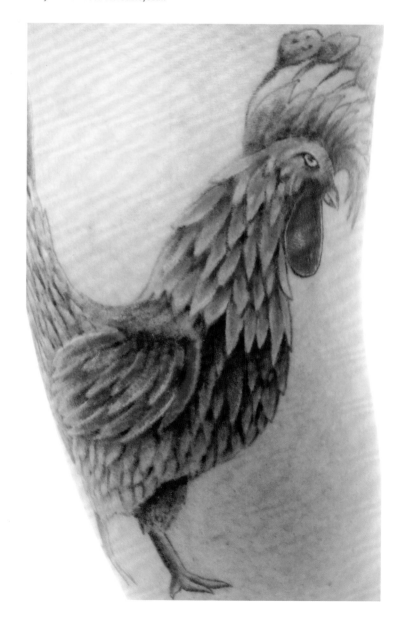

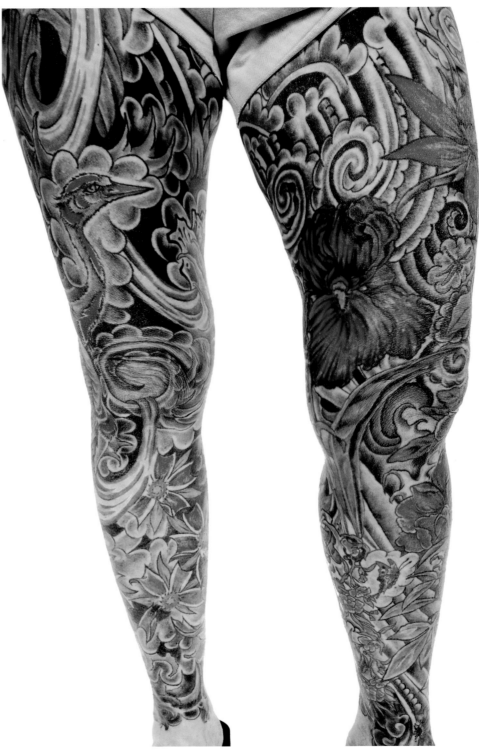

▲ Intricate details flourish amid the swirling nature-inspired collages on this model's legs. The black-and-white areas may eventually be colored in, but as they are, they do offer a nice contrast to the vivid flowers and leaves.

Subject: Cyndi Pape

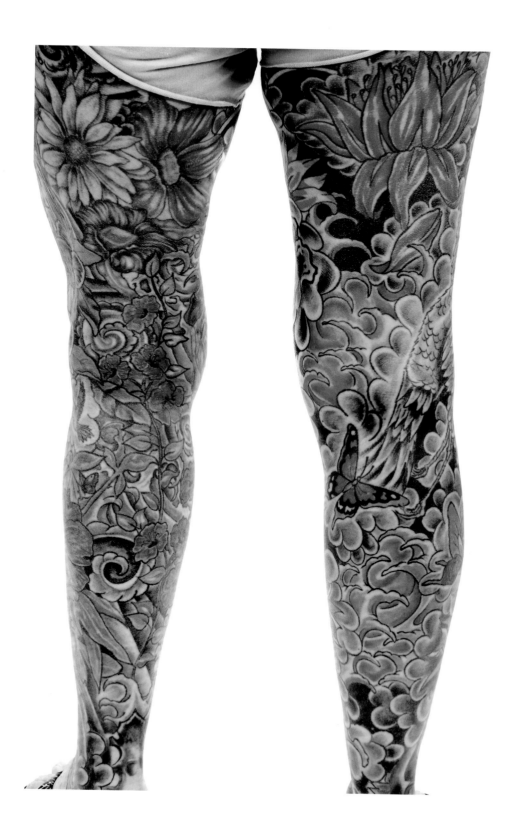

▽ The closer one gets to a piece, the more impressive the draftsmanship appears. On full-body designs, tattooist artists must become masters of collage, blending and harmonizing images with uncommon skill.

Subject: Cyndi Pape

▲ A school of fish conveys the mysteries of underwater life on this woman's body.
Subject: Siobhán A. Counihan

▶ Was the subject feeling "koi" when it came to choosing to this exotic fish tattoo with its vivid colors and Asian influence?
Subject: Rich / Carol Oddy, Medusa Tattoo

"This is an homage to Long Beach Island, New Jersey. I spent every summer of my life there, my grandparents live there; it's the only real home I've ever known."

--Siobhán A. Counihan

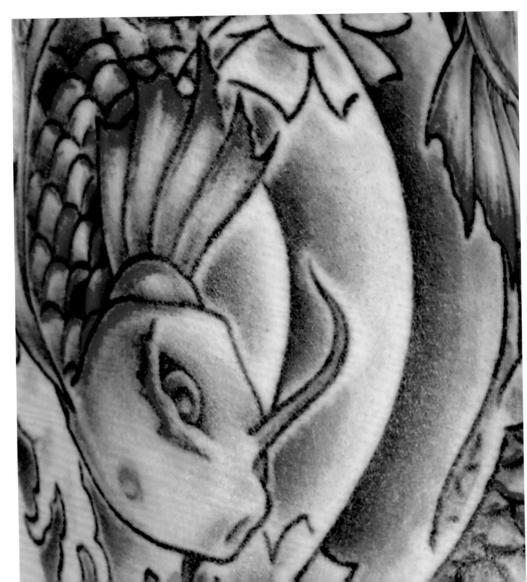

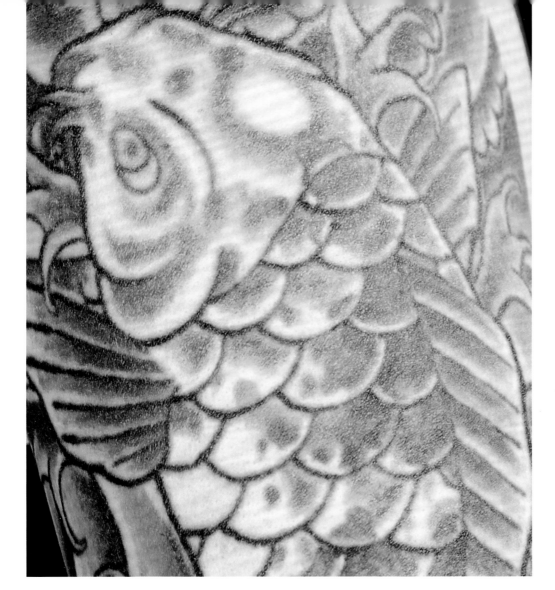

◄ This tattooist has deftly colored this koi fish, highlighting the variegated scales to convey the reflection of light. The natural color of a model's skin is among the hues a tattoo artist can work with.

Subject: Sara Purr

▼ Scales and petals alike receive the same meticulous attention to detail, with well-chosen variations of the same hues to form flowers, fish, and trees in this dense tattoo.

Subject: Cal / Artist: Brian Donovan

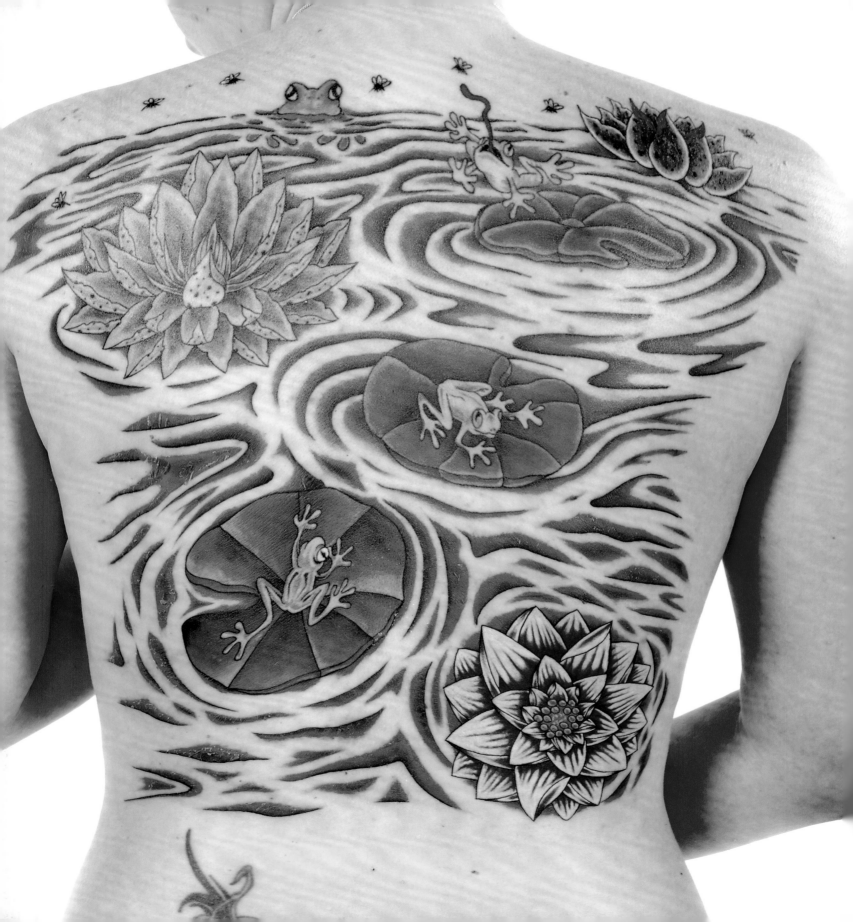

"Up high, the flies are playing, and frolicking, and swaying. The frog thinks: Dance! I know You'll end up here below."

--Wilhelm Busch, painter and poet

A vision of both peace and whimsy: the placid nature of this woman's lower back is belied by the frog leaping and snaring a fly on her upper back.

Subject: Cherry / Artist: Brandon Hamilton, Skin Images

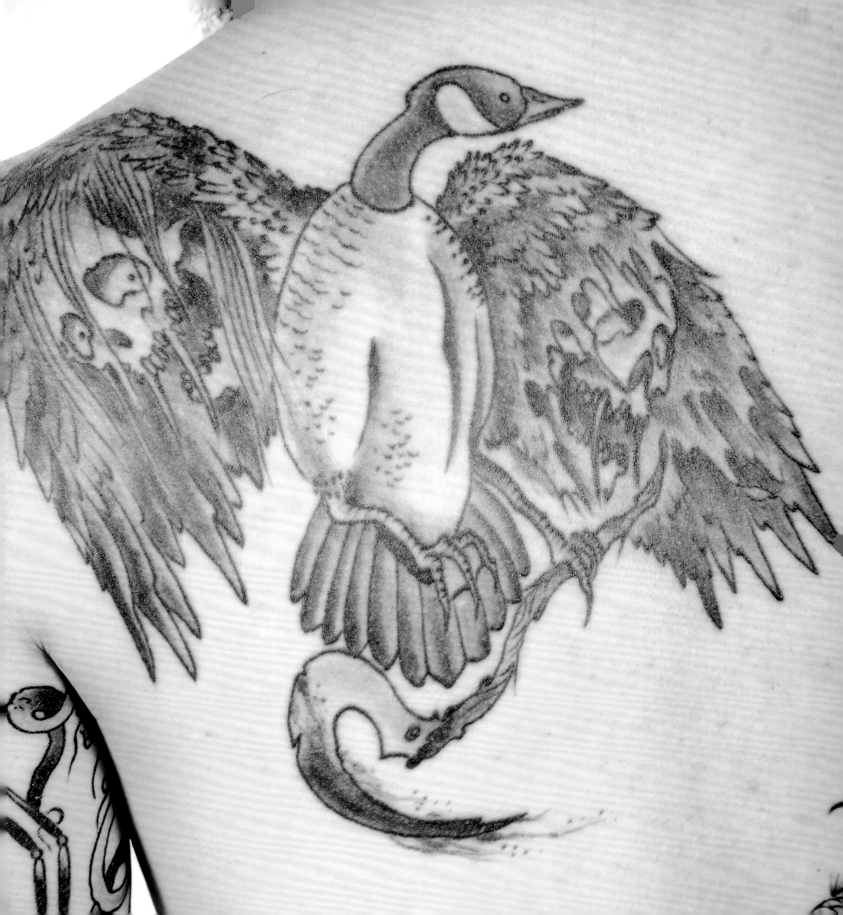

▲ A menagerie of fantastic animals decorates this man's body. A sinuous dragon occupies beastly waters on his right arm.
Subject: Raymond Baranowski

◄ A slinky centipede fronted by a bloodshot eyeball creeps across his skin, far left; while at near left, a ghoulish octopus swims across the underside of his left arm.
Subject: Raymond Baranowski

◄◄ Opposite page, a Canada goose toting a sickle and sporting wings inhabited by skulls takes flight across his upper back.
Subject: Raymond Baranowski

▲ This dragon, balled up amid fire and smoke, shows a nice combination of precision and abstraction.

Subject: Toonbrian

▲▲ A green and gold dragon bares its teeth as it snakes up the subject's upper arm to swoop downward across his chest.

Subject: John Baird / Artist: Joe Lasheski, Squid Ink

▲ With long, intricate, serpentine bodies and bestial but personified faces, dragons make eye-catching tattoos.

Subject: John LaForgia / Artist: Steve Bolt

� Some variant of the dragon inhabits the legends of most every culture around the world. Dragons with long, ribbonlike bodies are descended from Chinese lore.

Subject: Laura / Artist: Deirdre Aikin

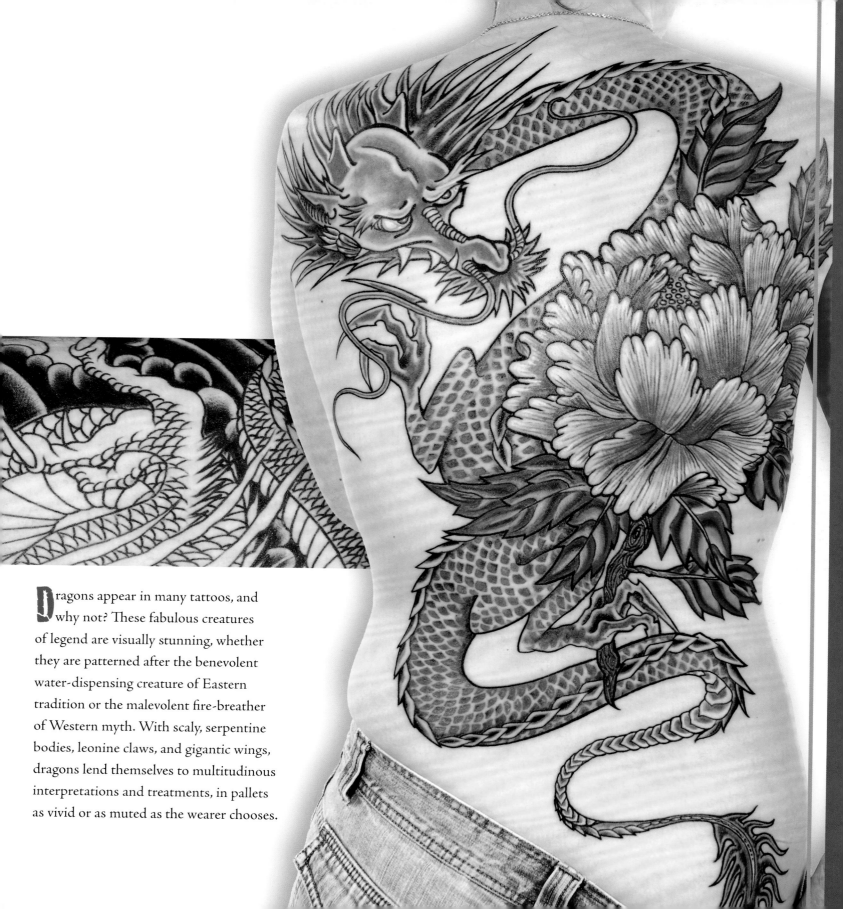

Dragons appear in many tattoos, and why not? These fabulous creatures of legend are visually stunning, whether they are patterned after the benevolent water-dispensing creature of Eastern tradition or the malevolent fire-breather of Western myth. With scaly, serpentine bodies, leonine claws, and gigantic wings, dragons lend themselves to multitudinous interpretations and treatments, in pallets as vivid or as muted as the wearer chooses.

"I love vampires, kitty, and ivy."

—Kelley Treat

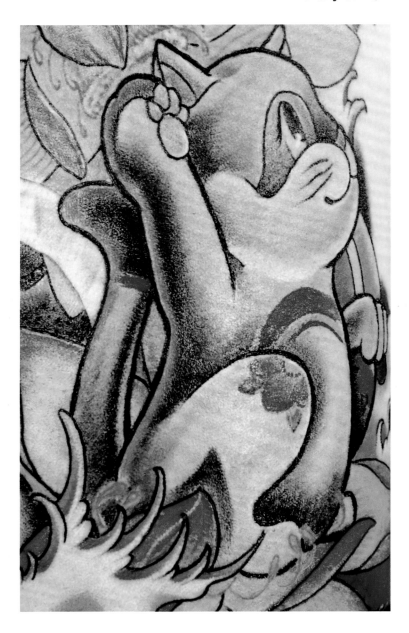

▲ A variation on the *Maneki Neko*—the lucky beckoning cat—is done in lollipop pastels to create a cute but not cloying tattoo.

Subject: Kelley Treat / Artist: "Kitty Love" by Mike Connors

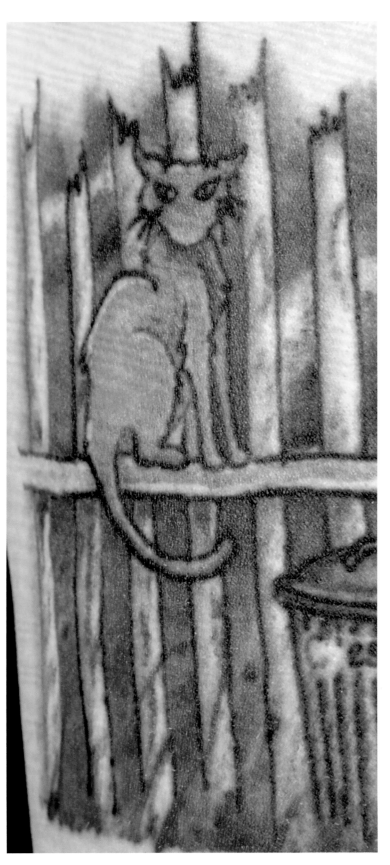

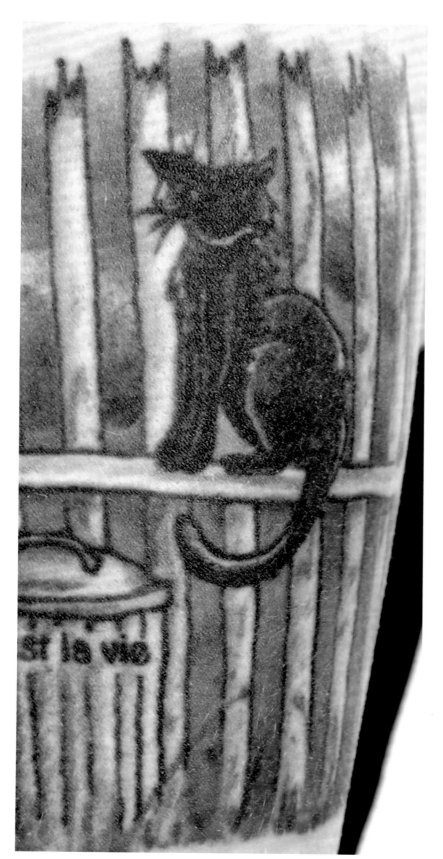

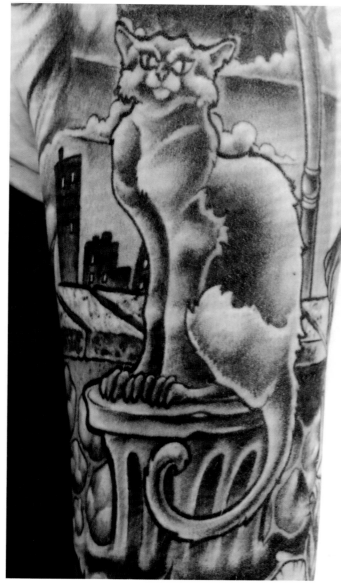

▲ Lean and hungry but still sitting proud and tall—the hard-luck life of the city stray is done in film-noir black and white.
Subject: Cat Golden / Artist: David Blake

◀ "Such is life." A technicolor take on the same theme. Stray cats, a midnight black and an orange ginger, stake out fence-side seating to their favorite garbage can.
Subject: Rebecca Kolodziejczak

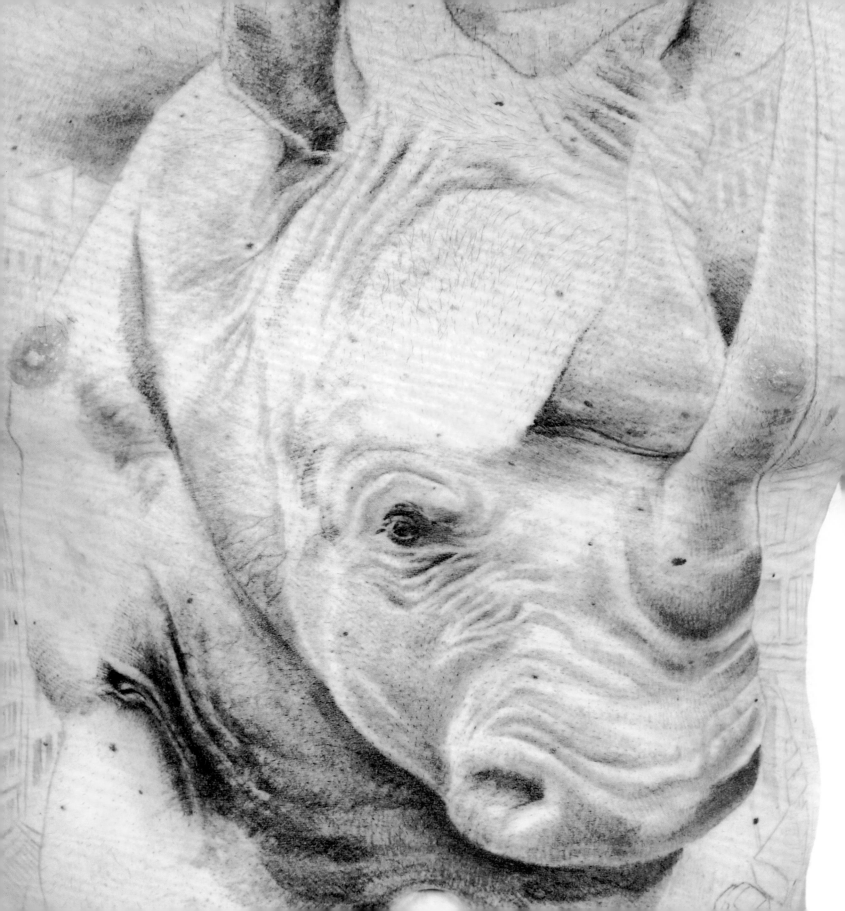

> **"New life with the lotus . . . the doves are my parents watching over me."**
>
> **--Willis**

▲ Graceful lines form these doves nestled in lotus petals.

Subject: Willis / Artist: Tony, Lady Luck Tattoo Gallery

◀ Commanding in its elegant simplicity, this monochrome rhinoceros, with its impressive tusk, takes up the entirety of this subject's torso.

Subject: Brian Doebler / Artist: St. Marq, New Breed Tattoo

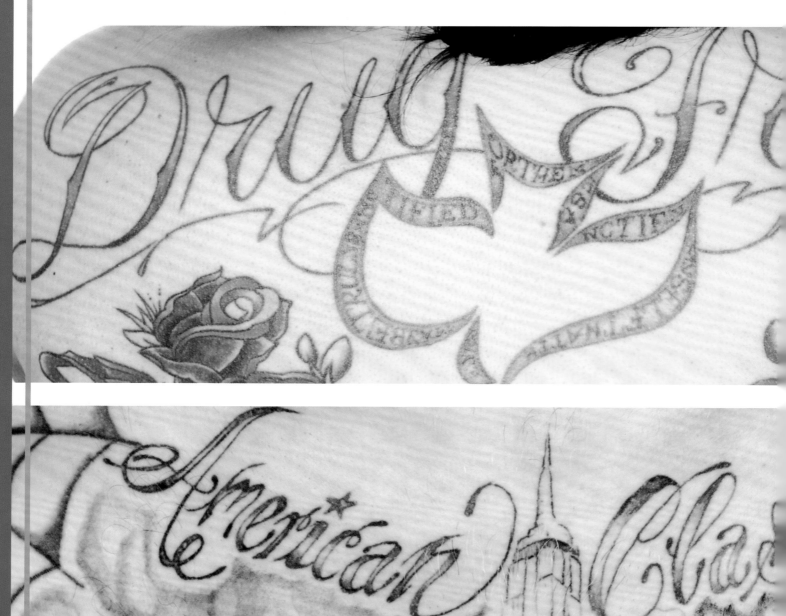
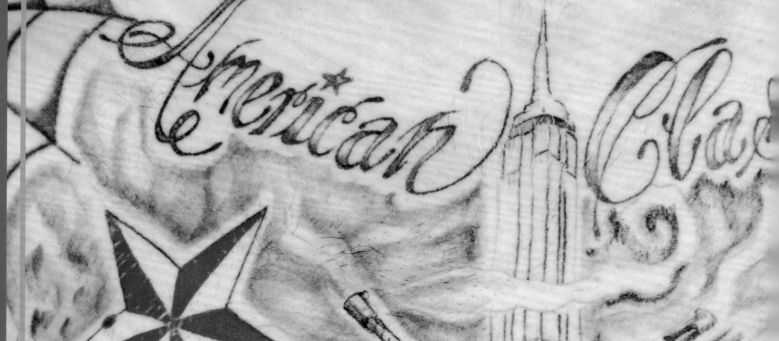

◄ Self-expression is an important facet of tattoo culture and can be conveyed with phrases as well as graphics. "Drug Free" likely indicates a personal epiphany.
Subject: Miss Mac the Knife / Artist: Jon Morse

▼ "American Classic" could either refer to nostalgia for the past or to a strong identification with the U.S.A.
Subject: Spider

It goes beyond to be or not to be. To be, you must answer the question, who am I, really? And here, the answers come in manifestos of embedded ink. In ancient Polynesian cultures the tattooist introduced his tattooees to their true selves—with needles and dye, he found the people they were meant to be and adjusted their bodies accordingly. The patterns that defined them were not theirs to choose. Today in the West, we believe in choosing our own identities—here then, are bodies wearing their identities literally on their sleeves. These tattoos are commitments to personal principles—forms of fidelity to certain experiences or beliefs. They are inked as words or scenes; they are both symbols of the past and the future. They answer questions of self in indelible ink that will last a lifetime.

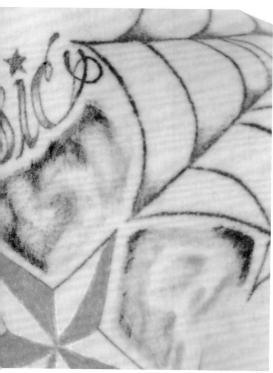

MY IDENTITY

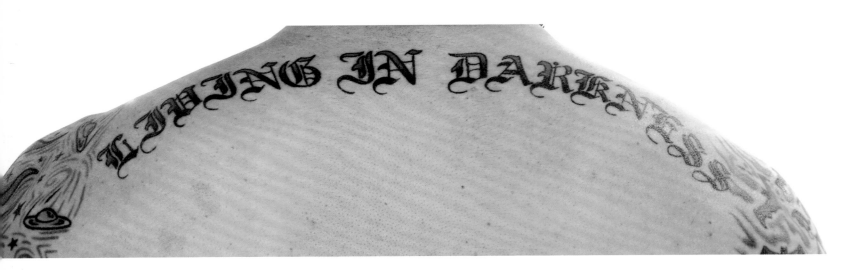

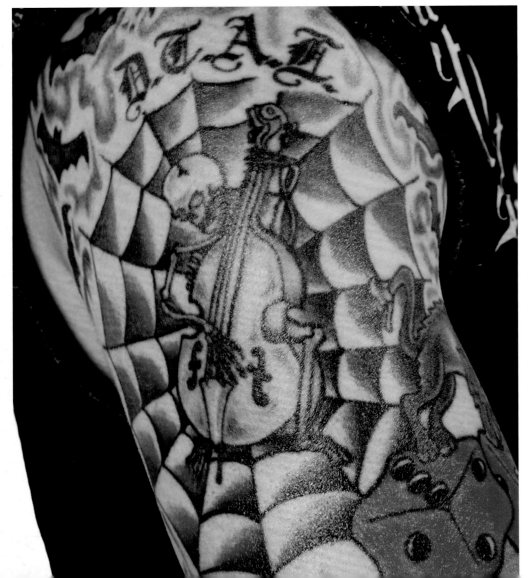

▲ Dark sentiments expressed with words and images have always attracted rebels and renegades. "Living in Darkness," spelled out in gothic letters across this man's shoulders, offers a very specific worldview.

Subject: Vic Victor

◄ A skeleton playing an upright bass on the subject's arm is both macabre and whimsical, while a black cat straddling red dice could symbolize bad luck at the gambling table.

Subject: Vic Victor

▶ This striking chest tattoo features a bat-winged skull wearing a crown. The Latin phrase below it, *mors ex supera*, appropriately means "death from above."

Subject: Vic Victor

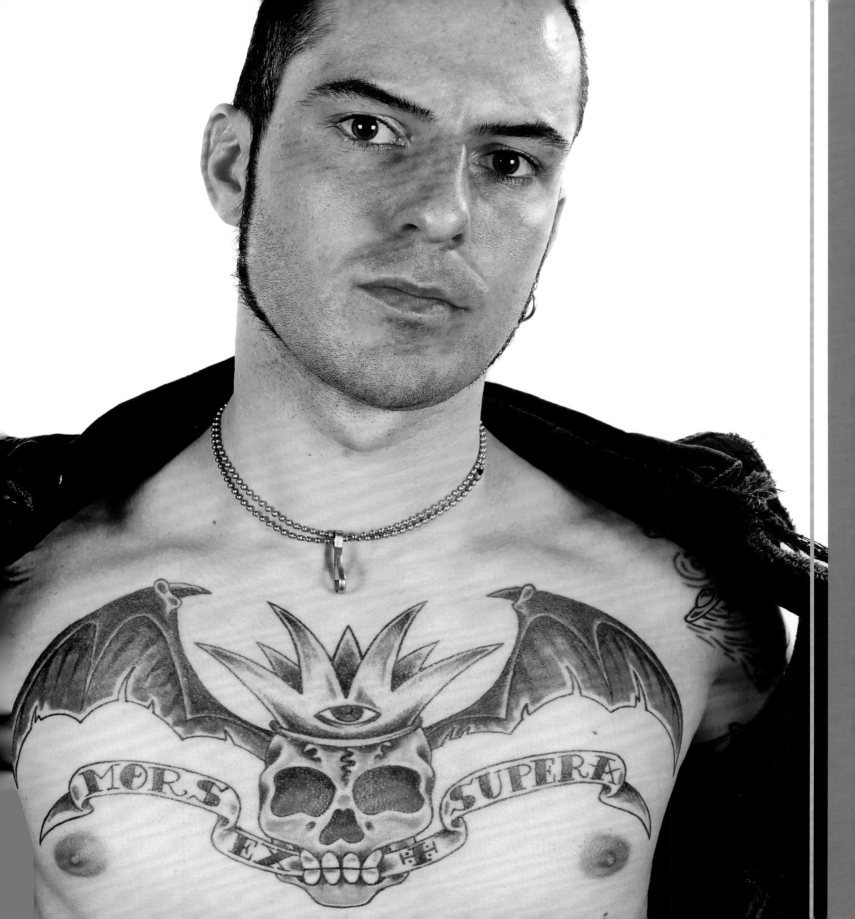

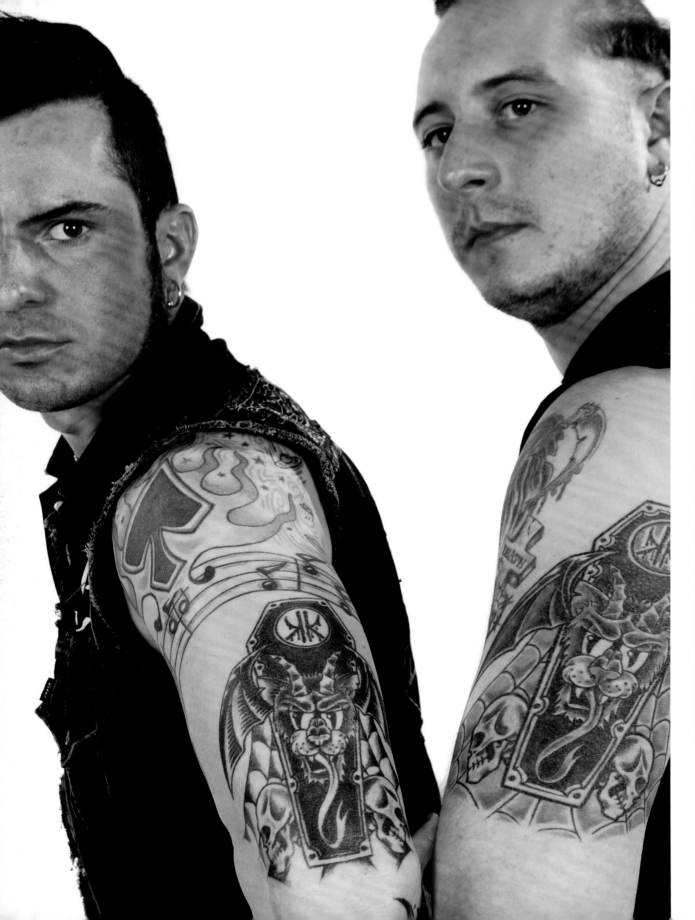

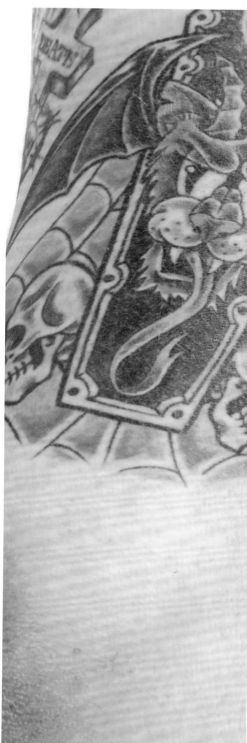

Two variations on a theme: these men show off the same Koffin Kats logo tattoo, a horned beast inside a coffin, but demonstrate how color choice can affect the outcome. The all-black version is punk-Goth intense, while the brightly colored and beautifully inked version replaces some of its wicked punch with a jolt of psychobilly humor.

Subjects: Vic Victor and Tommy Koffin / Artist: Sam Wolf

The semi-fierce goddess Vajra-yogini—or female Buddha—shown in these tattoos represents the feminine manifestation of Divine Wisdom. Hindus in Nepal also revere her under the name Chinnamasta. There are many other powerful female images women choose as tattoos: the Egyptian goddess Isis or Queen Cleopatra; the Greek love goddess, Aphrodite, or their goddess of wisdom, Athena. From Hindu mythology comes the ferocious goddess Kali and the mother goddess Shakti. There are lethal lady pirates and female figures from the Tarot: the High Priestess, the Empress, or Justice holding the scales. Even Lady Liberty appears. From dark fantasy comics there is Vampirella, Red Sonja, and Lady Death. These images all represent female empowerment and the strength of the feminine in male-dominated cultures.

The female Buddha Vajra-yogini appears here in all her glory. This subject chose to decorate herself with Vajra-yogini because of the goddess's "strong female energy—plus it's badass."
Subject: Lela Simon / Artist: JJ Simon

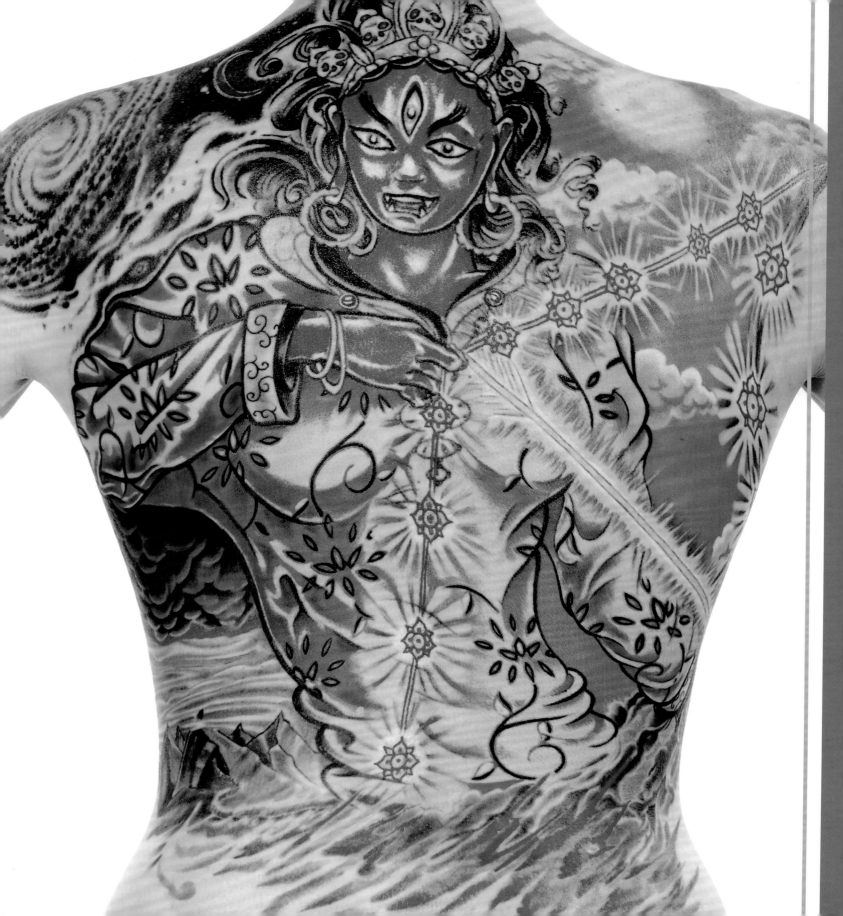

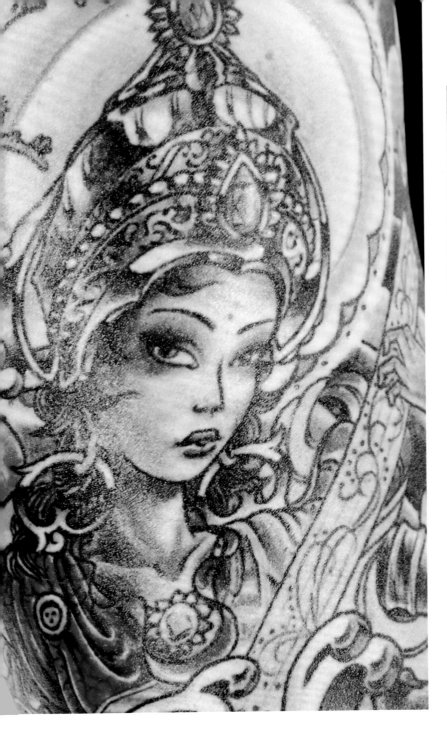

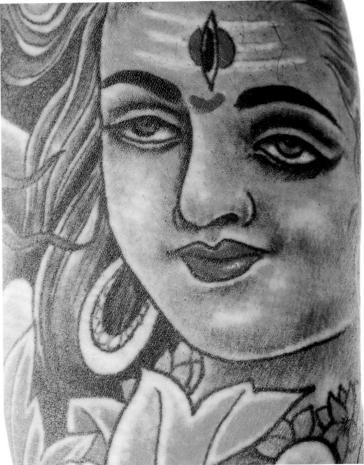

▲ Even traditional images of Hindu deities depicts them as fantastical creatures of brilliant color. Here Shiva, the destroyer or transformer, appears in his blue-skinned incarnation.
Subject: Mayimbe181

◄ Saraswati, the Hindu goddess of knowledge, music, and the arts is rendered here in a sultry comic-book style.
Subject: Hannah G. Lilly / Artist: C-Jay, Rising Dragon Tattoos

"She is the goddess of arts and intellect, and I'm an artistic smartass."

--Hannah G. Lilly

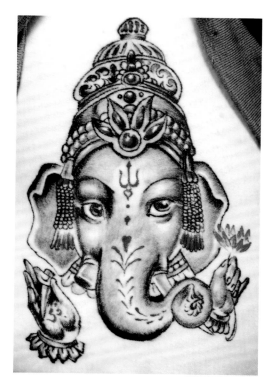

▲ One of the easiest to recognize of the Hindu gods—the elephant-headed Ganesha, who is often called the "lord of beginnings" or a remover of obstacles. This version uses a basic gray-black palette subtly enhanced with touches of magenta and yellow.

Subject: Melissa / Artist: Ruler, Silk City Tattoo

▮► "Overcoming incredible odds" inspired this subject's vibrantly colored take on Ganesha. With skin a sea-tinted blue and a bejeweled headdress of gold, the god sits on splendid royal plum–colored drapery.

Subject: Miss Amanda / Artist: Colby Long

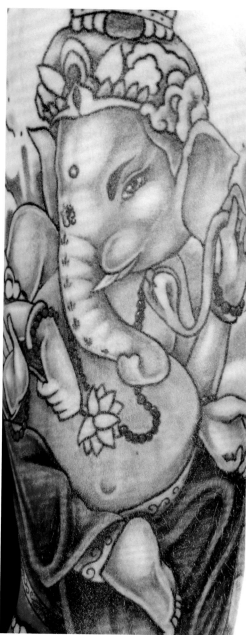

▲ A very flash interpretation of the hindu goddess Kali shows this consort of Lord Shiva in her blue-hued, many-armed form. Her azure skin is offset with gold adornments and purple and red finery. Despite her associations with death and destruction, recent movements have reimagined Kali as a benevolent goddess of change.

Subject: S.C. Gypsy Queen Aurora / Artist: Margo

▲ Color-saturation tattoos are not for the faint of heart. This charming Hello Kitty Geisha in pink is a virtual arm painting, complete with fully inked-in background.
Subject: Krista Ruttman / Artist: Frankie G.

◄ Another example of intense inking, this tropical floral tattoo showcases a rich, color-splashed airbrushed effect.
Subject: Krista Ruttman / Artist: Frankie G.

▶ With billowing sails, a square-rigged ship skims a frothy sea along the subject's arm, above. Below, Day of the Dead—style male and female skulls adorn the subject's feet.
Subject: Krista Ruttman / Artist: Frankie G.

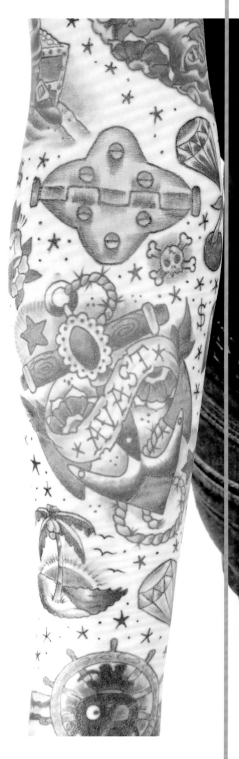

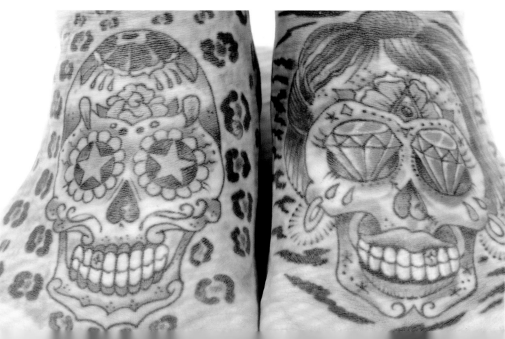

▲ Like nonstop eye candy, this collection of small tattoos covers the inner arm.

Subject: Krista Ruttman / Artist: Frankie G.

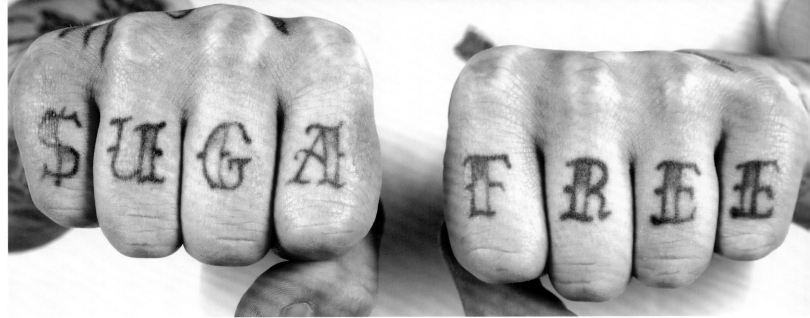

▲ Knuckles are popular for in-your-face message tattoos: why wear a medic alert bracelet when you can wear a warning on your skin?
Subject: Frankie G. / Artist: Marcus Koch

▧▶ Two very traditional tattoos are shown here—the ubiquitous "Mom," with hearts and flowers, and a "Dad" banner with an anchor.
Subject: Frankie G.

▧▶ Mexico's Day of the Dead is commemorated in bright colors with this iconic tattoo of the Virgin Mary with a skull head.
Subject: Frankie G. / Artist: Mark Cornwall

▧▶ Both halves of this couple are fans of heavy-coverage inking. Her lady pirate stands before a red Jolly Roger and straddles a treasure chest. His neck tattoo confesses that he's a "Hopeless Romantic."
Subjects: Krista Ruttman and Frankie G. / Artist: Frankie G. (her); Civ (him)

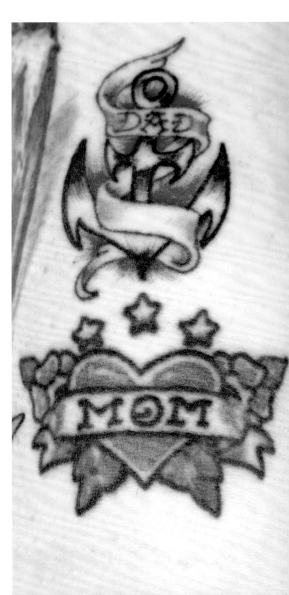

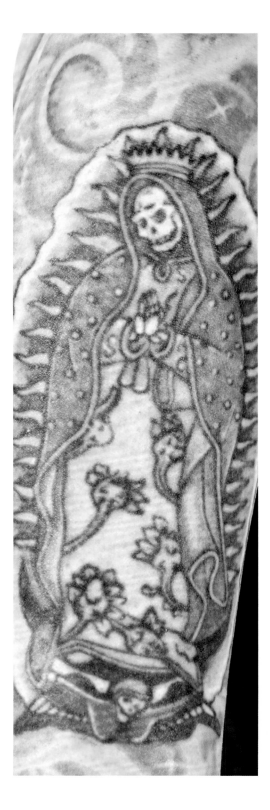

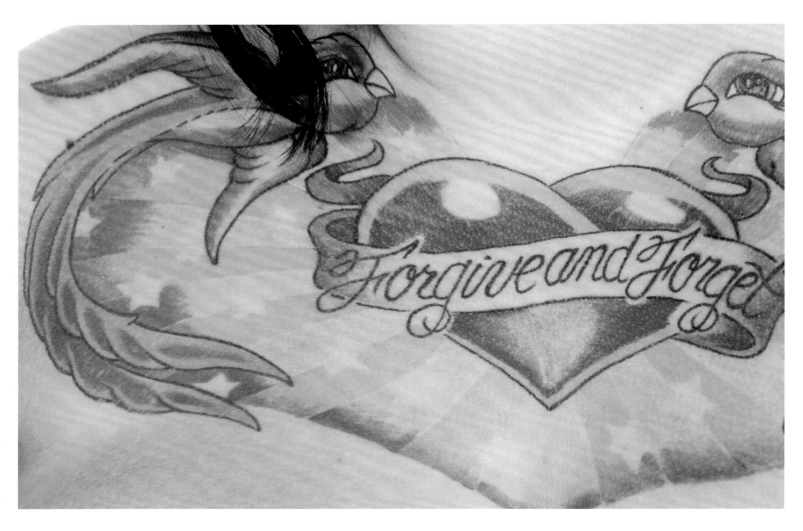

"Love lasts forever, but a tattoo lasts six months longer."

—Anonymous

▲ Her divorce inspired this woman's rainbow-hued "Forgive and Forget" heart-within-a-heart chest tattoo.

Subject: Megan Velazquez / Artist: Pork Chop, Chop Shop Tattoos

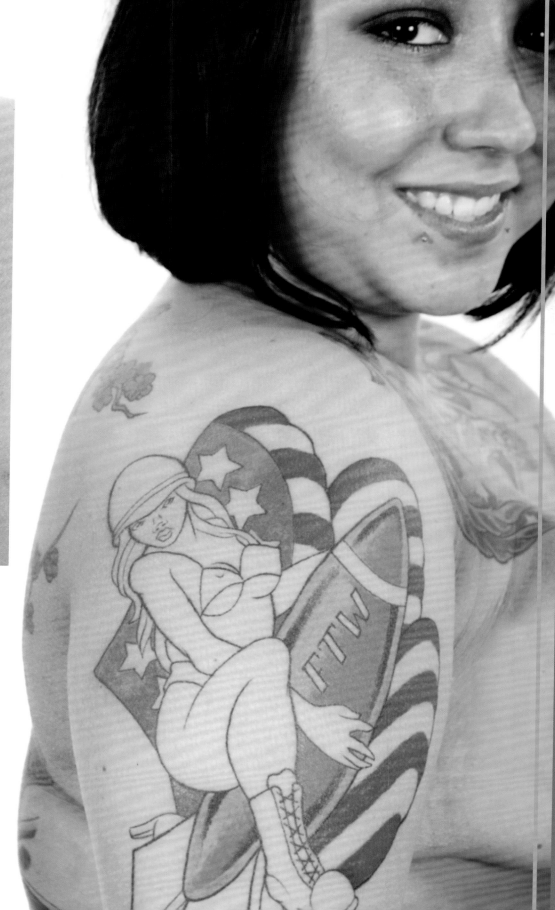

► Like a tattoo riff on *Dr. Strangelove*, a sexy female soldier rides a bomb while the Stars and Stripes billow in the background.

Subject: Megan Velazquez / Artist: Pork Chop, Chop Shop Tattoos

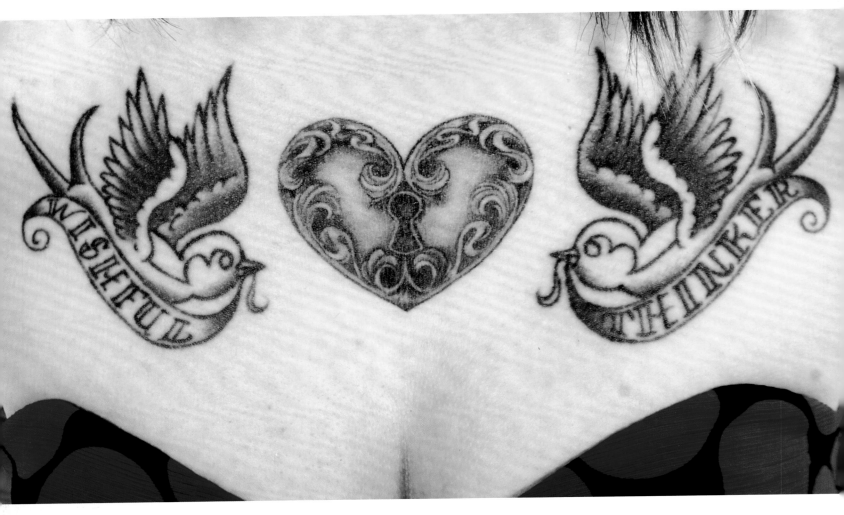

"Jem is my favorite cartoon and my role model. When I was little, I wanted to be her when I grew up."

—Mikey A

▲ All-black tattoos can be surprisingly feminine—if they are approached delicately. This "Wishful Thinker" chest tattoo of birds surrounding a heart-shaped lock has a definite Victorian feel.

Subject: Mikey A / Artist: Meghan Patrick

▷ Above right, another graceful monochrome tattoo, skeleton keys strung on a winding ribbon. The subject explains its meaning: "The keys to my heart can be unlocked. The keys on my hips read: 'Friends, family, music.'" Many tattoos contain ironic symbolism, such as this hand grenade shown below right, which comes wrapped in a pink bow and with a heart-shaped pull ring.

Subject: Mikey A / Artist: Meghan Patrick

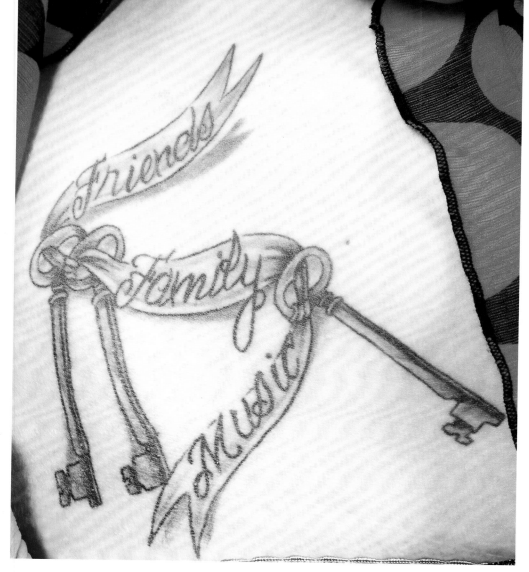

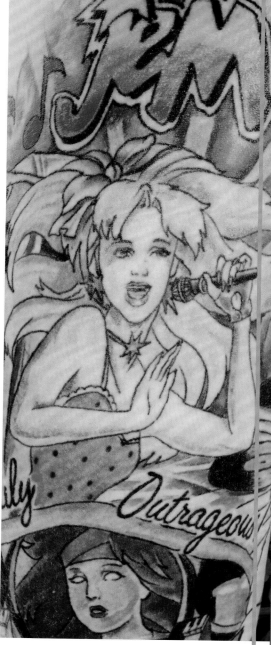

▲ This attention-grabbing comic book–style scene features animated pop stars Jem and the Holograms and other symbols of stardom.

Subject: Mikey A / Artist: Alex Feliciano

▲ Identity tattoos don't need to be somber or scary—many are playful even as they relate to the serious sides of life. Here, a husband and wife show off matching bikini babes—a redhead and a brunette—across their backs. Her pistol ridin' mamas bookend a coiled snake, while his two ladies wave the flags of Texas and Mexico, representing his son's heritage.

Subjects: Pearl and Shane Donovan / Artist: Jason "Bug Juice" Nightingale, Tiki Tattoo

◄ This couple sport Chinese-style dragons on their upper arms. Her dragon, in shades of teal, gold, and red, wraps around a knife-wielding female pearl diver—a symbol of her successful struggle against depression. His pair of scarlet serpents twining around each other are again for his son, who was born in the year of the dragon.

Subjects: Pearl and Shane Donovan/ Artist: Annette LaRue (her); Cameron Sweet (him)

"The pearl diver symbolized the struggle with depression and overcoming it."

--Pearl Donovan

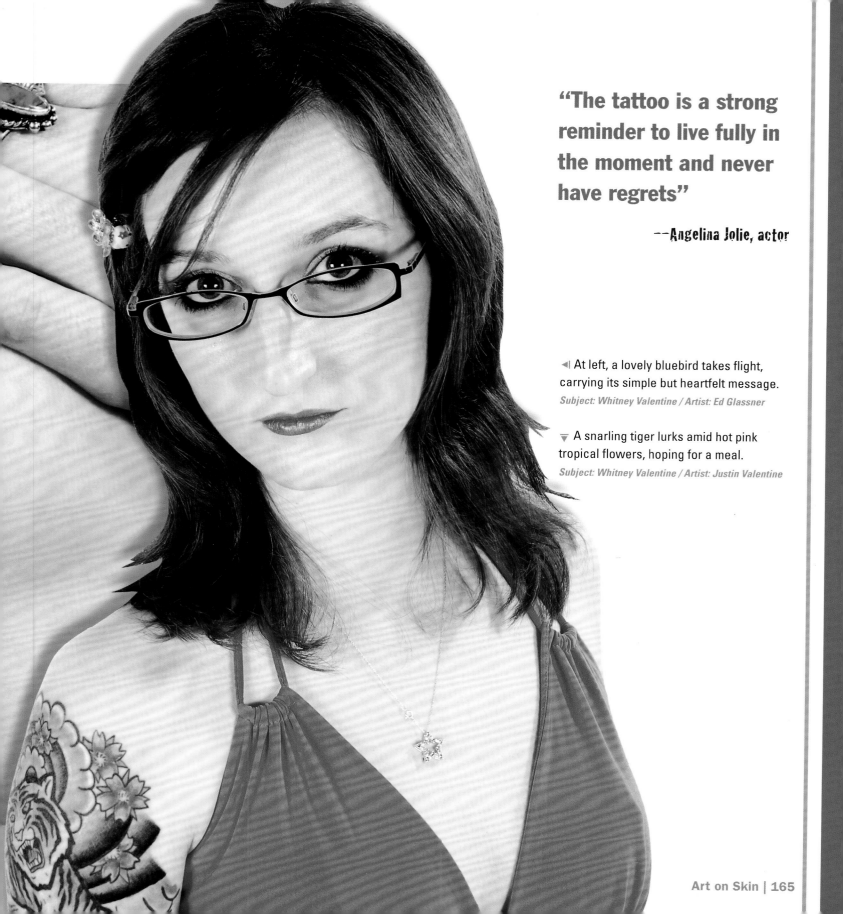

"The tattoo is a strong reminder to live fully in the moment and never have regrets"

--Angelina Jolie, actor

◄ At left, a lovely bluebird takes flight, carrying its simple but heartfelt message.
Subject: Whitney Valentine / Artist: Ed Glassner

▼ A snarling tiger lurks amid hot pink tropical flowers, hoping for a meal.
Subject: Whitney Valentine / Artist: Justin Valentine

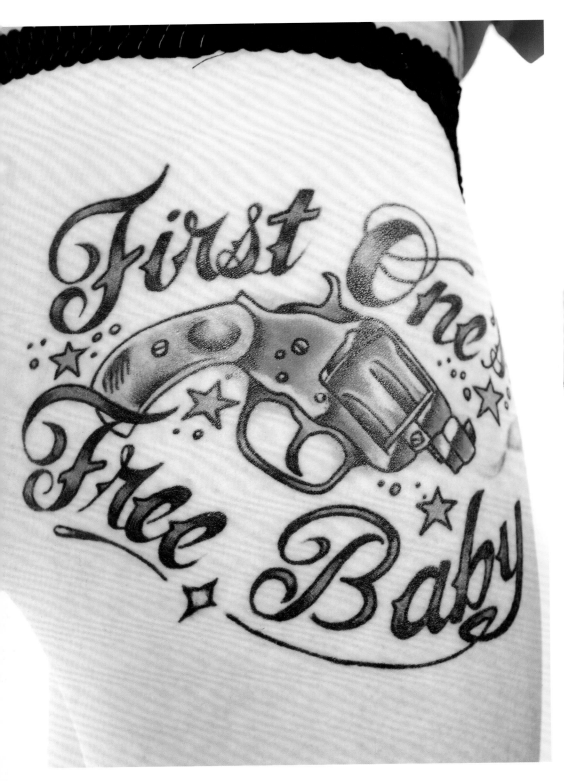

▲ This naughty girl is putting her best feet forward and tellin' it like it is.

Subject: Whitney Valentine /
Artist: Justin Valentine

◄ Her thigh-high message, embellished with a cerulean snub-nosed pistol, leaves little to the imagination.

Subject: Whitney Valentine / Artist: Ed Glassner

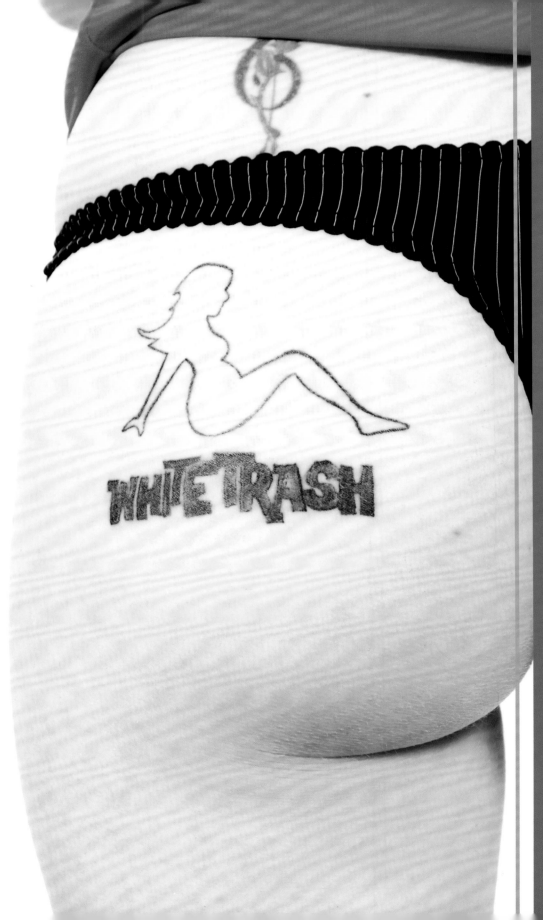

▶ A female silhouette from a popular trucker's mud flap is paired with a "tongue in cheek" affirmation.

Subject: Whitney Valentine / Artist: Jimmy Aguliar

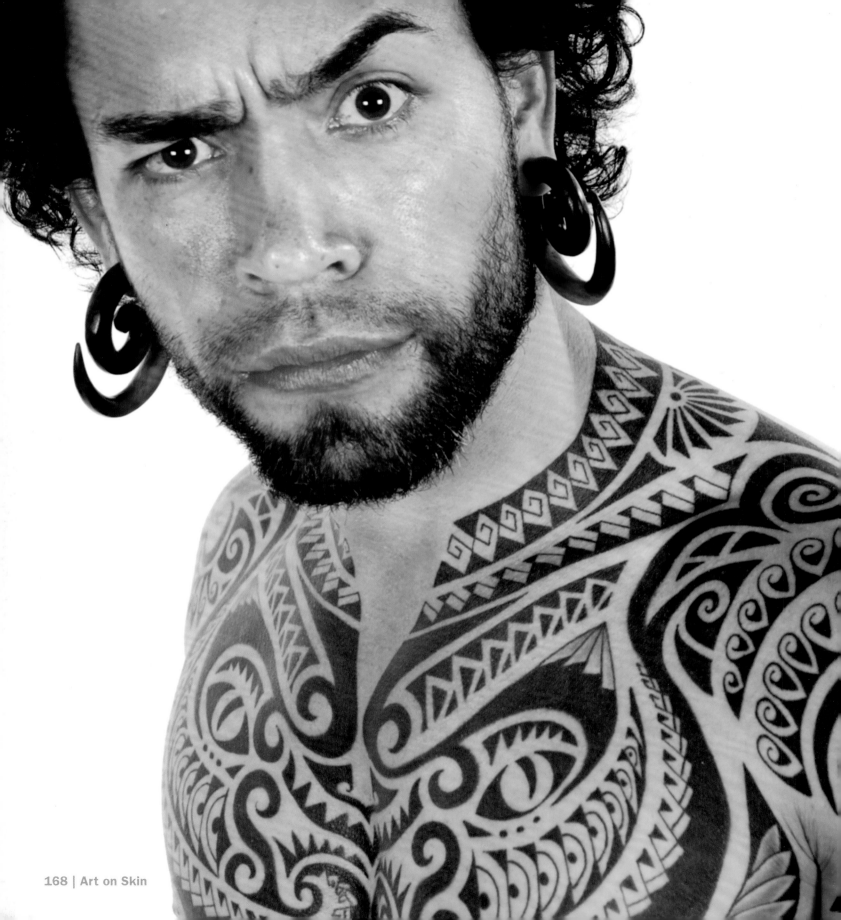

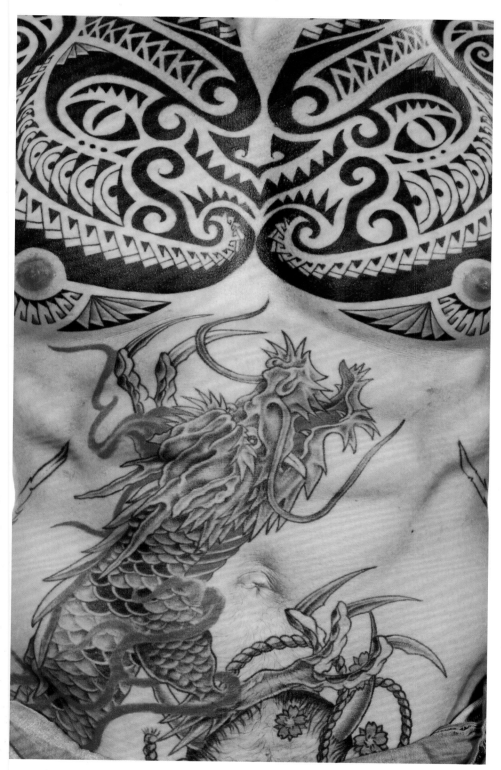

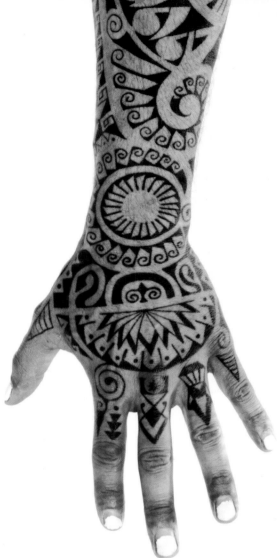

Across the shoulders and even down to the hand and fingers, classic tribal designs, stark in coal black, are joined on the torso by a sinuous Asian dragon with highlights of blood-red ink.

Subject: Seven / Artist: Mony (tribal); Natalie Jean (dragon)

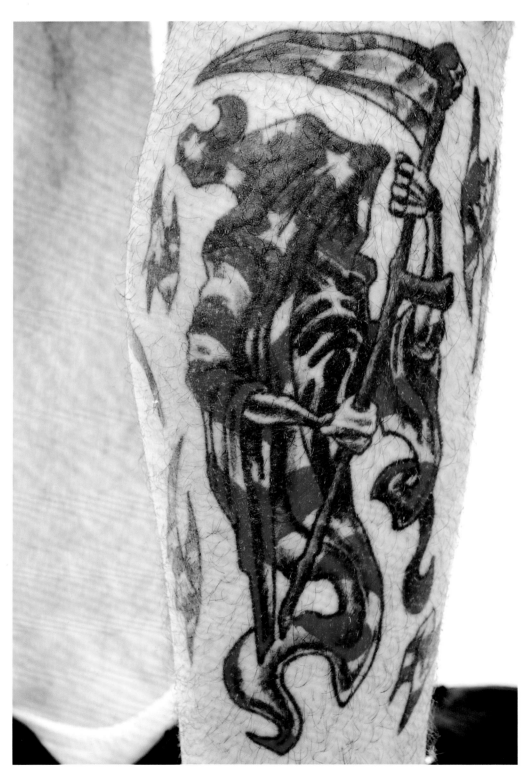

◀ Is the grim reaper wrapped in Old Glory sending a mixed message? At least that's not the case with the phrase on his other leg.
Subject: Bill Taylor

▶ So, tell us, was Daddy's blue-eyed (and blue-haired) son really "Made in the USA"?
Subject: Little Billy and Father

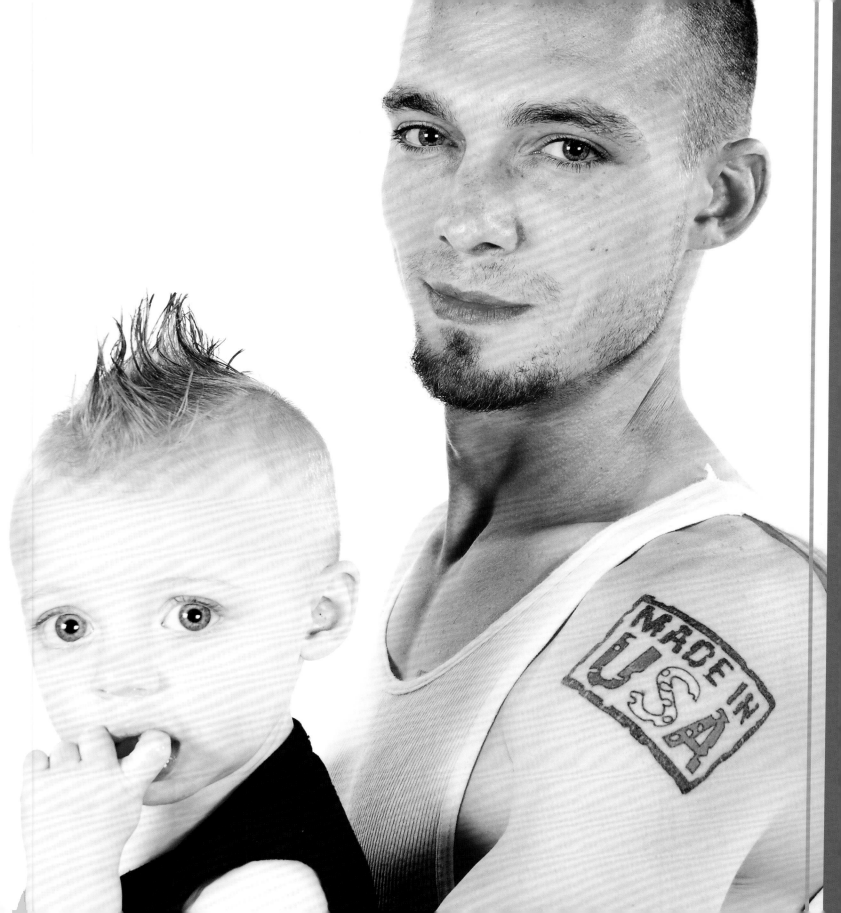

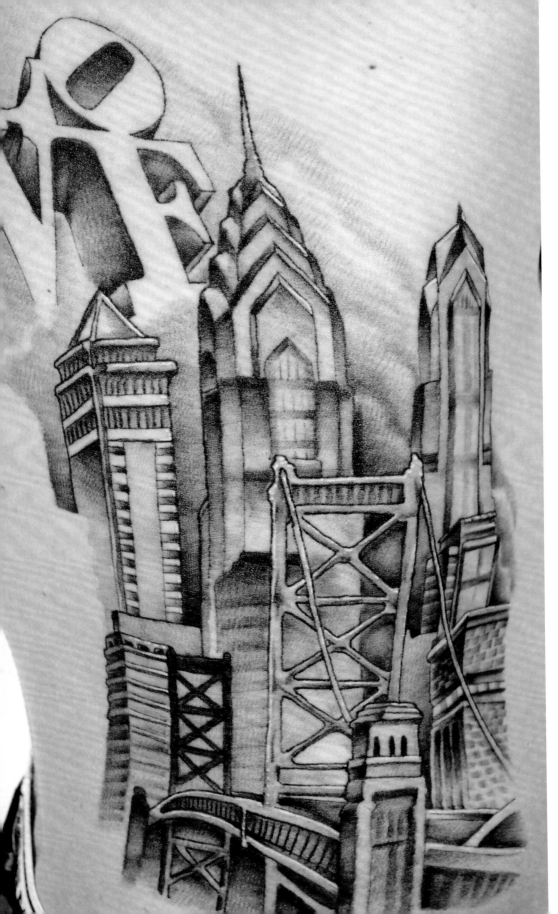

◀ Some people so identify with their hometowns that they want them inked permanently onto their bodies. This subject's pride in Philadelphia takes the form of a well-crafted collage of the city of brotherly love's distinctive skyline.
Subject: Anthony Lipczynski / Artist: Brian Donovan

▶ Other people may identify far more easily with a place "somewhere over the rainbow," as in this subject's finely detailed and sensitively shaded rendition of another famous skyline—the city of Oz.
Subject: Azad "Az" Shirozoau / Artist: Joe Lasheski, Squid Ink Tattoo

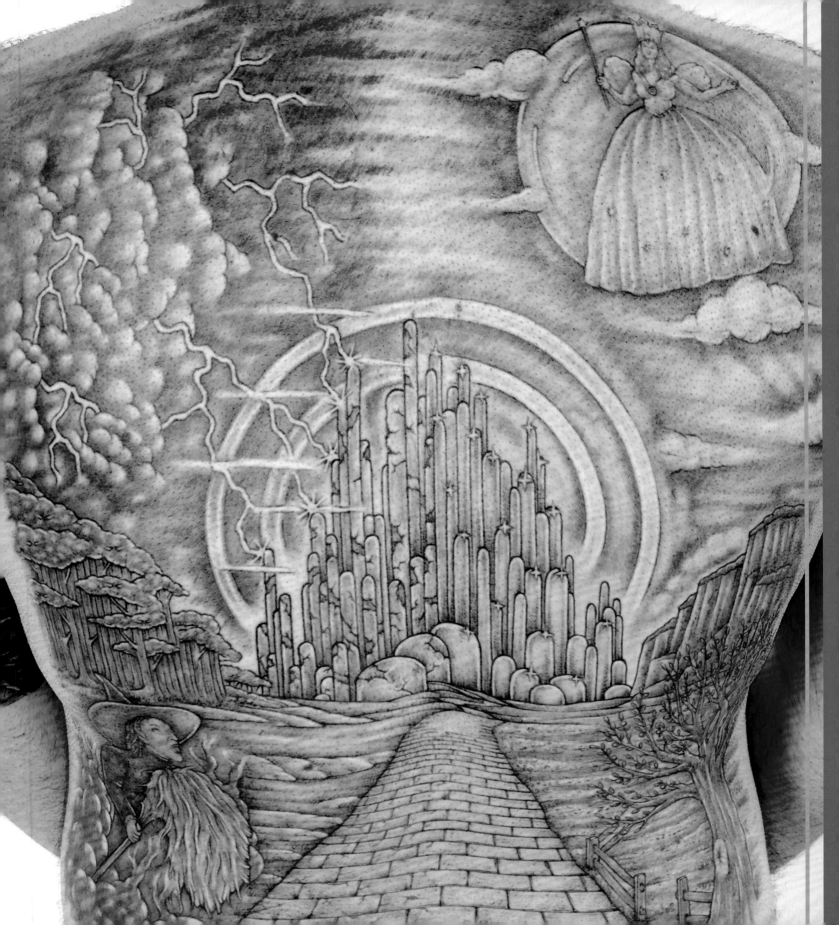

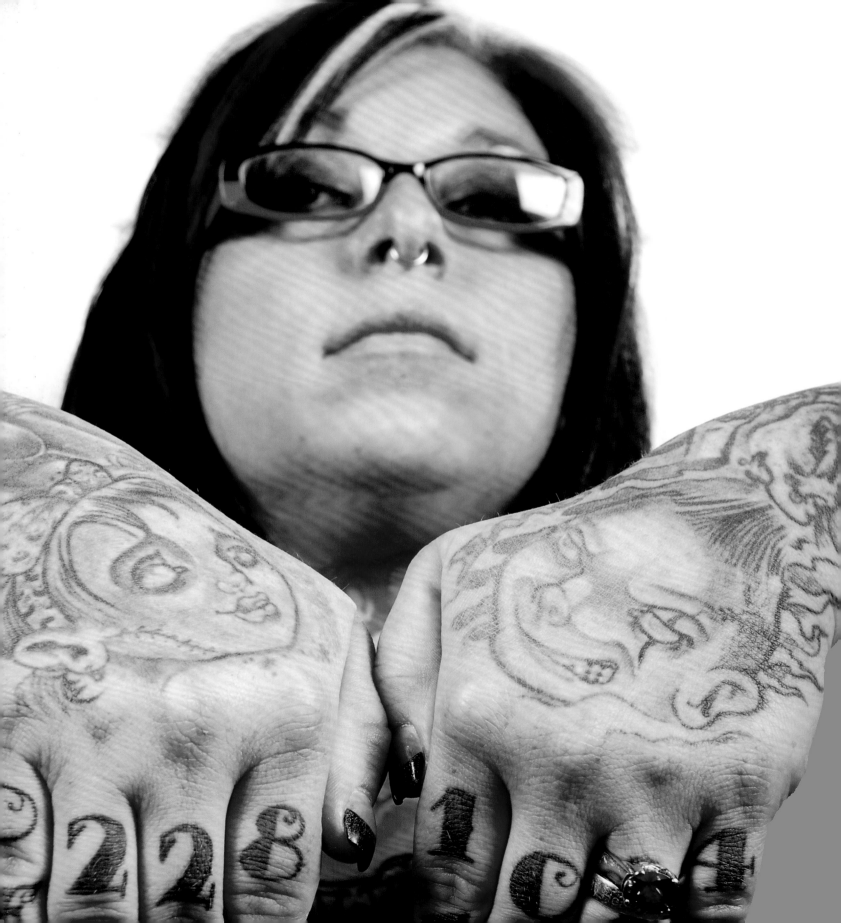

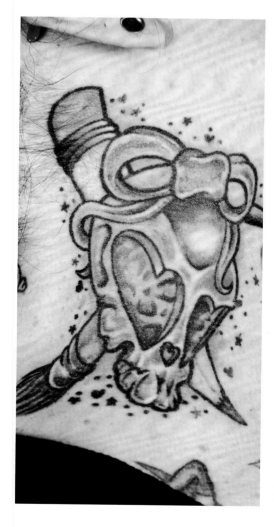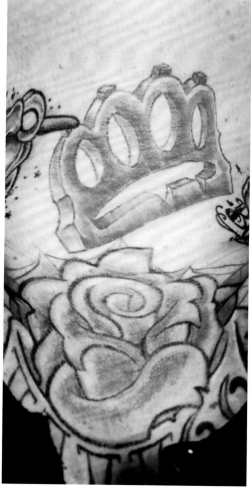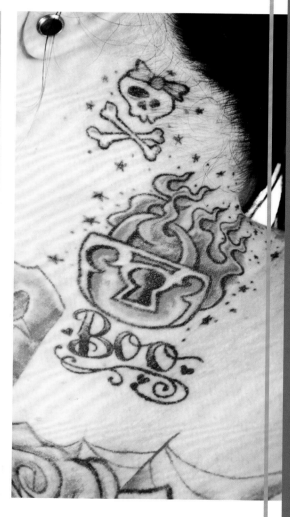

▲ Ink images wrap around the subject's neck from ear to ear. Starting under her right ear, an artist's insignia features a crossed pencil and paintbrush behind a beribboned blue skull. Sassy hot pink brass knuckles adorn her throat. Shown far right is like something from a cryptic dream: a skull and crossbones with a pink bow floats above a flaming lock.

Subject: Kristel Oreto

◄ Idle hands look like they are certainly the devil's playground when they're adorned with a pair of spooky girl and boy waifs.

Subject: Kristel Oreto / Artist: Gunnar (hands); Jason Leigh (knuckles)

"The brass knuckles are a reminder as a woman tattoo artist to be strong every day when I look in the mirror in this man-based industry."

--Kristel Oreto

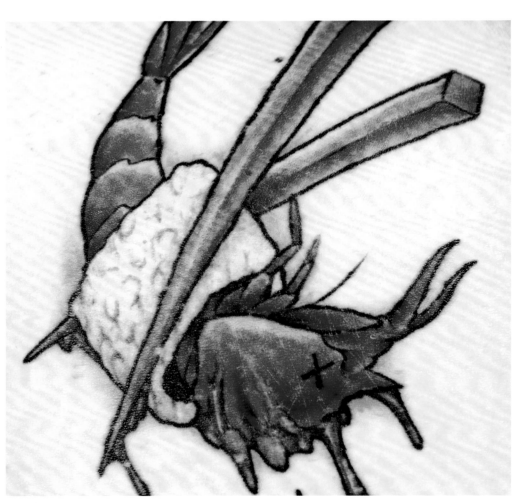

▲ Sushi, anyone? This tattoo features strong graphic lines and neon-bright color ink.

Subject: Kristel Oreto / Artist: Matt

▶ When a tattoo hits your eye like a big pizza pie, that's amore!

Subject: Kristel Oreto / Artist: Chris Bliston

▶▶ This squash may have a runny center, but the complementary color combination works great. Fitting for a woman who is writing a cookbook, these vibrant food tattoos circle the subject's waist.

Subject: Kristel Oreto / Artist: Chris Slota

"Having my kid's art on my body forever is awesome."

—Kristel Oreto

These seemingly random tattoos, a mix of writing and colorful imagery, create the dreamy effect of children's drawings, which is exactly what they are based on.

Subject: Kristel Oreto / Artist: Angel and Lucca

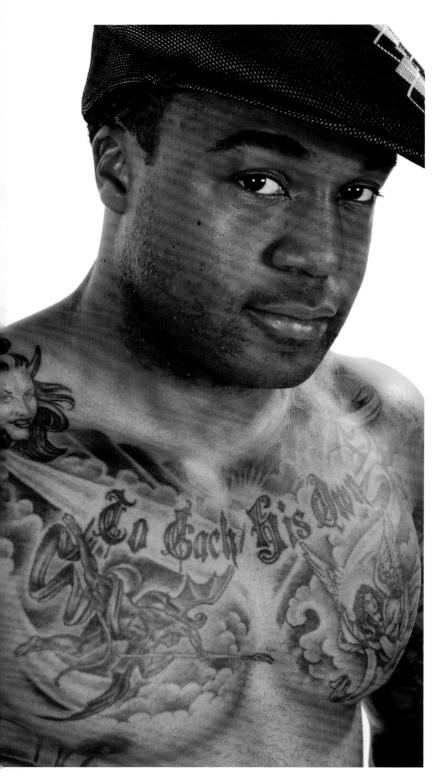

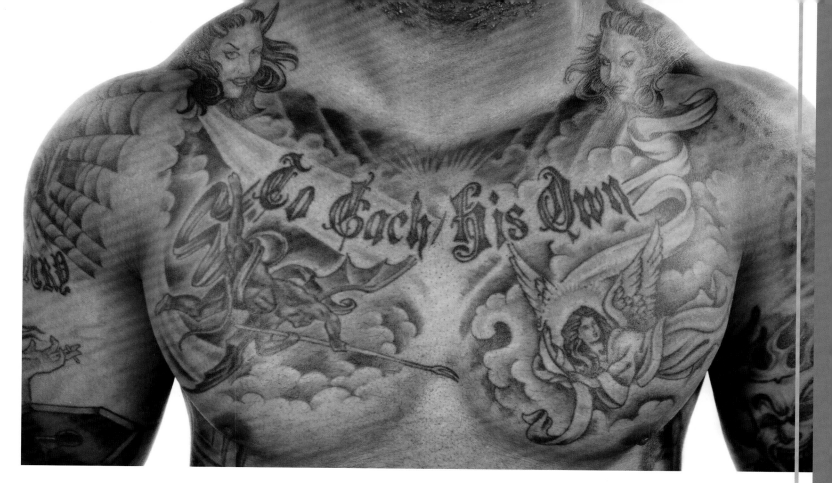

▲ A celestial battle between good and evil takes place on the subject's chest. The full scope of the battle scene—and the graphic intensity of the remarkable tattoos—can be appreciated in this upper-body view.

Subject: Carl Smith / Artist: Jason, Tattoo World

◄ In close-up, a devil in a jester's cap grins wickedly at the violence ensuing below him, all taking place under the banner, "To Each His Own."

Subject: Carl Smith / Artist: Jason, Tattoo World

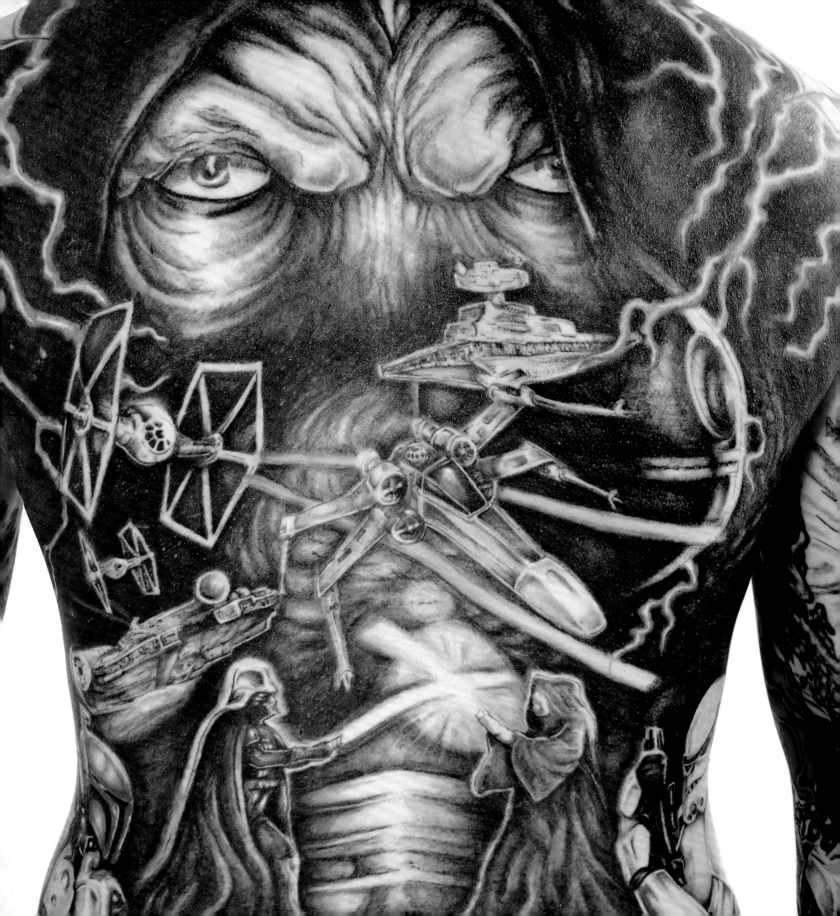

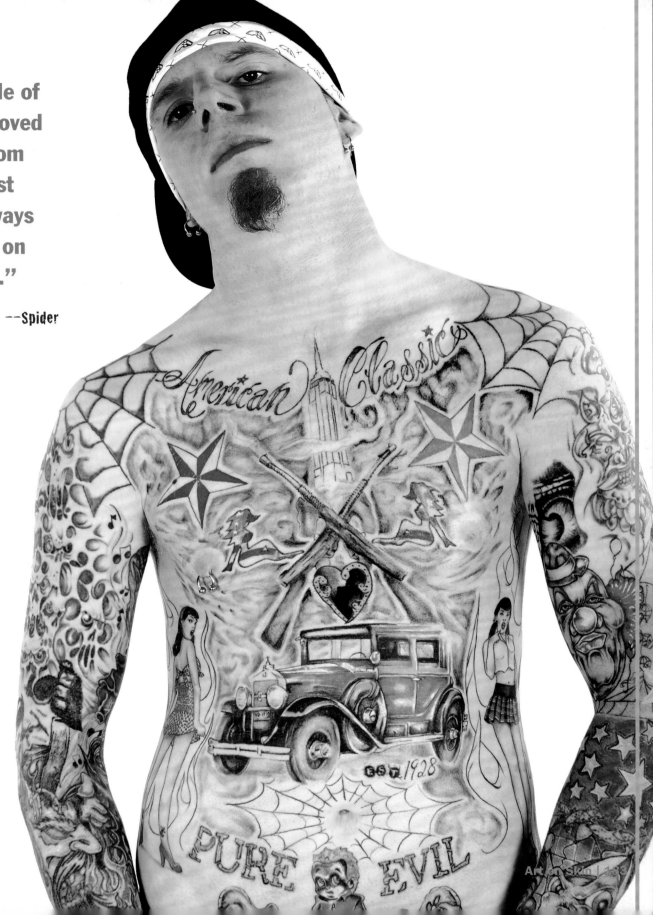

"The dark side of *Star Wars*. I loved that movie from childhood, just because I always wanted to be on the dark side."

—Spider

◄ This detailed *Star Wars* homage includes a looming Emperor Palatine and Darth Vader locked in a light saber duel with Obi Wan Kenobi.
Subject: Spider / Artist: Tommy Skoon, Ink Asylum

▶ This full-chest tattoo creates a vivid panorama of "American Classics," including the Empire State Building and a 1928 Model-T Ford.
Subject: Spider

A sad child-woman with her wounded teddy bears. Sometimes tattoos can tell a very personal story or mark a victory.

Subject: Nikki Sparks / Artist: Jose Garcia

"I was anorexic for seven years, and this tattoo is an ode to beating it."

—Nikki Sparks

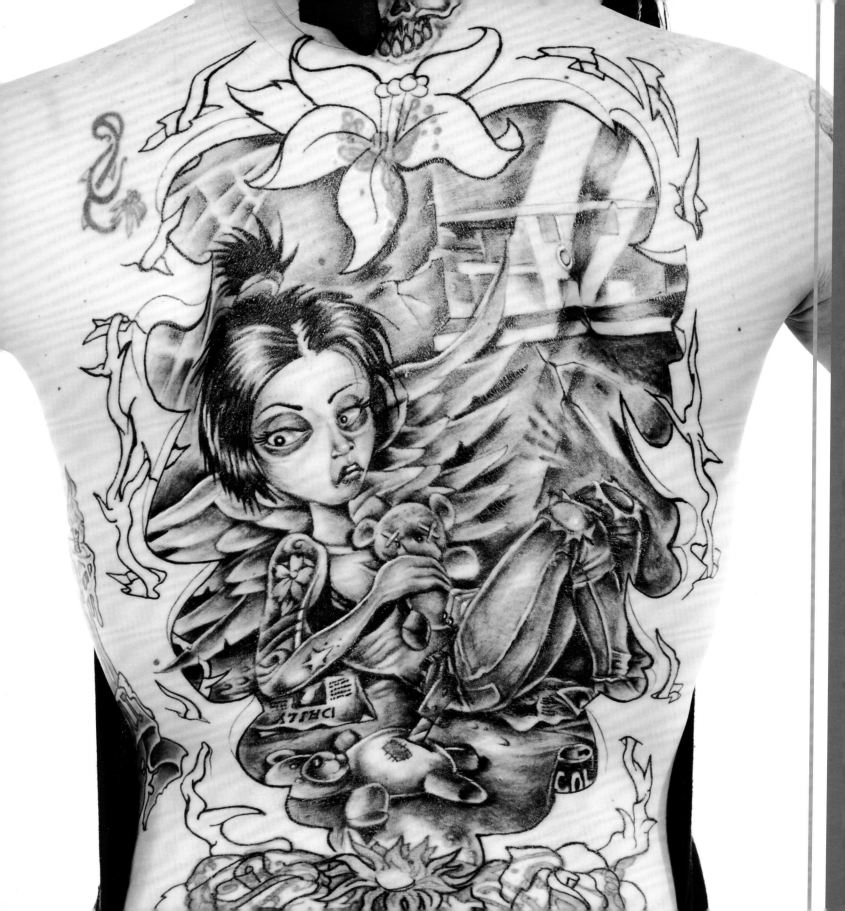

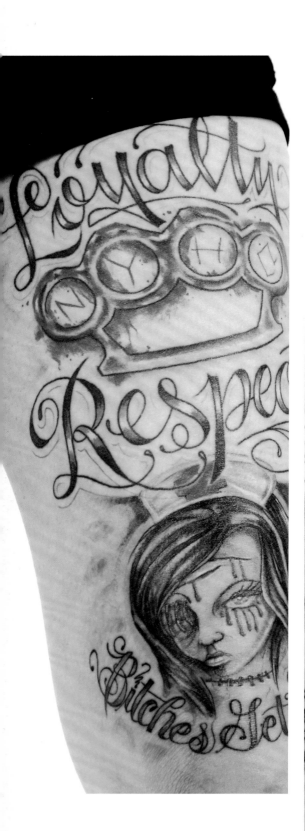
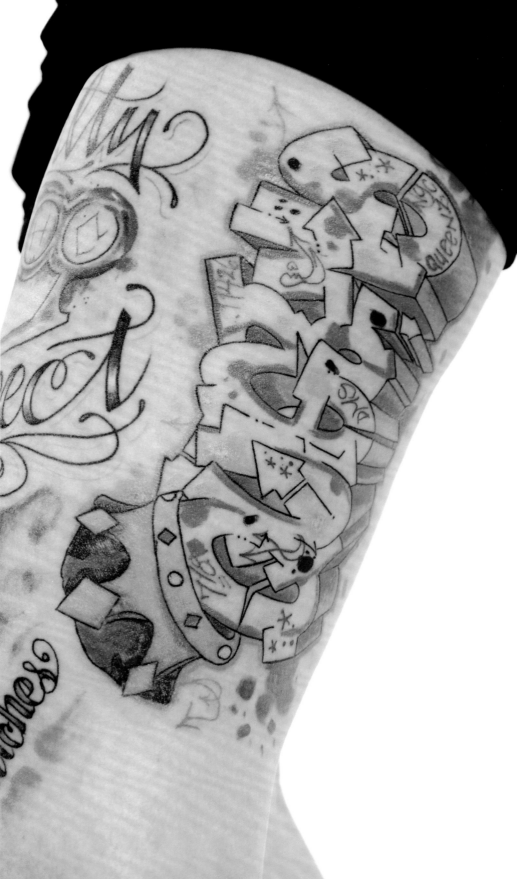

◄ This nearly fluorescent thigh ink offers a glimpse of a woman's personal philosophy and shows off her pride in her NYC hometown.

Subject: Bella / Artist: AJ and Vindeft

▼ Her belly tattoo displays a more whimsical message with its familiar Halloween refrain.

Subject: Bella / Artist: Joe Black

"My upper left leg is dedicated to hardcore; that's my life, so I wanted to do a whole piece for that, to represent where I'm from, Queens, and what I live for."

--Bella

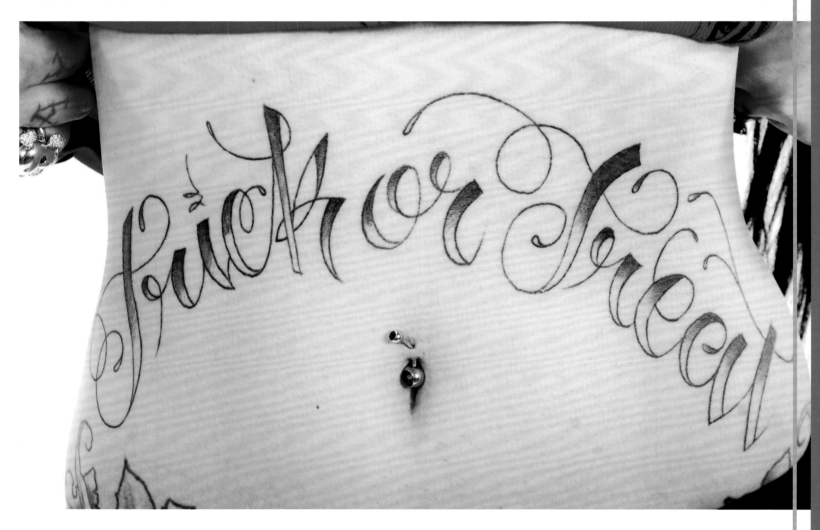

"There is no 'underground' community, no dark den of drunken sailors initiating themselves into manhood via cheap, ill-conceived exercises in bodily perforation; it's just a group of people who delight in using their bodies as billboards."

--Joanne McCubrey, *Walking Art Tattoos*

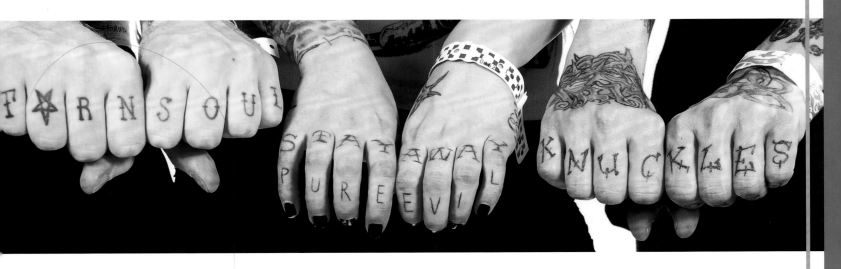

▲ Eight fingers offer the perfect canvas for message tattoos, including, "Torn Soul," "Stay Away," "Pure Evil," and the self-evident "Knuckles."

Subjects: Spider, Bella, and Nikki Sparks

◀ These three proudly show off their dramatic body art statements.

Subjects: Bella, Spider, and Nikki Sparks

◀ This subject and his son wear matching tattoos—their surname across their backs.
Subject: Michael Conte / Artist: Patrick Levins

▽ These tattoos symbolize a mother's love. "The swallows are for my twin son and daughter. Each banner holds their name and it is on the side they were on in my womb."
Subject: Laura DiBenedetto, World Wide Gypsy Queen President / Artist: Israel

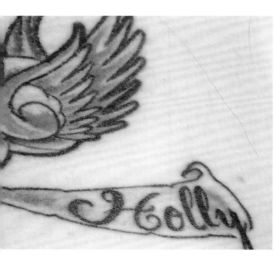

There are those whom we wish were always close to us, those we love and have loved, those who made us live our lives beyond ourselves. There are those who inspire us and push us, whose words live in our heads. There are those whom we wish to commemorate and repay through acts of beauty or commitment. Here are bodies that keep their loved ones permanently close. Here are people who have asked the tattoo artist to memorialize those whom they have lost and celebrate those whom they love. Feats of figurative drawing make monuments on people's torsos; faces sit snugly near to the heart. In an impermanent world, here is a sense of permanence, of lasting affection. Here is a new meaning to having somebody under your skin.

THIS IS DEDICATED

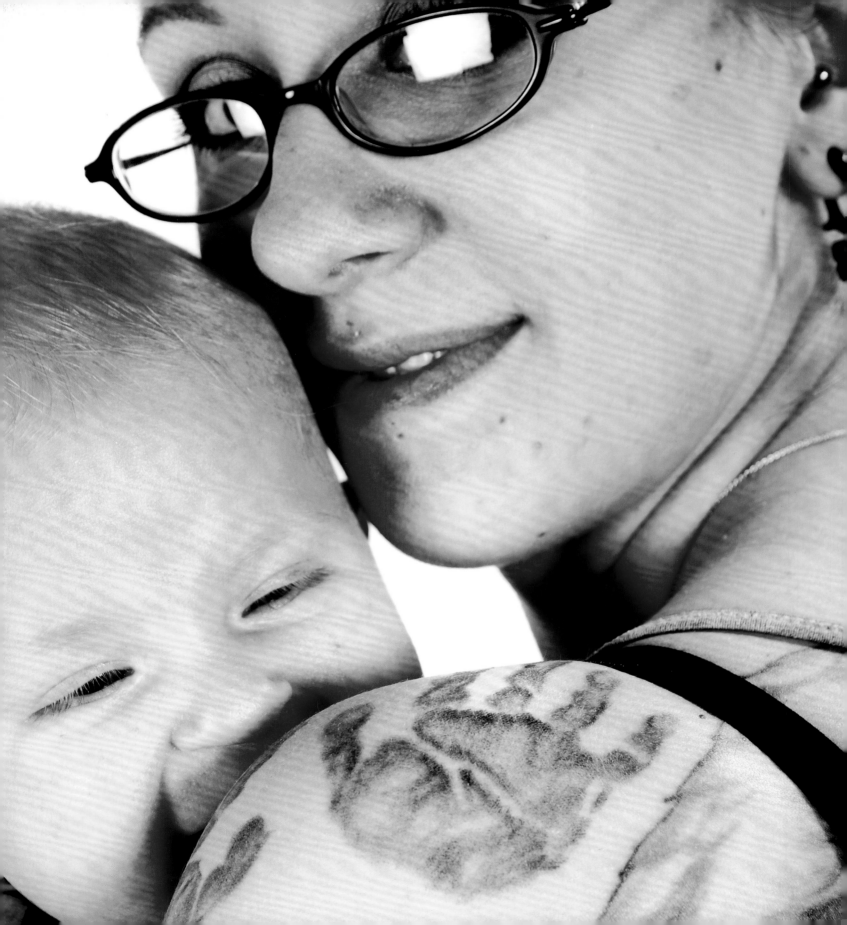

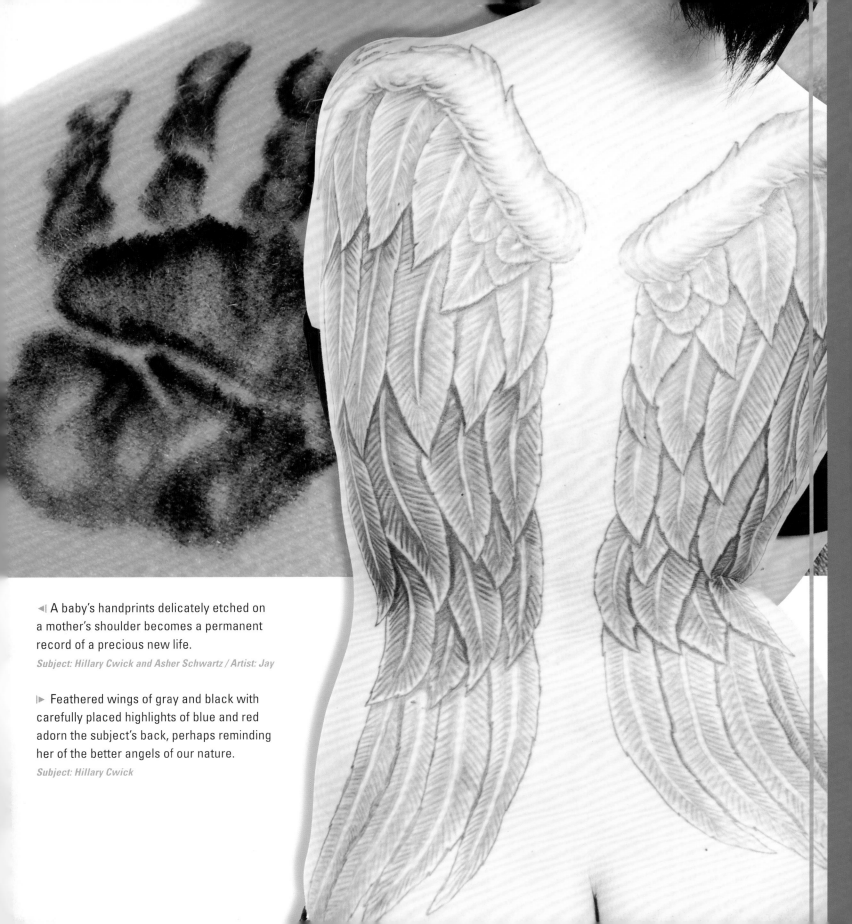

◄ A baby's handprints delicately etched on a mother's shoulder becomes a permanent record of a precious new life.

Subject: Hillary Cwick and Asher Schwartz / Artist: Jay

▶ Feathered wings of gray and black with carefully placed highlights of blue and red adorn the subject's back, perhaps reminding her of the better angels of our nature.

Subject: Hillary Cwick

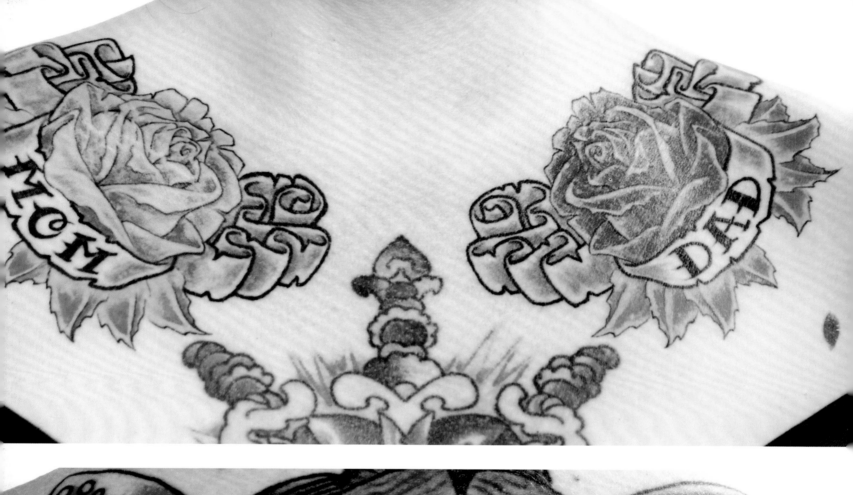
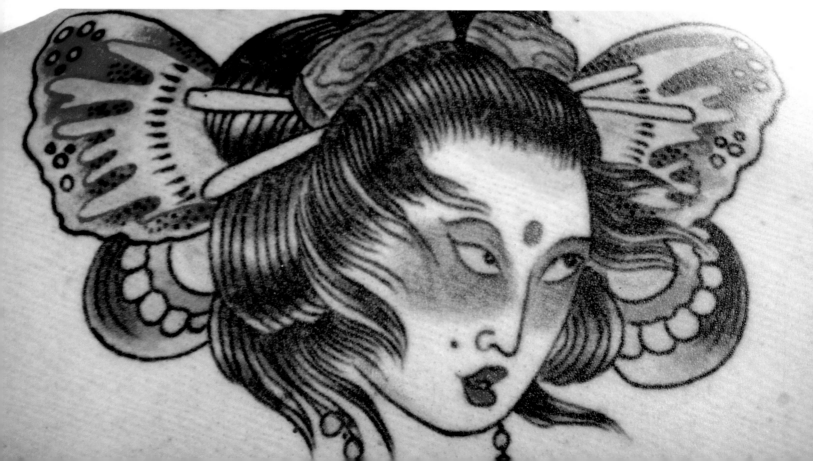

◀ "Mom" and "Dad" may be common subjects for tattoos, but rarely are the sentiments so beautifully expressed in ink.

Subject: Sara Purr

"Usually all my tattoos came at good times. A tattoo is something permanent when you've made a self-discovery, or something you've come to a conclusion about."

—Angelina Jolie, actor

A common sign in tattoo parlors is the old saying "Think Before You Ink," and that is certainly an appropriate warning for people thinking about tattooing names of girlfriends, boyfriends, wives, or husbands on their bodies. How many of them sat down in the tattoo chair absolutely sure that their object of affection was worth the ink? How many of them came to later regret that expression of undying passion for the lover or spouse who turned into an "ex"? A far safer dedication is also one of the most common: a memorial to Mom and Dad. While boyfriends and girlfriends come and go, our parents are with us forever.

◀ The subject's upper back reveals a Geisha framed by exotic butterfly wings.

Subject: Sara Purr


Art on Skin | 195

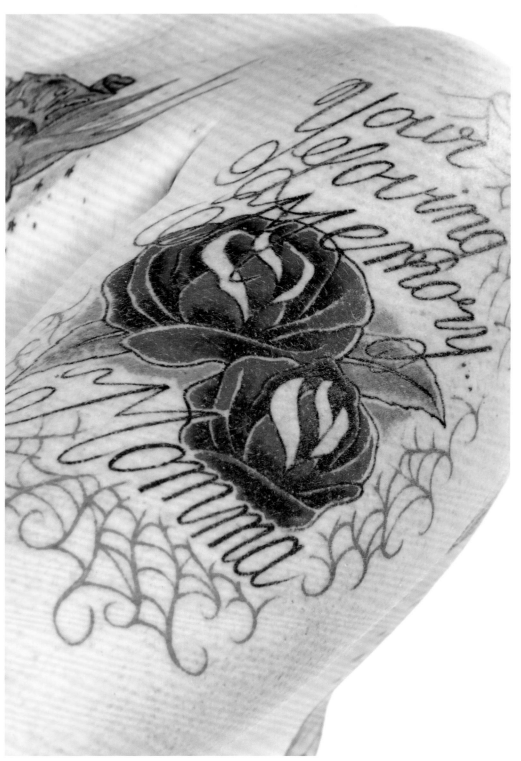

"Beauty is skin deep. A tattoo goes all the way to the bone."

--Vince Hemingson, tattoo historian

◄ Another loving testimonial to Mom, worked with elegant swashes and deep red roses.
Subject: Pamela Francis

▶ Of her collection of body art, the subject says it's a "work in progress. I've added bits and pieces over the past few years."
Subject: Pamela Francis / Chop, Chop Shop Tattoos

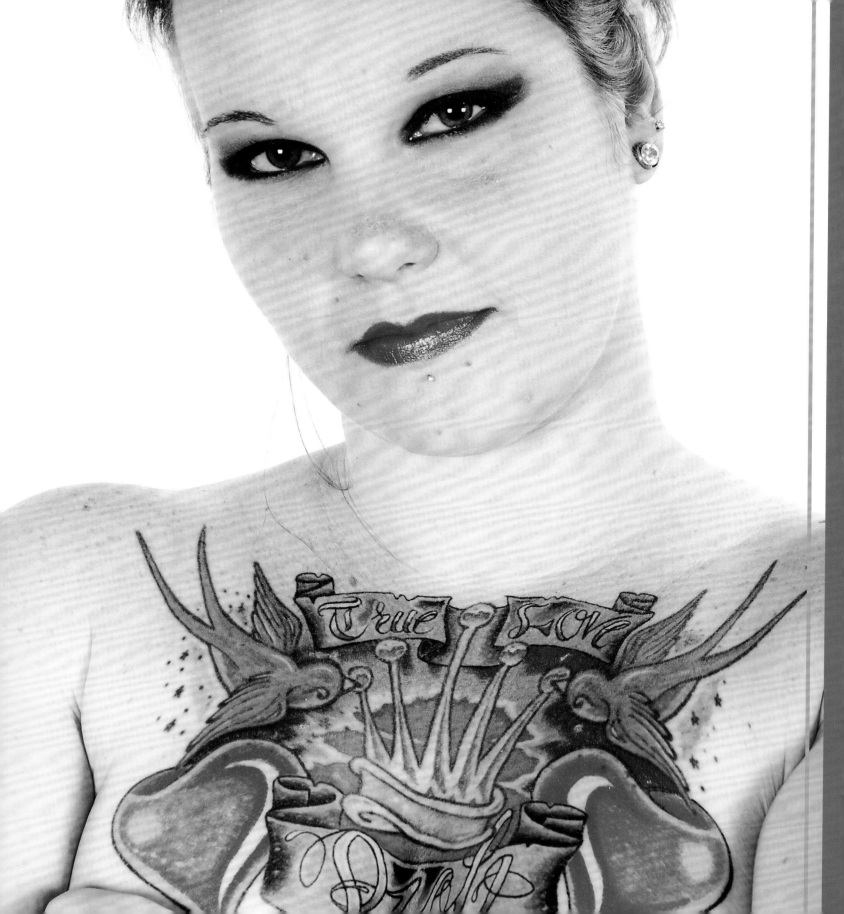

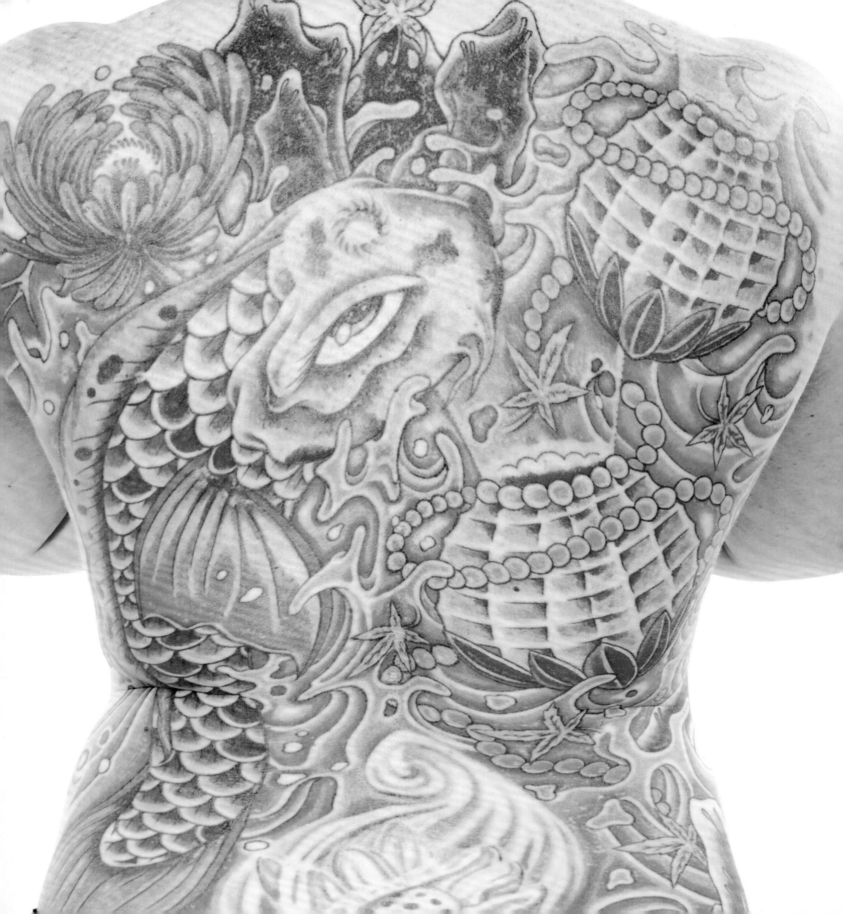

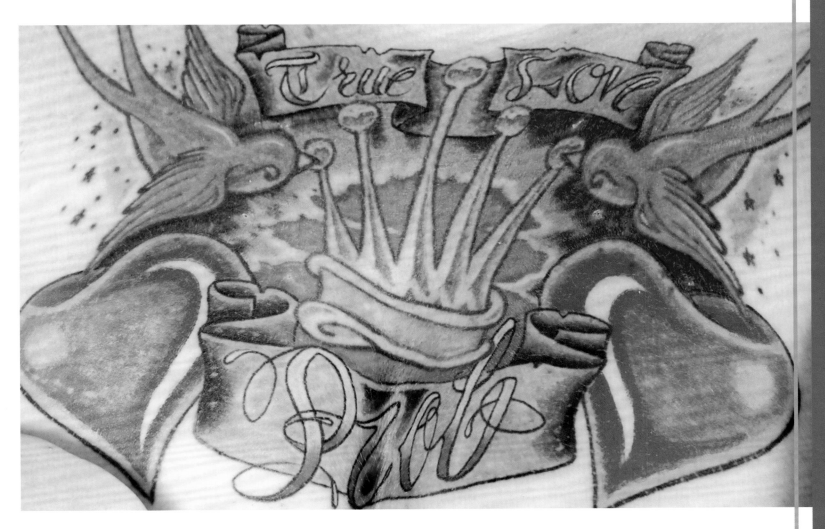

▲ The "True Love" tattoo on her upper chest is striking, with its vivid colors and twin hearts. The richness of the blues, shading from cerulean to cobalt, stands up to the bold purples that blend from lavender to grape.

Subject: Pamela Francis / Chop, Chop Shop Tattoo

◄│◄ A magical underwater scene complete with a lush koi immediately draws the viewer in. "I always wanted a large tattoo," the female subject explains. "And I love the Asian-inspired designs. Not meaningful, just beautiful."

Subject: Pamela Francis / Chop, Chop Shop Tattoos

◄│ This diamond-eyed skull tattoo, located on the subject's left foot, is "half of a complete set representing my husband and I. Sort of death 'til do us part."

Subject: Pamela Francis / Chop, Chop Shop Tattoo

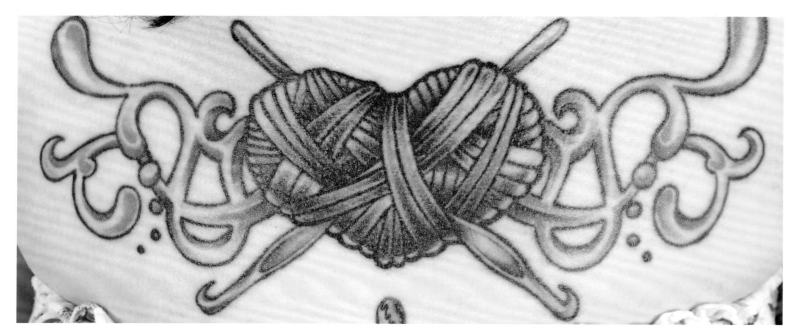

"My grandfather passed away this past November, and he drove a truck his entire life. The tattoo was the least I could do for him after all of the things he had done for everybody else."

--Mandi Starcher

▷ Not your typical tattoo, a purple yarn heart with crossed crochet hooks makes a homey, domestic statement. Above, a close-up of the heart shows intricate shading and skillful highlighting.

Subjects: Mandi Starcher and Rylee

◁ The image on the subject's inner left arm was inspired by her love of her grandfather.

Subject: Mandi Starcher / Artist: JR Tubbs

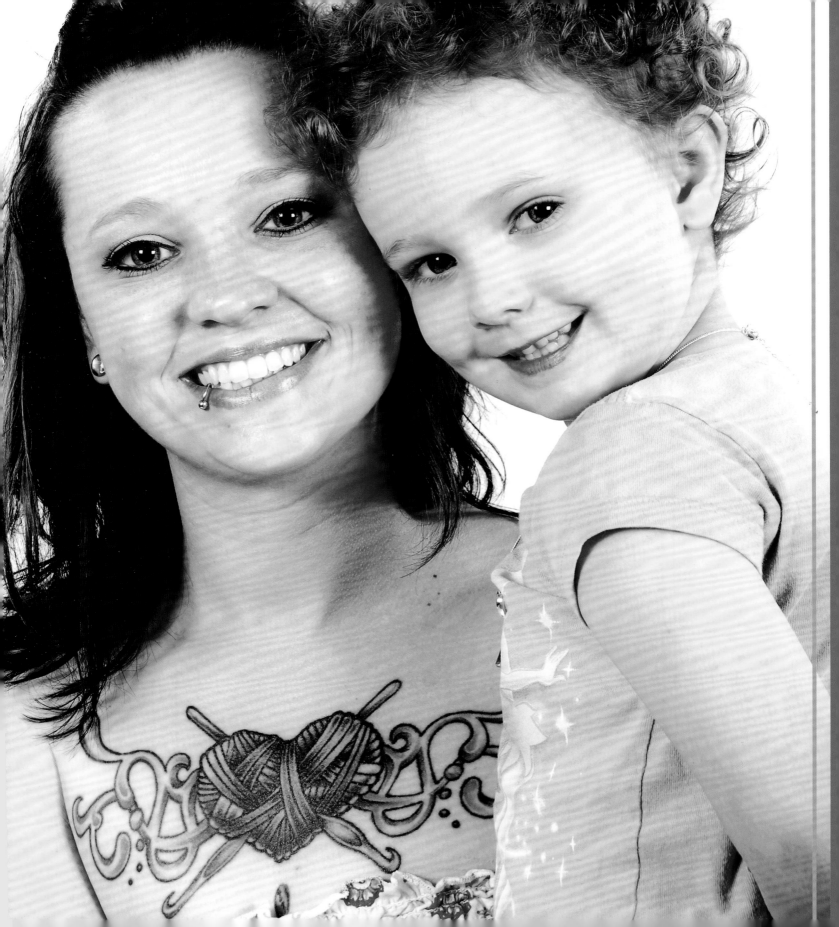

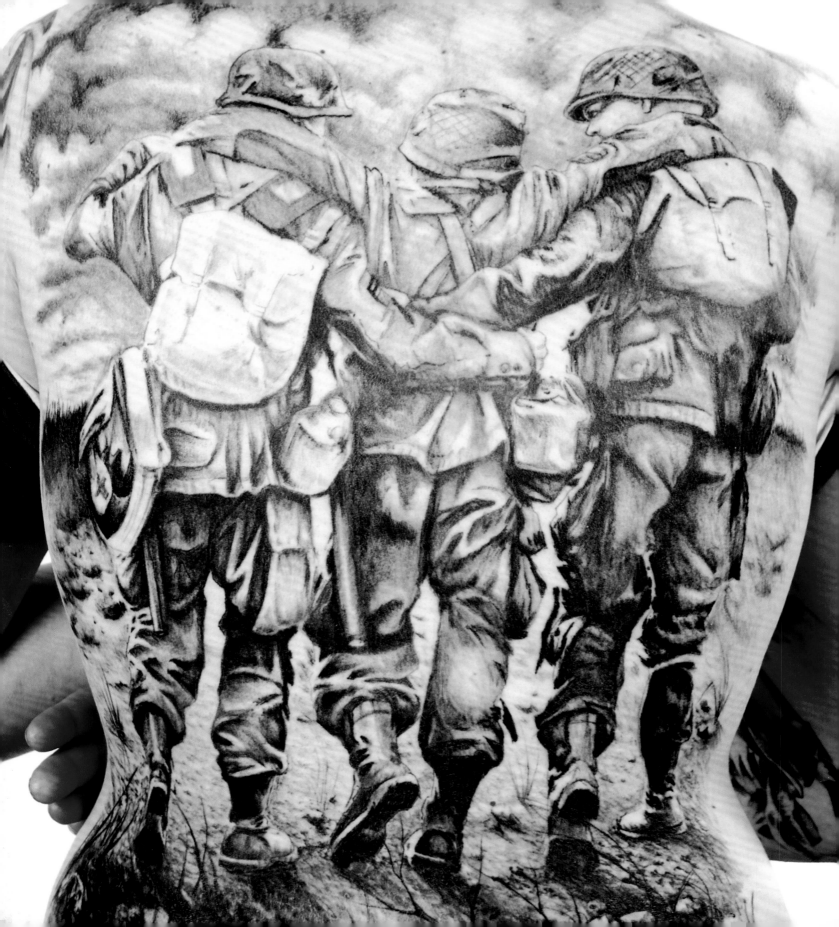

Nothing is more natural than wanting to commemorate a time of growth or a life-altering encounter. This could explain why many servicemen (and women) return from military duty bearing tattoos. They might want to show pride in their branches of service—the US Marine bulldog, an RAF soaring falcon, or a navy anchor, for instance; memorialize a particular battle or action; or simply remind themselves of the sense of unshakeable brotherhood and camaraderie that those in combat share. And is it any wonder that service members stationed in Asia take advantage of skilled local practitioners and come home wearing exotic body art?

Whatever their motivation, military men and women take pride in these tattoos, which represent their service to flag and country.

◀ This striking full-back tattoo conveys devotion to duty, as two medics aid a wounded comrade. The stark, photographic realism of the image underscores the urgency and poignancy of the scene.
Subject: Radoslaw Pieslak / Artist: Radek

▶ A close-up shows the tattoo artist's mastery of light and shadow.
Subject: Radoslaw Pieslak / Artist: Radek

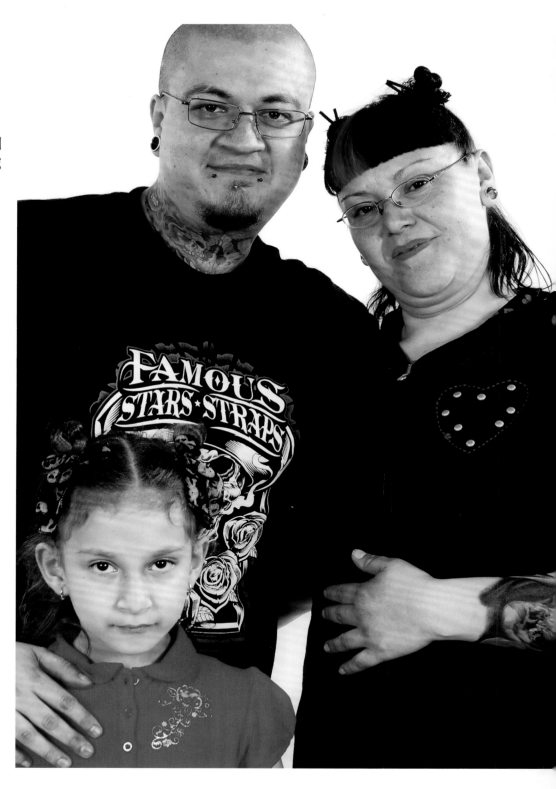

▶ An image of the subject's daughter called for a very special tattoo.

Subject: Alex Alien, Alid, Marquez, and Dafne Zoe / Artist: Alex Alien, Aztec Roots Tattoo

▶▶ Dad displays the shoulder portrait, which he says shows "the love for my daughter." She seems to approve the likeness.

Subject: Dafne Zoe / Artist: Alex Alien, Aztec Roots Tattoo

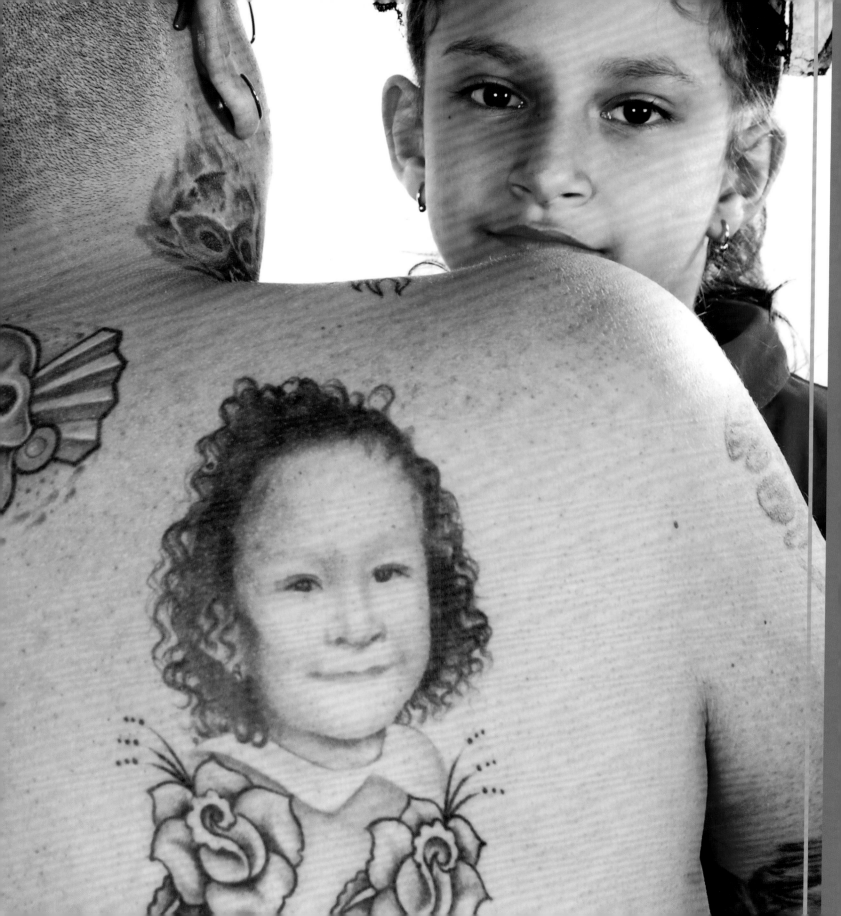

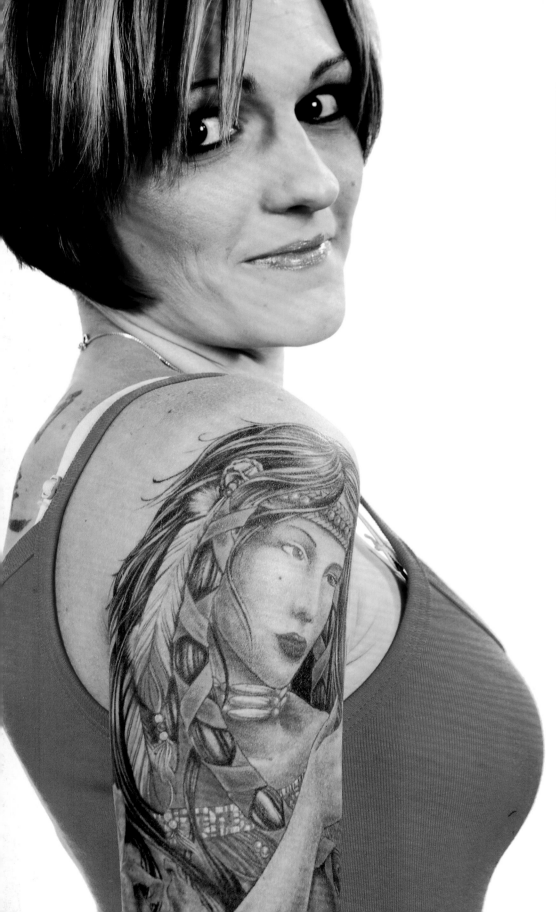

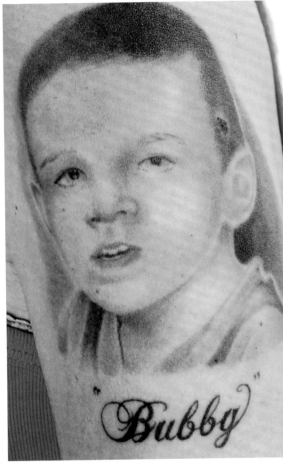

"My husband, Frank, always puts so much of his heart into each tattoo. Being his 'living canvas' and the mother of his children gives me more joy than words could ever express."

—Kristal Frank

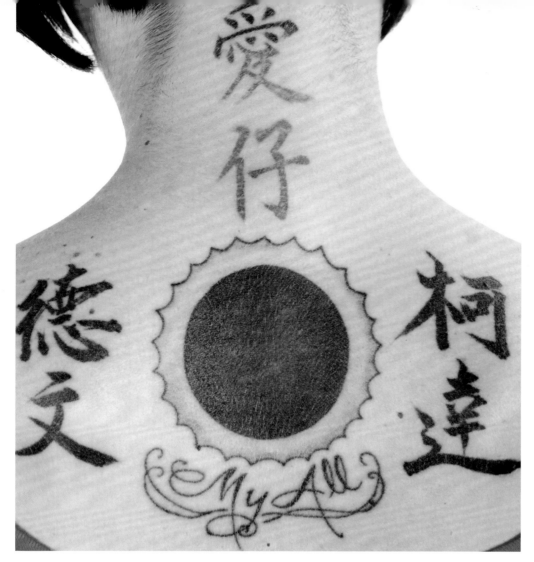

◀◀◀ Opposite page, left: this stunning portrait of a Native American woman, full of rich colors and amazing detail, graces the subject's right arm.

Subject: Kristal Frank / Artist: Walter "Sausage" Frank

◀◀ Opposite page, right: a realistic rendering of her son Devon is inked on her left arm.

Subject: Kristal Frank / Artist: Terry "Wookie" Hoffman

◀ A simple sun and the words "My All" grace the subject's back. Of her other tattoos, she says, "My tattoos all represent my three sons, Devon, Kodah, and Keeghan."

Subject: Kristal Frank / Artist: Walter "Sausage" Frank

▽ Strategically placed jewel studs decorate this butterfly, the centerpiece of a belly tattoo.

Subject: Kristal Frank / Artist: Walter "Sausage" Frank

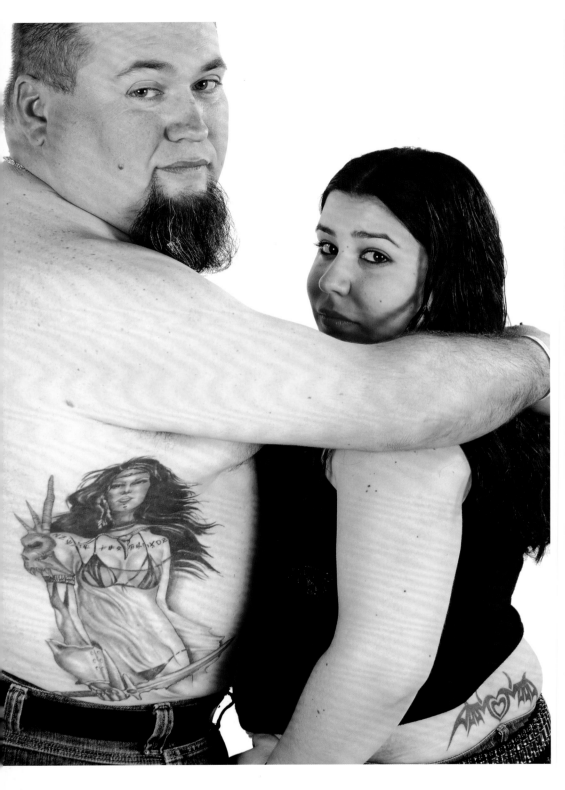

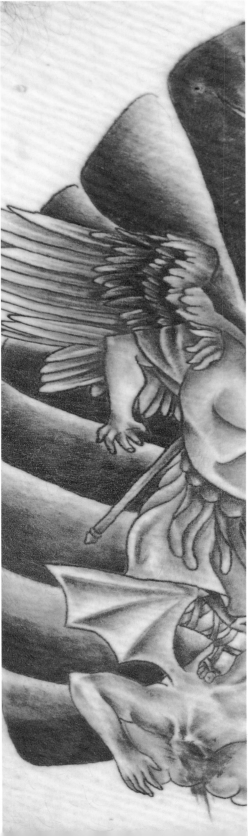

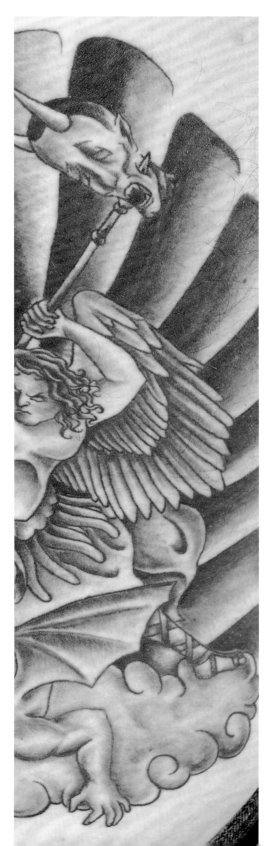

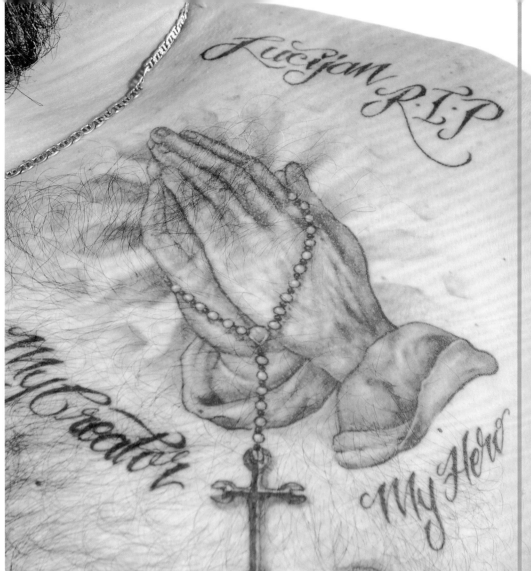

▲ An ink interpretation of Albrecht Dürer's famous *Praying Hands* holding a crucifix is the centerpiece of a memorial tattoo for a departed loved one.
Subject: Ziccy / Artist: Ian Shaffer

◄◄ This father and daughter pair has opted for strong black tattoos, rather than bright colors, to express themselves. He shows off a female shaman on his side, while she displays a winged heart at her waist.
Subjects: Ziccy and Nicole "Nixy" Zic / Artist: Ian Shaffer

◄ This tattoo of the archangel Michael defeating Satan is graphic and stirring, a prime example of the effective use of monochromatic color. Note the one kick of blood red at the devil's severed neck.
Subject: Ziccy / Artist: Michelle Haspel

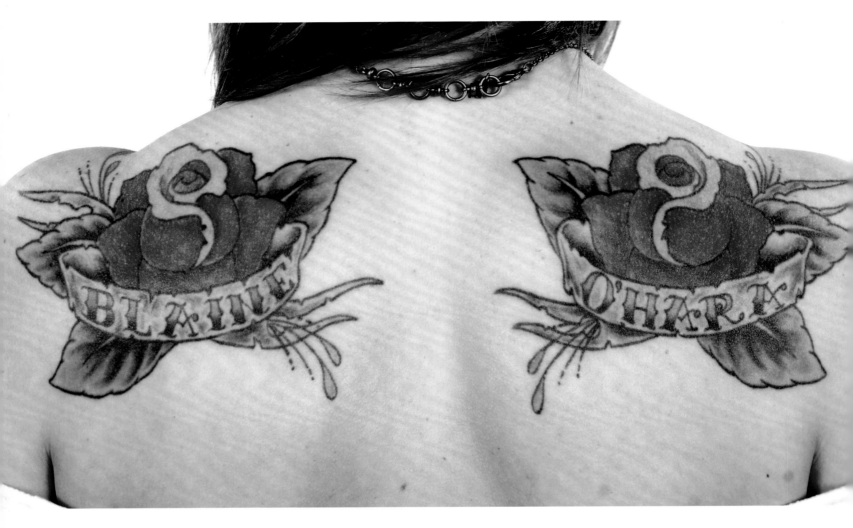

▲ Matching shoulder tattoos of carmine roses contain two names that are meaningful to the female subject.

Subject: loo / Artist: Chris Stumpf, Timeless Tatz

◀ A skeleton key is a popular motif, symbolizing secrets, knowledge, or maybe the key to someone's heart.

Subject: loo / Artist: Chris Stumpf, Timeless Tatz

▲ A simple heart awaits a key to unlock it.

Subject: loo / Artist: Chris Stumpf, Timeless Tatz

▶ This is a beautiful example of impressionistic nonlinear tattoo art. The woman shares her own philosophy behind the image: "Nothing lasts forever . . . sunsets, youth, etc. Live each moment as it happens."

Subject: loo / Artist: Chris Stumpf, Timeless Tatz

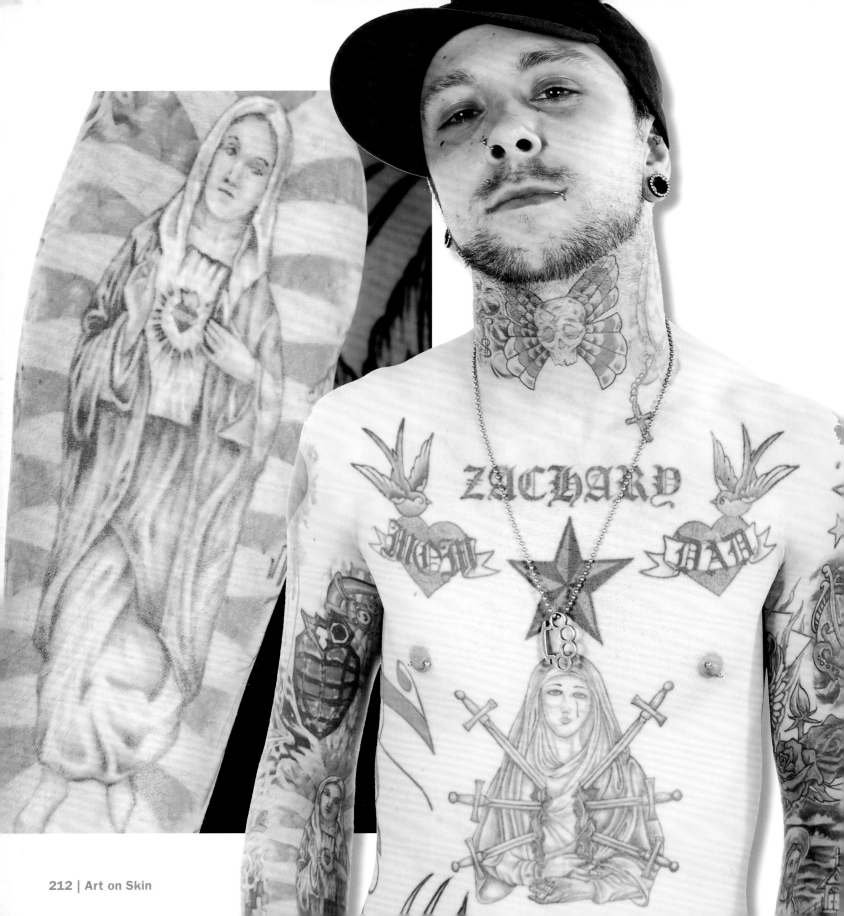

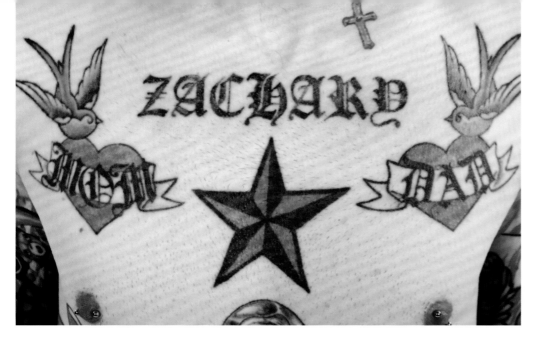

▲ The entire chest is a testament to family, featuring "Mom," "Dad," and "Zachary" tattoos.
Subject: Mike Jone$

◄ The subject describes the brilliant skull butterfly on his throat as "tough but kinda cute." The traditional and carefully rendered image of Our Lady of Sorrows on his right arm contrasts with the version of the madonna on his abdomen, which has taken a quirky turn. Rather than the heart, the madonna herself is impaled with swords, like a figure from the Tarot.
Subject: Mike Jone$ / Artists: Steve Monie; Tattoos by Phil

▶ A companion piece to right, his left arm bears a detailed image of the Sacred Heart of Jesus.
Subject: Mike Jone$

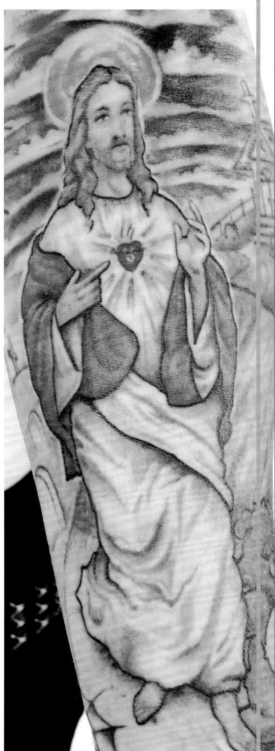

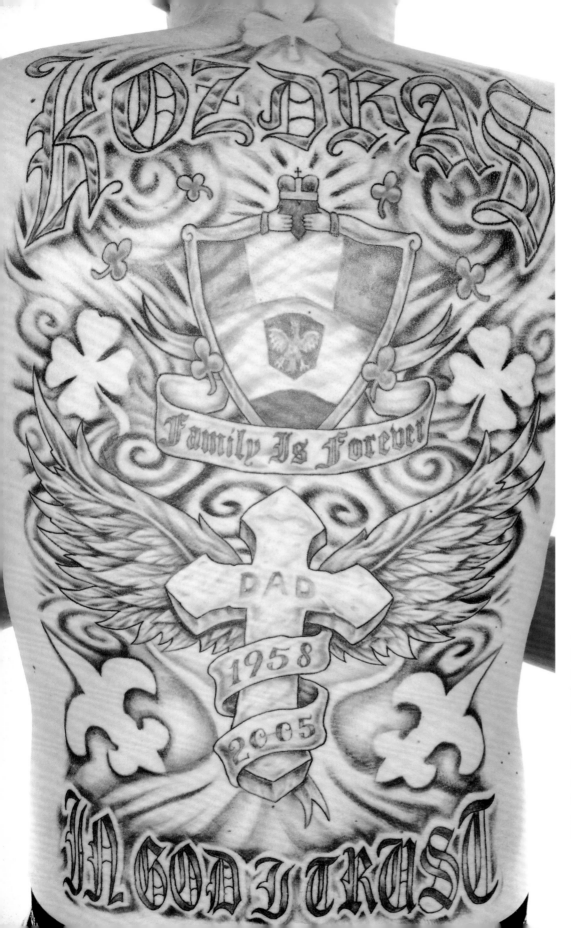

"The parrot's banners, 'Be good—If you can't be good, be careful,' it's something my grandmother used to say to me."

—Jenny B. Good

◄ The inspiration behind this dramatic full-back tattoo—which features a winged cross, shamrocks, fleur de lis, and a crest displaying the Irish and Polish flags—was "Family, Father, Passing Away."
Subject: Kyle Izozoras / Artist: Steve Monie

▶ This realistic tattoo of two parrots on a cherry tree branch expresses a warning that the subject's grandmother offered her.
Subject: Jenny B. Good / Artist: Kevin LeBlanc, White Lotus Tattoo

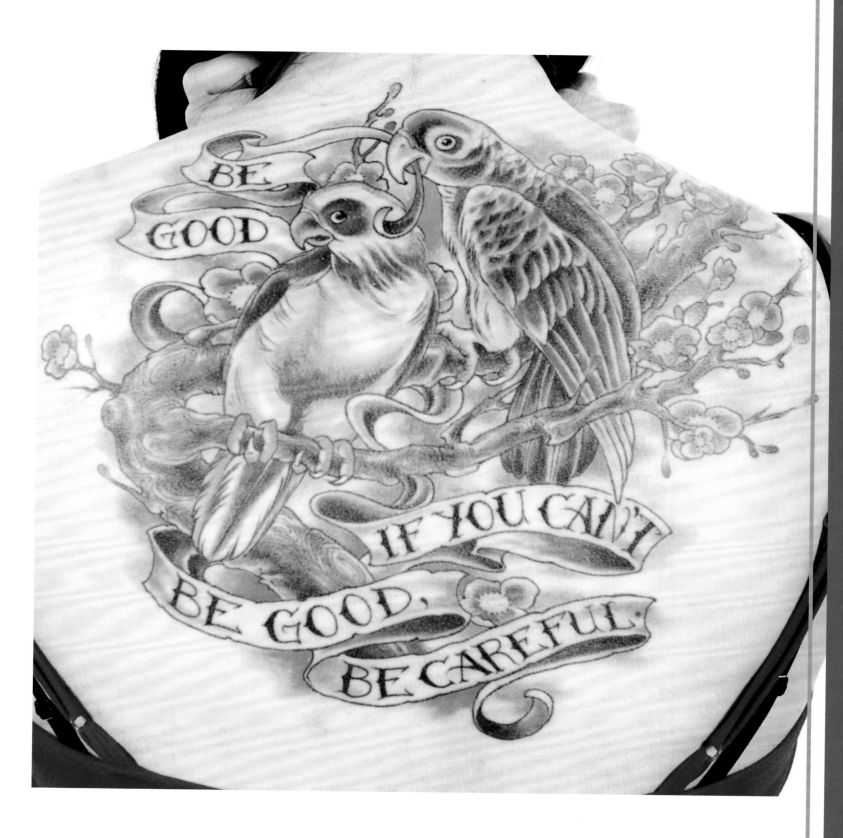

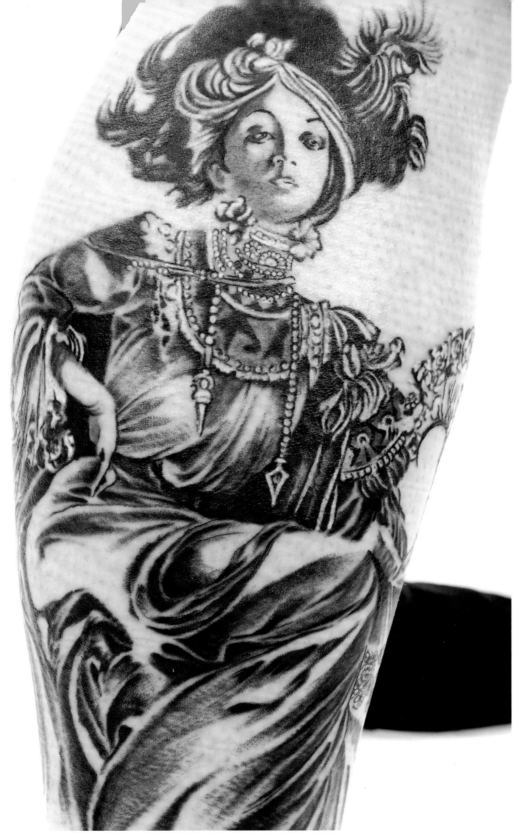

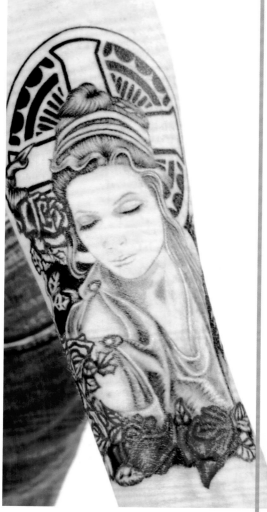

▲ A soft-focus portrait of a young girl displays an unusual stippled inking effect.
Subject: Nakia Lawton / Artist: Ink Slingers

◄ A portrait tattoo can be a true art form in the right hands. This elegant lady is dedicated to the female subject's mentor. "Rachel Telles . . . inspires me with my art and is one of my best friends. The Victorian lady was more for her to express herself through her art. It inspires me as an apprentice to strive to reach her level."
Subject: Shannaan / Artist: Rachel Telles

▶ This serene beauty has a madonna-like feel, posed against a cross amid a cascade of roses. This elegant tattoo evokes the feel of an Art Nouveau poster.
Subject: Karen Herb / Artist: Christopher Depinto

"My idea of a good picture is one that's in focus and of a famous person. "

--Andy Warhol

▷ On her left arm, the subject shows off the serene, mysterious face of the Buddha.
Subject: Carly "Underscore"

▷▷ On her right arm is an homage to Camille Rose Garcia, whose "art is amazing and daring. I took different pieces from her books and created a great tattoo."
Subject: Carly "Underscore" / Artist: Justin (Jersey)

▽ Of this vivid portrait of pop-art icon Andy Warhol, the female subject confesses, "he's my own idol in the art world."
Subject: Carly "Underscore" / Artist: Aaron Is

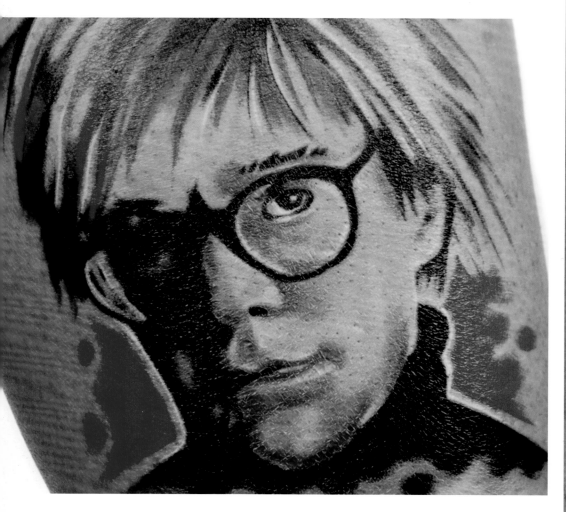

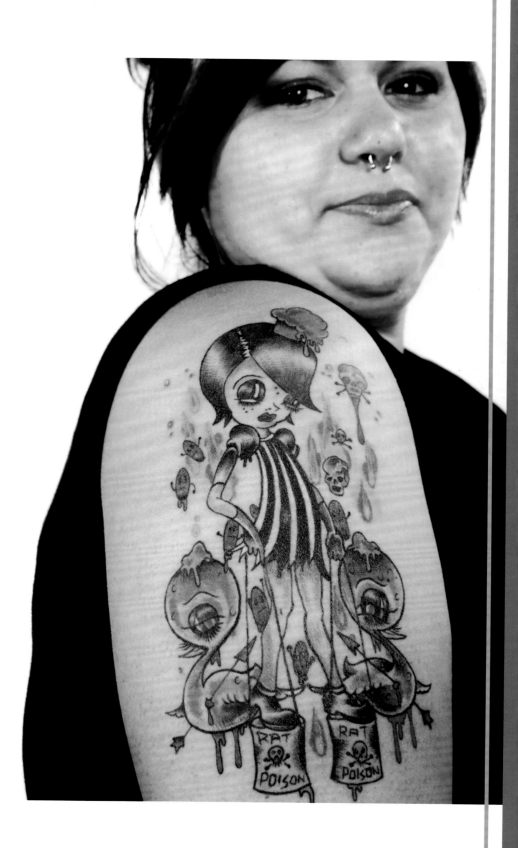

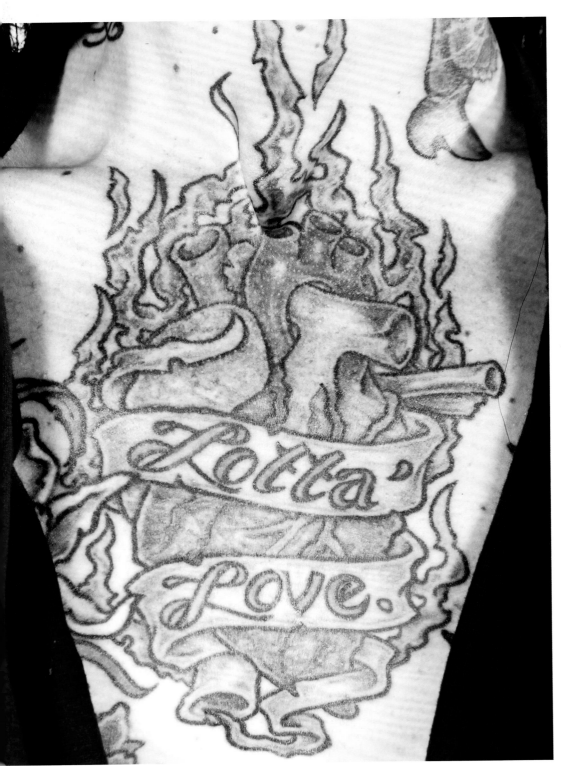

"Grandfather was raised in the depression and said, 'We ain't got a lotta money, but we got a whole lotta love.' He raised me, and it's a memorial to him."

--Nikki Sparks

◄ Far left, this chest tattoo is a memorial to the subject's grandfather, who brought her up. Left, irises and toadstools add a touch of spring.
Subject: Nikki Sparks / Artist: Greg Hess

▶ Of the rib tattoo of a candle hanging on a string, which was inspired by a past relationship, she explains, "No one holds a candle to you."
Subject: Nikki Sparks / Artist: Greg Hess

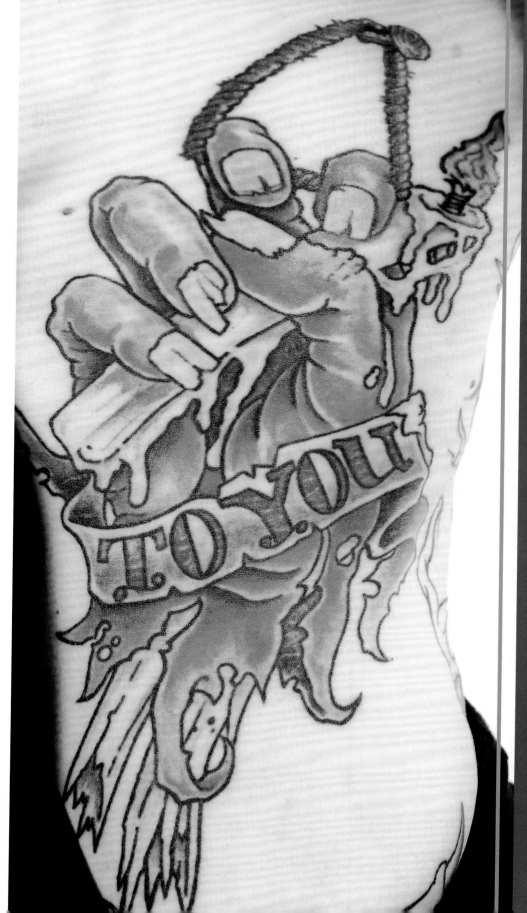

▶ This unusual tattoo with science fiction overtones runs right across the back of the subject's two clenched hands.
Subject: Anthony Enochs

▶▶ This photogenic couple displays their impressive upper body tattoos, while their smiling baby looks on—and maybe contemplates his own future ink.
Subject: Anthony Enochs, Erin McNish, and Evers Enochs

▽ More irony, as the sentiment *pur vida*, or "pure life," is juxtaposed with straight razors, brass knuckles, and twining, bloody thorns.
Subject: Anthony Enochs

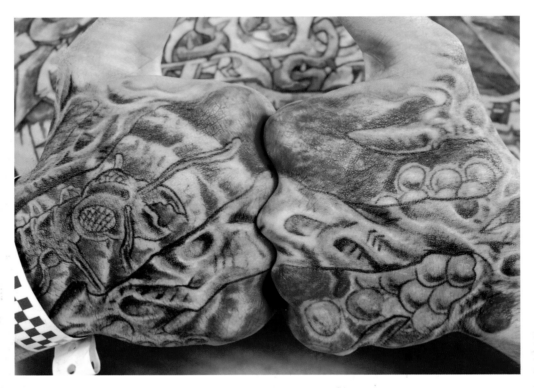

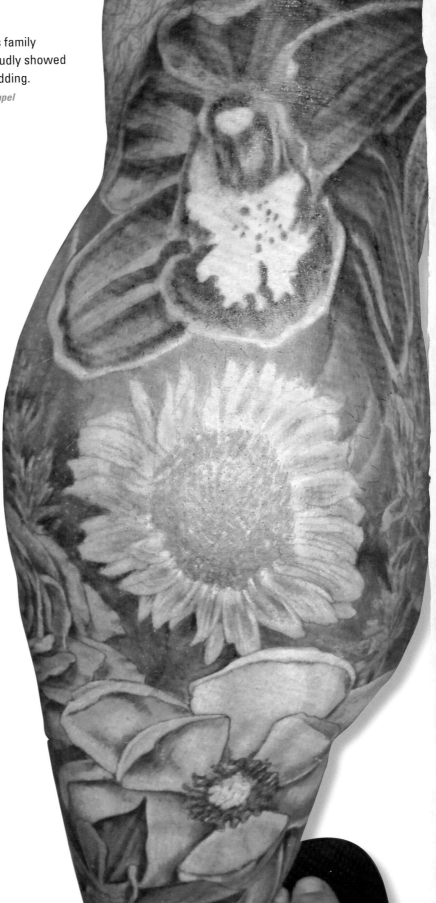

▶ This subject asked each of his family members to pick a flower. He proudly showed off the finished art at a family wedding.
Subject: Matt McGarvey / Artist: Troy Timpel
Photograph by Troy Timpel

CREDITS & ACKNOWLEDGMENTS

All photography by Jonathan Conklin, unless otherwise noted.

The publisher and authors wish to thank H. Lee, the book's designer, for jumping in head first on one of her first assignments, not only wrangling subjects but also coming up with a brilliant design; Suzanne Lander, ace editor, organizer, and wonder woman, who made the tattoo shoot happen and, with her usual charm, convinced so many people to smile for the camera; and Jonathan Conklin, photographer, for shooting so many images so quickly and still making each one a work of art.

We also sincerely thank the many, many subjects who willingly bared their skin to show off some amazing ink. This book is really all about them and their tattoos. We have made our best effort to credit each one as accurately as we could.

Special thanks to Troy Timpel (check out tattooedkingpin.com), tattoo artist and organizer of the Philadelphia Tattoo Arts Convention. Troy graciously gave us room to shoot. Without his generous help, we would have never had such a beautiful—and authentic—book.